Plain Painters

Making Sense of American Folk Art

Making Sense

NEW DIRECTIONS IN AMERICAN ART

Plain Painters

of American Folk Art

John Michael Vlach

Smithsonian Institution Press, Washington and London

Publications of the American Folklore Society, New Series
General Editor, Patrick B. Mullen

This book was edited by Judy Sacks and designed by Janice Wheeler.

Library of Congress Cataloging-in-Publication Data

Vlach, John Michael, 1948–
 Plain painters.
 (New directions in American art)
 1. Painting, American. 2. Primitivism in art—
United States. 3. Folk art—United States. I. Title.
II. Series.
ND203.V57 1988 759.13 88-600013
ISBN 0-87474-926-3
ISBN 0-87474-925-5 (pbk).

British Library Cataloguing-in-Publication Data is available.

Printed in the United States of America
10 9 8 7 6 5 4 3 2
98 97 96 95 94 93 92 91

∞The paper used in this publication meets the minimum
requirements of the American National Standard for Permanence
of Paper for Printed Library Materials Z39.48-1984.

For permission to reproduce individual illustrations appearing in
this book, please correspond directly with the owners of the
images, as stated in the picture captions. The Smithsonian
Institution Press does not retain reproduction rights for these
illustrations individually or maintain a file of addresses for photo
sources.

Cover: *Man of New Bedford*, ca. 1844, attributed to William
Matthew Prior (1806–73), 13½ × 9½ in., by permission of
Fruitlands Museums, Harvard, Massachusetts, photo by Ted
Dillard Photography.

Owing to an unfortunate error in printing, Plate V in the color
section is reversed.

For Warren E. Roberts

Contents

Acknowledgments

The origins of this book are to be found in the back row of a classroom at Indiana University. From that perch I listened to lectures by Warren Roberts on American folk art and craft. It was his custom to mention topics that we students might someday pursue on our own. One of his passing comments, on the problematic fit between the categories of portrait painting and folk art, stuck with me and has given shape to the central hypothesis of this volume. My first thanks are thus owed to Professor Roberts, and it is to him that I dedicate this book.

Almost fifteen years were to pass before the embers of his fine suggestion were to flicker into the flame of an idea. During that time I wrote some papers and published a few essays that grazed over some core issues, but it was not until 1986, when the Henry Francis du Pont Winterthur Museum awarded me a fellowship to spend eight months in residence, that I had sufficient time and freedom to examine the topic of folk painting with the seriousness it deserved. I would like to thank the Winterthur Museum for its generosity, particularly Kenneth Ames, director of Winterthur's Office for Advanced Study. He is a valuable and trusted colleague who generously gave good advice and responded enthusiastically to my tentative formulations.

Other members of the Winterthur staff were also very helpful. Catherine Hutchins served as my liaison to the museum and smoothed my path into its dense mazeway, introducing me and my project to the pertinent members of the staff. She also helped to get my manuscript put onto computer discs, which in turn has greatly eased the editorial process. I also want to thank Winterthur librarian Neville Thompson for her vigilant assistance; her interest in my research encouraged me to be productive. I thank Bea Franklin of the Rare Book Room for her kind attention while I was working with materials under her supervision. Other members

of the Winterthur staff who helped me with words of encouragement include Scott Swank, Ian Quimby, and Barbara and Gerald Ward. I especially want to acknowledge my fellow residents at the "Golf Cottage," Anne Withington and Brock Jobe, who took time away from their own projects to listen to my manic rantings about my latest discoveries. Having the luxury of an immediate audience, I could more readily put my ideas on paper. Because of its human resources, Winterthur turned out to be an excellent place to write a book about folk art.

As various chapters of a manuscript took shape I was provided with important opportunities to test them out on public audiences. Simon Bronner invited me to speak to his students at the Pennsylvania State University in Harrisburg. Reaction to my lecture "The Problems of Plain Painting" helped me refine the arguments that appear in the introduction. Invitations to speak at the *North American Material Research* conference and the *26th International Congress of the History of Art* allowed me to test out loud the premises of chapter 3. I would like to thank Gerald Pocius and Jules Prown, respectively, for placing me on these two programs.

Daniel Goodwin first brought my manuscript to the attention of the Smithsonian Institution Press and has remained a supporter of this work throughout the various editorial stages. Members of the Smithsonian Institution Press staff have shepherded my pages through the production gates with equal amounts of sensitivity and professional decorum. I have been well served by my copy editor, Judy Sacks, and book designer, Janice Wheeler, who have done their best to make my prose and pictures sound and look as good as possible. Susanna Stiles cheerfully accommodated my requests for additional typing and deftly inserted editorial changes where needed. My thanks go to all who have labored with me to put this book before the public.

A special acknowledgment must go to Kenneth Ames, Jules Prown, and Wanda Corn, who read the entire manuscript and offered suggestions for revisions. I have attempted to respond to their criticisms and sincerely believe that the book is better because of their sound advice.

Other scholars, students, and friends have contributed to this book in both obvious and subtle ways. They include Gene Metcalf, Archie Green, Henry Glassie, Barbara Fertig, David Taylor, Bert Wilson, Elizabeth Johns, Steve Ohrn, Bob Teske, Dick Ahlborn, Gary Kulik, Barney Mergen, John Moe, Charles Bergengren, John Burrison, Suzi Jones, David Jaffee, Howard Gillette, Nick Spitzer, Dell Upton, Jim Deutsch, Leslie Prosterman, Bill Aspinal, John McGuigan, Mike Jones, Kathy

Foster, Gary Stanton, Bob St. George, Buck Pennington, and Terry Zug. The many museums, institutions, and individuals cited in the figure captions also are thanked for allowing me to reproduce works of art from their collections.

I also want to thank my in-laws Ken and Ruth Wood, who took charge of the home front during my absence. They kept the household in order in countless ways and made, by their example, a good case for the return of the extended family.

Finally, it is more than appropriate that I thank my wife, Beverly Brannan, and my daughter Kate for being so patient. Writers of books frequently turn into cranky old bears while in pursuit of their publication deadlines, and I was no exception to this authorial custom. But Kate and Beverly graciously have endured my preoccupation with folk art and have done their best to make me lovable again.

Introduction

The passion for American folk art which first seized collectors early in this century was accompanied by a confusing rhetoric. Folk art has proved difficult to define because it has been described in contradictory terms. For example, it was said to be both unsophisticated and skilled. Folk art was frequently claimed to be the equal of modern fine art and yet said to indicate a "regression to childhood." Even its staunchest advocate, Holger Cahill, admitted that it was only a "second-rate" kind of art, while asserting that folk art was "the oldest, most pervasive art expression we know about."[1] Paradoxically, folk art was said to be good because of its flaws. According to Alice Ford the folk artist was judged "not on the basis of the talent he possessed but upon what he accomplished in spite of all he lacked."[2] The public thus was told to accept as virtuosic a level of performance normally considered inept and perhaps artless. It is no wonder, then, that standards for defining and evaluating American folk art have been vague and difficult to determine.

Matters were not made any clearer by the sort of works put forward as trustworthy examples of folk expression. Paintings—mainly portraits—dominated most early collections and exhibitions, as they do now. Given the elite origins of easel painting, these pictures are a strange choice. The oil painting, particularly the framed portrait, was invented in northern Europe during the fifteenth century to serve the interests of the ruling class; only the powerful and wealthy could afford one.[3] Determined by elite tastes and intended to confirm restricted class boundaries, such works of art are the opposite of folk expression. The members of a folk group, defined as a relatively small community of like-minded people bonded by shared concerns for ethnicity, religion, place, or occupation, tend not to need or be impressed by works of art in the studio tradition. In elite society, virtuoso artists challenge accepted conventions with their personal and novel insights.

Creation in folk groups tends to foster connection through the sharing of familiar experiences, but among the elite it tends to establish hierarchy and separation by the promotion of unique experience. Presenting paintings as typical folk expressions, then, completely overturns the meaning of the term *folk*. American folk artists have been viewed not only as inept artists but also as thorough individualists pursuing the ideals of studio-derived art to the best of their limited abilities. While derivative art of this sort is not without interest, it is certainly misleading to describe it, as have so many folk art commentators, in terms of its alleged honesty, vigor, and strength.[4]

The extensive confusion that characterizes folk art commentary arises mainly from collecting the wrong things for the wrong reasons. If one really wants to understand folk art, it makes little sense to study amateur easel paintings because they seem to resemble modernist canvases.[5] Yet this is the dominant rationale employed in the evaluation of American folk art, and it has resulted in raising negative stereotypes to the level of accepted dogma. If American folk art is ever to be judged on its own merits rather than as the crude, country imitation of fine art, its definition must be rethought and scholarly attention must focus on pertinent art forms—on those expressions which actually stem from tradition rooted in folk societies. In this process so-called folk paintings will have to be reexamined, and ultimately much of what is called folk painting must be removed from the current list of certified folk genres.

Fig. 1 Norwegian rosemaling painted on a wooden chest by Thomas Luraas, 1863. Photo courtesy of the Norwegian-American Museum, Decorah, Iowa; Luther College Collection.

In 1942 James Thomas Flexner outlined useful criteria for identifying three classes of painted pictures commonly considered to be works of folk art. Artisan painting, he suggested, consisted of pictures by professionals who had only slight training, while amateur painting was done by nonprofessionals for personal pleasure. Folk painting was a category reserved for artworks like the *frakturs* of the Pennsylvania Germans or the rosemaling by Norwegian immigrants (fig. 1); these expressions were grounded in local custom and passed down generation to generation by shared experience. Artisan and amateur paintings, by contrast, were allied to studio work.[6] Thus only a small portion of the vast body of folk collectibles logically could be defended as folk paintings. Derivative forms of fine art, Flexner cautioned, were not to be mistaken for the product of the folk tradition.

Writing about the problems of folk painting again in 1950, Flexner claimed that folk art enthusiasts were driven by chauvinism. Consequently, they had a deep emotional need to coin their own version of history constituting works of folk art as "unique products of the American soil." Flexner's tripartite

scheme, which recognized the connection of supposed folk painting to studio practice, thus was ignored by folk art collectors. Even museums failed to heed his warning that "Everyday it is becoming more clear that most landscape and genre scenes by amateur and artisan painters are copies, close or free, of conventional originals, often European in origin."[7]

By 1951 even Cahill, chief architect of and prominent spokesperson for collector tastes, sought to define folk painting. Following the lead of art historian Virgil Barker, he separated folk painting into artisan and amateur categories. The artisan group included professionals who worked with some awareness of studio practice for either the style or the content of their canvases. Amateurs were inspired by personal motives and showed only the slightest influence of academic conventions in their work. Significantly, Cahill noted, "not all amateurs are folk artists" because folk art must appeal to a "people's sense of community." Folk art was a "function not so much of the genius or rare individual giving his vision to the community as it was of the community or congregation itself."[8] Consequently he implied that much of what had previously been claimed as folk painting was, in fact, misattributed.

These early calls for the reevaluation of folk art thinking went largely unheeded. Most collectors and some curators of folk art responded by clinging even more tenaciously to an emerging mythology constituting American folk art as the wholesome expression of a national heritage. Such claims only inhibited understanding of folk art history. Given the continued strength of such attitudes today, it is certainly appropriate to return to the calls for rational evaluative criteria that were made by Flexner and Cahill. At bottom, that is the purpose of this volume.

A useful, accurate interpretation of folk art is needed. To achieve that goal requires a new label for so-called folk painting. A number of terms have already been attached to a vast and unmanageable body of work, with the result that no one is ever very clear about what folk painting is and how seriously it should be considered. Each of the most common adjectives—primitive, naive, provincial, amateur, artisan, itinerant, country, anonymous, pioneer, folk—presents problems of tone or has only limited applicability.[9] The terms *primitive* and *naive* have strong pejorative connotations, even if unintended, and cannot be used without risking the suggestion of inferiority. *Amateur* is applicable only to a portion of the accepted body of folk painting and thus cannot serve as a comprehensive label. The same limitation applies to the term *artisan*, since much of what is called folk painting was done

by amateurs or by professionals with art rather than craft training. The terms *provincial* and *country*, in naming the place of origin or the destination of some artworks, are not very useful, since much folk painting was created by city dwellers for other city dwellers, often with an eye to the latest in sophisticated taste. The term *itinerant* does not work for two reasons: first, artists from both the folk and fine art traditions spent time on the road, and second, many so-called folk painters never traveled very far at all. *Anonymous* tells us more about the deficiencies of our knowledge than about any meaningful characteristics of an artwork. *Pioneer*, while it has heroic connotations, focuses too much attention on the past. There was folk art during our pioneer period but there is also folk art in the present.

The very word *folk* requires constant clarification and justification, in large measure because of how the concept of folk groups has been distorted by many folk art historians. For them there can be no folk, just folks—the implication being that folk means everybody, everywhere, at every time, so that folk means nothing. Further, in using a negative definition—folk art is art that is not fine art—folk art historians rarely indicate what intrinsic qualities folk art has. Like *primitive* and *naive*, *folk* has both positive and negative nuances, pointing at once to a wholesome and strong people as well as to an oppressed, downtrodden social class. But the biggest problem with this term is that paintings generally are not expressions of folk culture; the term *folk painting* therefore embodies an internal contradiction, particularly when applied to works on canvas.

The attempts by Flexner, Cahill and others to assign appropriate labels to the appropriate kinds of art sought to separate genuine folk art from spuriously attributed folk painting. This is a useful move but it still leaves unsettled the problem of what should be done with the vast assemblage of portraits, landscapes, still lifes, schoolbook exercises, weekend daubings, and institutional therapies that are called folk painting. Reasonable subgroupings might be developed, but there is good reason for categorizing all of the work that is not really folk as a single phenomenon. All two-dimensional work employs the generic conventions of Western studio practice to some degree. It is then not only useful but necessary to highlight the way a particular painting or drawing derives its form, content, and style. The connection between a certain painting and the fine art tradition might be tortuously complex or stretched quite thin, but the relationship is no less real or significant. Students of folk paintings frequently comment on the difficulty of finding the lines that separate the studio profes-

sional from the minimally trained artisan, the artisan from the self-taught amateur, the amateur from the idiosyncratic naive, the naive from the innocent primitive. The reason for this difficulty is that all of these artists exist along a continuum of expertise and experience with the fine art of painting. The closer one is to the "secrets" of studio technique, the greater one's potential control over the conventions of painting. With less access to this information, for whatever reason, a work will have fewer resemblances to studio-based art. But regardless of the degree of visual similarity, working in the genre of easel painting presumes knowledge of painting, even if only slight. Much of what is usually called folk painting is, in fact, a variety of fine art—a common garden variety to be sure, but fine art nonetheless. Still the question remains: "What should this class of reclaimed fine art be called?" None of the extant terms are suitable, and this work has been estranged from the studio tradition for so long that a conventional high-art label seems inappropriate.

My solution to the problem of terminology is the label *plain painting*.[10] This phrase has several advantages. First, it is a new term and hence does not suffer from the contamination of previous abuse and misrepresentation. Second, it does not carry a pejorative connotation, as do the terms *primitive* or *naive*; rather, it projects a modest but meritorious image that neither demeans this class of painting nor confers on it an undeserved prestige. Third, the term *plain* accords with what most commentators have said about folk painting, namely that it is similar to fine art but at the same time intriguingly different. What they have struggled to describe is this: in the paintings generally labeled as folk the conventions of fine art are present but not fully deployed. The net result is a work like fine art but simpler, less ostentatious; it is a plain version of what potentially could have been quite elaborate or complex under different circumstances. Plain paintings might seem limited and thus lacking in sophistication, but as most connoisseurs have recognized, plainness has a power, too, an appeal of another sort. Finally, the adjective *plain* is a homonym for the word *plane*, meaning surface. Given that folk paintings are most frequently described as pictures that emphasize the two-dimensional surface or plane of the canvas, the phrase *plain painting* fortuitously evokes both style and form.

A dialect of doubletalk has been used to describe and defend folk art for almost sixty years. Objects declared to be crude, primitive, and naive are routinely accepted as charming, witty, and sincere. One finds art praised for its mistakes, artists championed for their incompetence, historical processes

inverted, and critical categories rendered useless. Jane Kallir has noted recently that the very concept of folk art has become "one of negation" and that folk art is seen as "a catchall category for misfits—wallflowers at the dance of Western civilization."[11] Interpreted in this way, folk art serves as a foil for fine art, as fine art's opposite. If fine art is sophisticated, then folk art must be naive; if fine art is elite, folk art must be common, and so forth. It is this inverse pairing which prevents folk art from being properly understood, for if studio-based idioms are judged as good, then folk forms grounded in social custom will be seen as bad. This book thus aims to restore to the painters of plain pictures a basis for evaluating their lives and their works fairly and accurately, in addition to clarifying the limits of American folk art.

Plain Painters

Making Sense of American Folk Art

The Plain Mode and the Evolution of Talent

In order to evaluate correctly a plain painting, or any painting for that matter, it is necessary to understand an artist's technique. Such features as faulty perspective or anatomy, limited palette, lack of contrast, or overall two-dimensionality are generally taken as signs of plain painting.[1] But the most important question regarding these traits of execution is whether the artist produced them deliberately or accidentally. The answer is crucial. If, for example, an artist did not really mean to achieve a two-dimensional likeness, then that trait cannot be listed as a positive feature no matter how appealing it might be to a contemporary viewer. The matter of intention bears directly on the matter of competence: unless the painter intended the canvas to look as it does, then the so-called virtues of plain painting must be registered as errors or evidence of ineptitude.

But how can we learn what plain painters from the past intended? One way to determine that artists meant to paint as they did is to examine a representative body of works for stylistic consistencies.[2] If an artist's canvases repeatedly share the same traits, one can infer that limited palette or stiff gestures were intended and not merely accidental. These features, rather than being interpreted as flaws, can be considered as choices. Caution must be used, however, because a characteristic like faulty perspective might stem from an early misstep in training that was never corrected. In such a case, a reputed feature of plainness is a mistake that has become a habit, not a facet of an alternative way of seeing. Deviations from the standards of the studio tradition can be interpreted positively only when the artist can control the conventions of both plain and studio painting; otherwise we have to conclude that the plain painter either does not know any better or cannot do any better. In neither case would we have good reason to celebrate the work of this artist as a particularly outstanding achievement.

Fundamentally at issue in the evaluation of plain painting is the matter of talent. In addition to stylistic consistency, plain paintings often exhibit careful workmanship that implies skill and therefore a degree of talent. What is problematic is the level of that talent. Holger Cahill decided that, despite their virtues, American primitive painters were still second-rate artists. To draw comparisons with masters like Copley, Stuart, or Homer, he suggested, "would be foolish." Folk painting had "peculiar charm" which arose from "what are technical deficiencies from the academic point of view."[3]

Cahill's judgment, moving simultaneously in two opposite directions, sets a course for further investigation. Folk or plain painting is granted its own standards, but those standards are determined by studio practice. Cahill unconsciously acknowledged that painting from the fourteenth until the early twentieth centuries was concerned to a great extent with the illusion of three-dimensional reality. For many viewers the better the artist created that illusion, the higher the estimation of the artist's ability. As Joshua Taylor notes, painting of that type was "magic."[4] And despite the contemporary celebration of minimalist and abstract design, we still consider the illusion of three-dimensional reality a fascinating trick. To be sure, the painter does more than simply capture a photographic image of a person or place; there is much that the eye sees and a person feels that the camera cannot. But to decide if a painter is truly competent, one usually considers his or her ability to capture three dimensions on a two-dimensional surface, to render forms as they actually appear, and to reproduce colors as they occur in nature. Plain painters, it seems, generally have shortcomings with these tasks. Often when they have command over one requirement they fail to meet others. For example, while a sitter's features may be anatomically correct, the room in which he or she is placed suffers from skewed perspective. This odd combination of skill and error is what struck Cahill and others as "charm." But it would be better to regard such combinations as indications of a painterly process. If we can assume that plain painters, like most bearers of Western culture over the course of almost 500 years, knew that a painting was supposed to resemble what was being depicted, then any particular canvas may be interpreted as an attempt to reach that ideal.

It is not at all easy to make a flat surface appear to contain space—in the case of a portrait, to create essentially a box containing a person. Instruction or examples therefore are prerequisites at the start of any painting career. One's first attempts are destined to fall short of the academic ideal. Creating the illusion of the third dimension requires coordinat-

ing several attributes of the process of vision, and one may learn to manipulate one of these—say, diminishing size in perspective—sooner than the others. Indeed, the process of painting often stimulates a heightened awareness of just how much is involved in seeing the real world. With enough experience, practice, insight, and motivation, the novice eventually may gain command over all the skills required of a studio painter. A marvelous transformation occurs when ability replaces awkwardness, when the flat colors of a portrait become a corporeal, almost breathing, presence. But how does this transformation actually occur? If there are stages, is there a critical point at which a painter becomes a fine artist? At what stage does plainness give way to polish?

EXAMPLES OF ARTISTIC GROWTH: MASTER ARTISTS

The careers of several master artists may yield some insight into the degree of skill it takes to move beyond plain painting. Because they eventually learned the techniques needed to be regarded as competent academic artists, tracing their development as artists should indicate not only what level of competence plain painting entails but also how one moves past that stage into the ranks of professional studio painting.

Benjamin West

Benjamin West (1738–1820), born in rural Pennsylvania, was eventually to become history painter to George III and president of the British Royal Academy of Arts.[5] His tremendous fame and success could hardly have been predicted from his unpretentious Quaker origins in the American backwoods. That he would achieve such acclaim, including a reputation as the "American Raphael," seems even more unlikely after studying his earliest paintings. One of these is a portrait of Robert Morris (fig. 2), done some time between 1747 and 1750. The likeness, while it is quite amateurish with only moderate attempts at shading and accurate rendering, is nevertheless quite good for a boy of only about nine years old. By 1755 West's painting style was somewhat improved as he acquired greater knowledge of the conventions of portraiture. In his portraits of William and Ann Henry he placed his sitters in three-quarter poses and filled in the backgrounds with classical columns, draperies, and a distant view of an imaginary castle. His palette became more subtle, his shading more somber, and he demonstrated a greater sense of anatomical structure, but

3

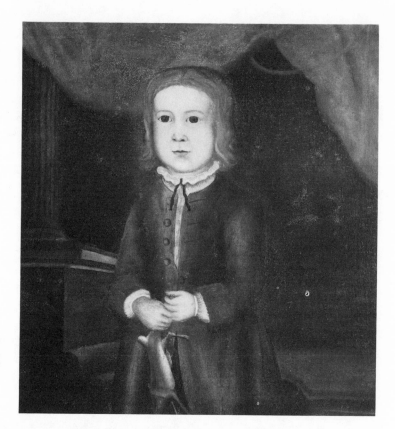

Fig. 2 Benjamin West, *Robert Morris*, ca. 1747, oil on canvas, 18″ × 17½″. Courtesy of the Chester County Historical Society, West Chester, Pennsylvania. Photo: George J. Fistrovich.

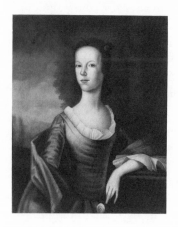

Fig. 3 Benjamin West, *Sarah Ursula Rose*, 1756, oil on canvas, 29″ × 23⅜″. Courtesy of the Metropolitan Museum of Art, New York; Gift of Edgar William and Bernice Chrysler Garbisch, 1964. (64.309.2) All rights reserved. The Metropolitan Museum of Art.

his pictures still seem flat, with formulaic faces and details like hands and fingers left unfinished (fig. 3). After 1756 West moved to Philadelphia and his canvases became more refined. He learned to capture more of his sitter's personality and was more precise in his treatment of details of clothing. But while West was sophisticated about such matters as the sheen of satin, James Thomas Flexner notes, "Piously ignorant of the female figure, he made the torsos of his women look like flaring pipes of cast iron."[6] Nevertheless, his efforts so impressed the gentry of Philadelphia that in 1759 a group led by merchant William Allen put up the money to send him to Italy to study the master works of Europe. Once in Rome, through a series of beneficial alliances and chance encounters West became the darling of the art crowd. For three years he studied classical and Renaissance works under the guidance of Raphael Mengs and Johann Winckelmann. In 1763 he moved to London to enter an art world he was destined to dominate.

The rise of West is certainly amazing, but the cause of his success is no mystery: West's growth as a painter was the result of adequate training. Having captured his parents' attention with some intriguing sketches, West was introduced by his father to William Williams, an English painter then liv-

4

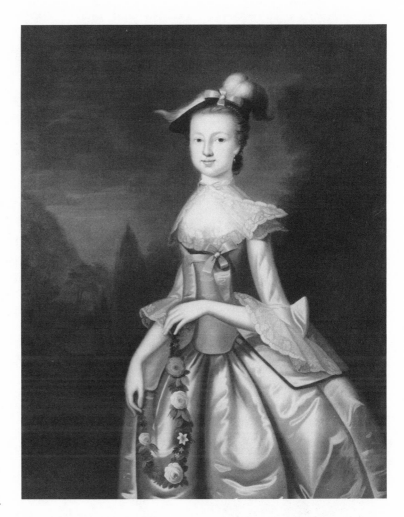

ing in Philadelphia. Williams showed West some basic techniques and loaned him a copy of Jonathan Richardson's *Essays on Painting*. West would later recall that "had not Williams been settled in Philadelphia I should not have embraced painting as a profession."[7] West's oldest surviving work closely copies Williams's technique.

Shortly after meeting Williams, West encountered John Valentine Haidt, a Moravian minister and painter living in Bethlehem, Pennsylvania. Haidt's paintings seem to have served as the model for West's portraits of the Henrys, and elements of Haidt's religious works also turn up in West's *Death of Socrates* (1756). When West later moved to Philadelphia he came under the influence of the English painter John Wollaston, who was known for giving his sitters almond-shaped eyes. These same eyes appear in West's Philadelphia portraits, in addition to a more sophisticated approach to the modeling of the human form and the rendering of fabric, which West also learned from Wollaston's work (fig. 4).

Fig. 5 John Singleton Copley, *The Rev. Mr. William Welsteed*, 1753, mezzotint. Yale University Art Gallery, New Haven, Connecticut; Mabel Brady Garvan Collection.

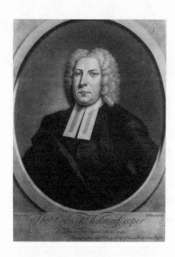

Fig. 6 Peter Pelham, *The Rev. Mr. William Cooper*, 1743, mezzotint of painting by John Smibert. Yale University Art Gallery, New Haven, Connecticut; Mabel Brady Garvan Collection.

When West embarked for Europe he was already extensively trained, certainly the most accomplished artist in the middle colonies. His thirteen-year program of training had become increasingly more sophisticated and persistent; he was ready to have his few rough edges polished. West's ambition to become a painter should not be discounted, but his desires would hardly have been realized without specific training and the influence of professional artists, publications, teachers, and supporters of sophistication.

John Singleton Copley

The career of John Singleton Copley (1738–1815) of Boston parallels West's, except that Copley at first had to be more self-reliant when finding instruction.[8] The son of a widow who sold tobacco to sailors on the Long Wharf, Copley was fortunate that his mother's second husband was Peter Pelham, an engraver and art teacher. Between 1748 and 1751 Pelham introduced his stepson not only to drafting and painterly techniques but also to such publications as *Letters upon Painting* by Count Francesco Algaroti and *An Inquiry into the Beauties of Painting* by Daniel Webb. The clearest influence of Pelham is seen in Copley's 1753 engraving of the Reverend William Wellsteed (fig. 5). Copley seems to have carefully observed Pelham's earlier engraving of John Smibert's painting of Reverend William Cooper (fig. 6) and followed it closely in rendering his new, if homely, image.[9] Copley probably also learned something of the work of Smibert, since Pelham did several engravings of that renowned painter's canvases. But Smibert died in 1751 and Copley had to turn to other Boston artists for inspiration.

While still in his teens Copley attempted portraits that drew directly upon the models of a number of local artists as well as the pictures published in mezzotints. His painting of Joshua Winslow closely follows Robert Feke's portrait of Isaac Winslow (no relation); his likeness of Mrs. Joseph Mann imitates John Greenwood's picture of Mrs. Frances Cabot. When a new English painter, Joseph Blackburn, arrived in Boston in 1755, Copley immediately followed his style and technique, copying even the lettering of Blackburn's signature.

Copley sensed that many of the examples available to him were defective because they stressed a two-dimensional mode of rendering that made the sitters look like paper dolls. In a portrait of Jane Browne (fig. 7) done in 1756, he experimented with sharp light, blacked out the background, and employed heavy shadows. The net effect was a solid delineation of shape and an intense reality that was to become the hallmark of his

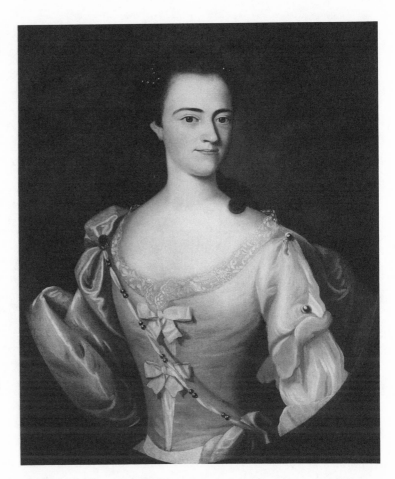

Fig. 7 John Singleton Copley, *Jane Browne*, 1756, oil on canvas, 30⅛" × 25⅛". National Gallery of Art, Washington, D.C.; Andrew W. Mellon Collection.

distinctive and winning style. Realizing that he was fast out-distancing his local contemporaries, Copley corresponded with the Swiss artist Jean-Etienne Liotard, asking him to send a set of pastel crayons. He also suggested that Liotard's drawings would serve as fine "patterns for our imitation."[10] Despite his apparent talent Copley lacked confidence and continued to imitate the works of famous painters; his portrait of Mrs. Jerathmael Bowers is a plagiarism from Sir Joshua Reynolds's *Lady Caroline Russell*. Nevertheless he developed a sure-handed command over a powerfully realistic technique, and colonial sitters were entranced by his work. He was, however, afraid to show his triumphant *Boy with Squirrel* (1765) to the Royal Academy and even hoped that it would be damaged in transit from Boston to London.

Flexner has said of *Boy with Squirrel* that it "resulted less from European models than from the isolated Colonial's lonely struggles. The sitter looks up from play with a naturalism that would have shocked Lely or Kneller."[11] Equally striking is the distance Copley had moved from his engraving of Reverend Wellsteed in 1753 or the stiffly posed group por-

7

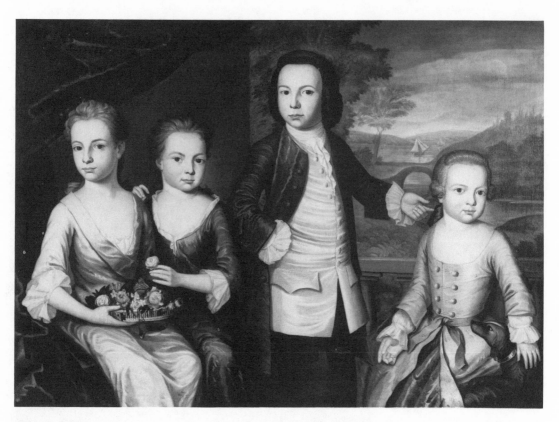

Fig. 8 John Singleton Copley, *The Brothers and Sisters of Christopher Gore*, ca. 1755, oil on canvas, 41″ × 56½″. Courtesy, the Henry Francis du Pont Winterthur Museum, Winterthur, Delaware.

traits, *The Brothers and Sisters of Christopher Gore* (1755, fig. 8). In thirteen years he had progressed from an awkward imitator to a bold new stylist, from a copier of models to a model to be imitated himself. His style, however, was not without flaws. Reynolds criticized his work as having "a little Hardness in the Drawing, Coldness in the Shades, an over minuteness."[12] So concerned was Copley with the correctness of the content of his canvases that he tended to lose sight of the focus of a painting. Faces, clothing, and props were all given the same degree of attention. In his portrait of Mrs. Goldthwait (fig. 9) her likeness competes with the bowl of fruit on the table next to her. Both are finished to a high degree, suggesting that Copley may have confused the concerns of portraiture and still life and thus neglected to subordinate the secondary elements of the picture. West counseled Copley that his pictures were too "liny" and added that "endeavoring at great correctness in one's outline, it is apt to produce a poverty in the look of one's works."[13] Apparently Copley's early training as an engraver had affected his painting more than he realized, such that he emphasized draftsmanship more than color. In fathoming many of the mysteries of painting on his own he developed peculiar quirks that required correction. According to Alfred Frankenstein, Copley had a "curious way of

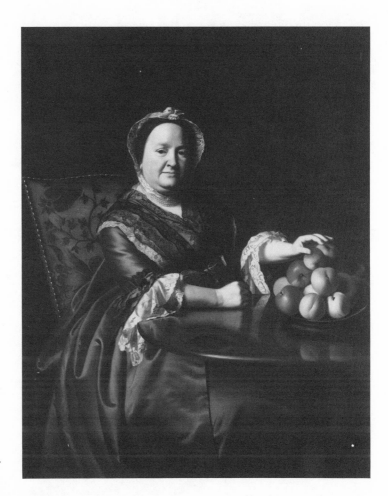

Fig. 9 John Singleton Copley, *Mrs. Ezekiel Goldthwait*, 1770, oil on canvas, 50″ × 40″. Courtesy, Museum of Fine Arts, Boston, Massachusetts; Bequest of John T. Bowen in memory of Eliza M. Bowen.

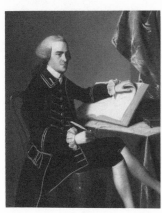

Fig. 10 John Singleton Copley, *John Hancock*, 1765, oil on canvas, 49½″ × 40½″. Courtesy, Museum of Fine Arts, Boston, Massachusetts; deposited by the City of Boston.

showing [his sitters] apparently in the act of kicking themselves out of their own portraits, over and over again a gray-stockinged leg comes down and its foot is awkwardly buried in a corner of the frame" (fig. 10).[14] Yet so impressed were both Reynolds and West with Copley's hard, cold, liney style that they invited him to come to Europe to refine his art by experiencing the great masters.

Copley did leave Boston in 1774, never to return to America. He studied at the Royal Academy and in Rome, and his canvases changed considerably as he attempted to include all the new aspects of content and technique he was discovering. By 1784 he was painting in a new style full of atmosphere, color, and brushwork that downplayed concrete detail. He was also attempting huge canvases of historical narratives, including *The Death of Chatham* (1779), *The Death of Major Pierson* (1784), and *The Repulse of the Floating Batteries at Gibraltar* (1786). These stirring paintings done on yards of canvas earned him much fame and prestige, for they were among the most remarkable paintings of their time.

9

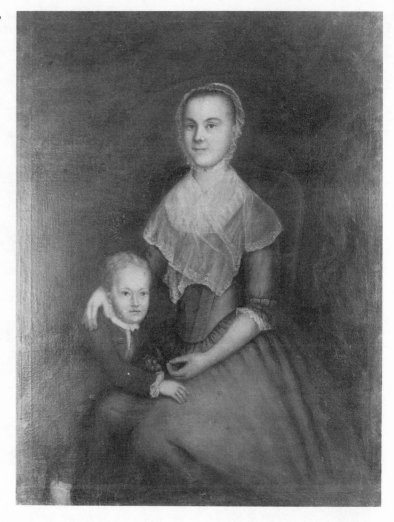

Fig. 11 Charles Willson Peale, *Mrs. James Arbuckle and Son Edward*, 1766, oil on canvas, 48″ × 36¼″. Private collection. Photo: Frick Art Reference Library.

Copley reached this high level of success by hard work and continuous practice and refinement. Largely self-taught, Copley was in no way untrained. He set for himself a program of study that took him from one example to another in his search for perfection. It was his own drive to capture reality on canvas that pushed him onward, but it was also the sequence of progressively more talented models that provided him with the required technique. The line of Pelham, Smibert, Feke, Greenwood, Blackburn, and Reynolds, supplemented with lectures found in books and the silent testimony of numerous prints and engravings, shaped his ability to paint with great naturalism. There was no magical moment of transformation after which he was fully able to capture the objective character of a sitter or a subject. Indeed, his entire career was one of unending experimentation and study.

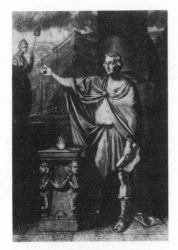

Fig. 12 Charles Willson Peale, *William Pitt*, 1768, mezzotint. Courtesy of the Pennsylvania Academy of the Fine Arts, Philadelphia.

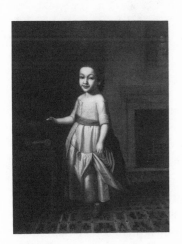

Fig. 13 Charles Willson Peale, *Girl with a Toy Horse*, ca. 1768, oil on canvas, 36″ × 28″. The Museum of Fine Arts, Houston, Texas; the Bayou Bend Collection; Gift of Miss Ima Hogg.

As was true for Copley and West, the success of Maryland's Charles Willson Peale (1741–1827) as a painter was not predictable from his first works.[15] Trained initially as a saddlemaker, he also learned to make and repair clocks and watches, to cast brass, and to do some silversmithing. He was twenty-one when he first tried his hand at painting, resolving to outdo some miniatures by Charles Fraser. Unawed by the requirements of easel work, he studied a painting by Van Dyck to pick up some clues regarding the procedures involved. He also acquired a copy of Robert Dossie's *The Handmaid to the Arts* and visited a professional painter in Philadelphia named Steele. Next he struck a deal with John Hesselius of Annapolis to trade him a saddle in exchange for watching Hesselius paint a portrait. The impact of this bargain can be judged by comparing Peale's crude picture of Mrs. James Arbuckle and son (fig. 11), done in 1766, with Hesselius's painting of Anne Tilghman and son, done four years earlier.

Eager to learn as much as he could about the painter's craft, Peale traveled to Boston and visited Copley's studio. Peale writes, "I found in his room a considerable number of portraits, many of them highly finished. He lent me a head done by and representing candle light, which I copied."[16] About this time he was also copying the works of Reynolds, just as Copley had. Peale's early efforts so pleased the gentry of Maryland that in 1760 a group of men led by the governor of the colony raised sufficient funds to send him to London for further training.

Peale studied in England under West, familiarizing himself with the requirements of fashionable compositions. His major experiment in this regard was an allegory portraying William Pitt as a Roman senator (fig. 12), which Flexner has labeled a "ridiculous combination of the high-flown neo-classical idiom and the crudely direct approach of American craftsmen."[17] Very little of Peale's European education had much impact on him at that time. He did, however, accomplish one of his goals: to "learn how to create a more perfect illusion of reality."[18] In his 1768 picture *Girl with a Toy Horse* (fig. 13) he confidently captured the third dimension. He "defined the background," writes Dorinda Evans, "so that it recedes from the figure, which is now conscientiously shaded so that it occupies the room with a sculptural roundness which his earlier American pictures did not have."[19]

When he first returned from England in 1769 his paintings were very uneven and downright unflattering (fig. 14). "He had," observes Flexner, "great difficulty painting eyes,

11

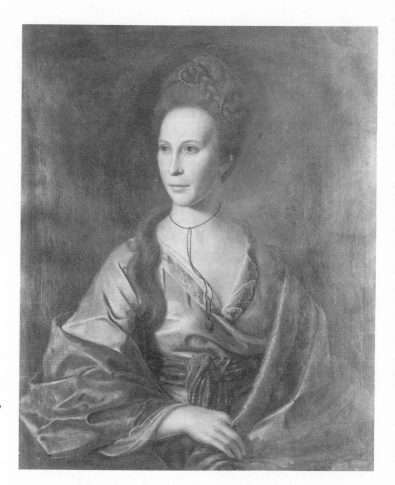

Fig. 14 Charles Willson Peale, *Mrs. Robert Polk*, ca. 1770, oil on canvas. Whereabouts unknown. Photo: Frick Art Reference Library.

which he made too small and often he traced the contours of a nose with a heavy black line that joined with eyebrows to make the round-bottomed longhand V that stands out like a signature on so many of his early full faces."[20] Peale would eventually overcome this defect and paint many noteworthy pictures.

Some of Peale's most outstanding paintings include his portrait of Benjamin Franklin (1785), alleged to be the best likeness of him ever made; a portrait of his brother James; and the *Staircase Group* of his two sons Raphaelle and Titian, both done in 1795. These pictures were painted at the height of Peale's artistic powers, and before he became extensively involved in the study of natural history and the establishment of the first science museum in America. Given the progress that can be recognized in Peale's paintings, the over twenty-five years of practice between 1770 and 1795 may well have contributed more to his refinement than his training at the Royal Academy. After studying with West in London Peale was only slightly better than an amateur, but his connection to the stu-

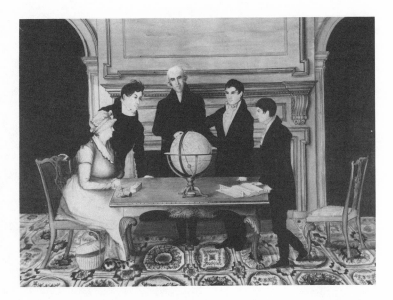

Fig. 15 Samuel F. B. Morse, *The Morse Family Group*, ca. 1809, watercolor on paper, 12″ × 15″. National Museum of American History, Smithsonian Institution, Washington, D.C.

dio tradition is plainly evident; the precepts of English face and history painting set a high mark at which he constantly aimed. Classical antecedents and the painterly theory of composition were, he admitted, "more than I shall ever have time or opportunity to know."[21] Peale absorbed what he could of the high style and learned to work within his limitations.

Samuel F. B. Morse

The final example of artistic growth from the ranks of the master painters is found in the career of Samuel F. B. Morse of Boston (1791–1872).[22] Inventor of the telegraph, first president of the National Academy of Design, and painter of such notable pictures as *The Old House of Representatives* (1821), *Lafayette* (1825), and the *Exhibition Gallery of the Louvre* (1832), Morse began his career by painting in his spare time. He cut paper profiles and attempted mourning pictures following the local vernacular style of rural New England. At age eighteen he painted a watercolor of his family, the *Morse Family Group* (fig. 15), which has been characterized as a "more virile rendering of the art created in ladies' finishing schools."[23] In this picture Morse presents most figures from the profile and is overly concerned with secondary elements like the pattern of the carpet and the details of the woodwork. His amateurish vision allowed him to depict only a rising two-dimensional scene, and though he was aware of the works of Smibert, Feke, and Copley, their techniques were clearly beyond him.

At about the time he painted the *Morse Family Group* Morse came under the tutelage of Washington Allston, who

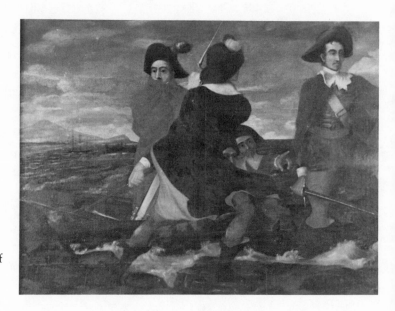

Fig. 16 Samuel F. B. Morse, *The Landing of the Pilgrims at Plymouth*, 1811, oil on panel, 35″ × 45″. Courtesy of the Trustees of the Boston Public Library.

introduced him to the rigors of the academic style. He set Morse on a program of drawing, reading books on art theory, and studying anatomy. Morse may have read Reynolds's *Discourses* and Uvedale Price's *Essays on the Picturesque*, but clearly it was Allston's immediate example that was most significant. In 1811 Morse attempted a complex historical scene, *The Landing of the Pilgrims at Plymouth* (fig. 16). Full of student flaws, it has been critiqued by art historian Paul J. Stati: "The leg of the figure in the far right . . . is painfully amputated at the knee by the picture frame; the boat is not large enough to accommodate five adults; and the two central figures are lost in an awkward heap of legs, oars, arms, ropes, and bayonet."[24] Yet this effort had some redeeming qualities. Oliver Larkin found the hills in the background and the sky well managed, among other successful details.[25] Morse did have some command over the array of skills required to produce an academic painting, but he was not equally competent in all of these aspects. He had made considerable progress, but he was still immature. Allston recommended to Morse, as did Gilbert Stuart, that he go to London for further training.

Set to work at the usual classic exercises at the Royal Academy, Morse produced the heroic *Farnese Hercules* in 1812 (fig. 17), representing a dramatic improvement over the flat, schematic figures of the Pilgrims he had painted just months earlier. There were still traits of the inventorial style used in the *Morse Family Group*—each muscle is depicted as a distinct item of the body, for example—but clearly Morse had made remarkable strides. Yet in this work he remained very much of a copyist, following very closely the work of his men-

tor Allston. This dependence can be seen by comparing Morse's *Hercules* with Allston's *Dead Man Restored to Life by Touching the Bones of the Prophet Elisha* (1811) and Morse's *Self Portrait* (1813) with Allston's portrait of *Francis Dana Channing* (1808).[26] Indeed, Morse never created a style exclusively his own. Throughout his career he appropriated techniques and features from the works of both Stuart and Thomas Sully. This is not to suggest that he was incapable of good work, but rather he pursued an erratic course in search of fame and recognition. Since success did not come as quickly as he had hoped, Morse grasped for any promising alternative whether it was scientific invention, politics, academic theory, or painterly technique. There was about his career a "dizzy aimlessness" and at one point he even wrote "I have no wish to be remembered as a painter, for I was never a painter."[27] This statement must be understood, however, as a rhetorical ploy. Morse was a noted painter but he was also a disgruntled painter, and so he turned away from the skills he had learned in the studio.

What are we to make of these four master artists? Certainly, in each case so-called primitivism was transformed into sophisticated ability. Rough, awkward, naive pictures disappeared with instruction. Often, to be sure, a residue of earlier inexperience lingered as these painters developed their talents. Early pictures by Copley, for example, show his engraver's training as he conceived of his pictures more as outlines rather than in terms of mass. Peale took two decades to fully comprehend the anatomy of the face. When modest, self-trained technique was challenged by academic precepts, the overload of new ideas lead sometimes to a pointless eclecticism. This occurred for a while in the works of both West and Copley. In time, however, they found their own pace within the flow of studio ideals. Morse, by contrast, never took hold of any particular idiom. Talent thus evolves not instantaneously but gradually, not effortlessly but painstakingly—a process that is especially clear with West, when he could paint fabrics but not faces; and with Morse, when he could paint skies but not figures. Slowly all the elements of painting are mastered and never in the same order by different students. No single formula, then, describes the development of painterly skills, even if there are some patent requirements.

The careers of these four artists provide us with some insights regarding the evaluation of plain painting. None of these artists regarded their first efforts—the works that might

Fig. 17 Samuel F. B. Morse, *The Farnese Hercules*, ca. 1812, oil on millboard, 12½" × 5½". Yale University Art Gallery, New Haven, Connecticut; Gift of Miss Helen E. Carpenter of West Woodstock, Connecticut, in 1898.

be consigned to the plain category—as particularly good. They were good enough for their families and peers because they bore the promise of superior work if only more care, more precision, and more accuracy were to be used. It seemed certain, in short, that with suitable training these artists could become much better artists. This is why friends undertook the financial risk to send West and Peale to Europe; this is why other artists argued on behalf of Morse and Copley. The germ of talent, while necessary, is therefore not enough to make a competent painter. Raw skills might satisfy the audience that knows little of illusionistic easel painting, but throughout the eighteenth and nineteenth centuries the American public was coming to know more and more about how a painting should look. They learned to value realism and used resemblance as the main standard of critical judgment. The plain painter was on one side of that judgment, the academic painter on the other. Plain paintings were good amateur works, but the best of them were those that showed the most awareness of professional standards. There was then a line of value to be crossed. The careers of West, Copley, Peale, and Morse suggest that experience, practice, and exposure to academic training are the keys to moving from one side of that line to the other. To improve their basic abilities plain painters have to see the right pictures, read the right books, and study with the right teachers. Beyond this, they must also practice constantly to train their eyes and hands to capture their vision. Only in this way do plain painters become fine painters.

EXAMPLES OF ARTISTIC GROWTH: PLAIN PAINTERS

Erastus Salisbury Field

The question of how the talent of a plain painter evolves can be analyzed effectively by reviewing the career of Erastus Salisbury Field of Leverett, Massachusetts (1805–1900). Lionized as a master folk artist and frequently included in anthologies of "folk" paintings, Field is the subject of an extensive literature detailing a career that spanned nearly seven decades. Almost 400 paintings have been attributed to Field.[28] Given such a long and prolific career, significant changes were bound to occur and register in the body of his surviving paintings. Late in the nineteenth century Field was a very different painter than he had been in the second quarter of that century. That transformation and its cause are instructive regarding the nature of plain painting.

Field's career breaks into two distinctive phases. In the

Fig. 18 Erastus Salisbury Field, *Elizabeth Billings Ashley*, 1825, oil on canvas, 24½″ × 22½″. Museum of Fine Arts, Springfield, Massachusetts; The Morgan Wesson Memorial Collection.

first he painted portraits exclusively; in the second he expanded his repertoire to include pictures of landscapes and historical events. He also continued to paint portraits, but in a different style. The key to these changes is the influence of Samuel F. B. Morse and the New York art scene.

Field studied with Morse in New York in 1824, during the period when Morse was commissioned to paint his full-length portrait of Lafayette. This relationship was both a boon and a problem for Field: he was with Morse at a moment of great enthusiasm and energy, but Morse was often away in Washington preparing the studies he needed to complete the commission. Field was able to spend only three months in New York, and the supervision and training he received probably was minimal. He returned to Massachusetts with only a general sense of his famous teacher's style. Nonetheless, Mary Black has argued that Field left New York with certain academic notions about how a portrait was to be painted. Black attributes to Morse Field's habit of placing a sitter against a cloudy, monochromatic background.[29] The maestro had indeed painted Lafayette backed by a dramatic, cloudy sky streaked with red. While Field occasionally did fill in his backgrounds with furniture, props, and elements of landscape, he most often placed his subjects in a fuzzy gray or brown nimbus (fig.

Fig. 19 Erastus Salisbury Field, *Lauriette Ashley*, 1828, oil on canvas, 70″ × 50½″. The Saint Louis Art Museum, Saint Louis, Missouri; Gift of Mrs. James H. Spencer.

18). While this is the slimmest of linkages, it makes sense that Field would have picked up such a trait from Morse; it is the sort of general feature that a novice would be sure to notice. Further, since Morse could instruct Field only in passing, it is unlikely that Field would have learned the specific fine points of painterly technique.

Field had apparently shown some inclination to paint before seeking training with Morse. No paintings earlier than 1824 survive, but it has been surmised that he was influenced by local itinerants, who produced numerous likenesses of people posed in a stiff, formulaic manner.[30] Once back home he seems to have depended to a great extent on conventions usually found in the works of New England's self-taught professionals. Like these itinerant painters, Field had little sense of anatomy and thus had trouble making hands and bodies look real. Black adds to the list of imperfections for Field's portraits that his "waists are too short, shoulders too

narrow, arms too long."[31] His awkward assemblages of misproportioned body parts can only be regarded as blunders, despite numerous claims of their charm and appeal. Field knew he had a problem with foreshortening and he tried hard to hide it, usually with disastrous results. In his large portrait of Lauriette Ashley (fig. 19), for example, he tucked the arm nearest the viewer behind the sitter, producing a strange posture. Another of his solutions was to place the sitter's body within an outsized costume, so the lack of accurate articulation of arms with shoulders and thighs with hips was of little consequence. In some of his portraits (fig. 20) he positioned his subjects at an angle in a chair so that one arm was shown in profile and the other, which would then project forward and require foreshortening, was hidden behind the chair with only the hand draped vertically over the top of the chair. The dorsal view of the hand was apparently easier to draw than the whole arm. A final solution was simply to paint busts and leave hands out of his pictures entirely. This was perhaps the best solution, since hands were one of Field's most problematic areas. He made fingers that looked like blunt tubes and

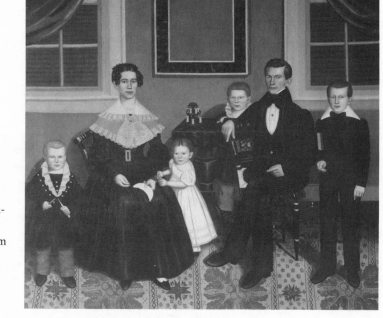

Fig. 21 Erastus Salisbury Field, *Joseph Moore and His Family*, 1839, oil on canvas, 82¾" × 93¼". Courtesy, Museum of Fine Arts, Boston, Massachusetts; Gift of Maxim Karolik for the M. and M. Karolik Collection of American Paintings, 1815–1865, 1958.

knuckles like a series of red welts. Art schools today often offer classes that concentrate just on the rendering of the hands, so it is understandable that Field, with almost no training, encountered problems with this complex feature of human anatomy.

The strength of Field's portraits is mainly his rendering of the details of costume. He was quite competent with lace collars, elaborately patterned ribbons, fancy bonnets, and padded trapunto dresses, as well as with wood graining, stenciled furniture, and carpet designs. In fact, his portraits often look like property inventories in which the people obscure one's view (fig. 21). So focused was Field on the display of personal property that he generally ignored the conventions of perspective and painted his floors in a vertical manner, rather than receding them away from the viewer. Perhaps Field had the same problem conceptualizing perspective as he had with foreshortening. Or maybe he consciously chose to provide a clear view of the carpet pattern, since table tops, chair seats, and window ledges all are depicted in the correct horizontal attitude. This inconsistency may stem from the inventorial style that pleased Field's clients. They were members of an upwardly mobile middle-class who had invested much of their wealth in clothes, books, musical instruments, and household furnishings.[32] They wanted paintings that displayed their wealth as much as themselves. However, even if Field's mixed presentation of perspective satisfied a New England merchant, it bore little connection to what Morse would have taught him.

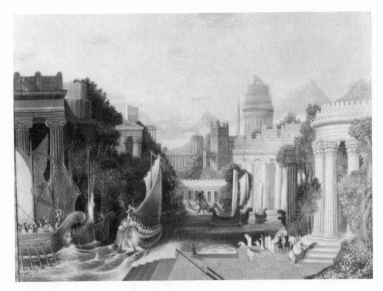

Fig. 22 Erastus Salisbury Field, *The Embarkation of Ulysses*, ca. 1844, oil on canvas, 34¼″ × 45½″. Museum of Fine Arts, Springfield, Massachusetts; The Morgan Wesson Memorial Collection.

After seventeen years of such commissions, and a good deal of financial success—despite several economic depressions—Field had had enough. In 1841 he left New England to return to New York for seven years. This is a period when his work changed dramatically. Field himself changed his title from *portrait painter* to *artist*. Why he gave up his comfortable practice and committed clientele is unclear, but it is not too difficult to imagine that as a painter he was sensitive to the general changes in the role of the arts in American society. By the mid-nineteenth century pictures of the American landscape were becoming more popular. Scenes of everyday life and important historical moments were highly prized. Hundreds of manuals on painting and drawing and collections of views intended to pique the imagination of amateur daubers had been published. The nation was hungry for new inspirational pictures.[33] Field no doubt sensed that if he wanted to get ahead, he would have to get closer to the center of the art movement. In New York Field immediately turned to landscapes based on classical themes. Taking his inspirations from a Homeric poem, he did a painting entitled *The Embarkation of Ulysses* (ca. 1844, fig. 22), which was basically a copy of J. W. Appleton's *A City of Ancient Greece with the Return of Victorious Armament* (1840). Other landscapes and historical scenes adapted from prints soon followed.

More critical to the improvement of Field's painting was an association he developed with Abram Bogardus, a daguerreotypist. The daguerreotype is often credited for the demise of plain painting, but it had a positive impact on Field. Since the daguerreotype was introduced into the United States

Fig. 23 Erastus Salisbury Field, *Henrietta Field*, 1860, oil on canvas, 16″ × 14″. Museum of Fine Arts, Springfield, Massachusetts; The Morgan Wesson Memorial Collection.

by Morse—Field's old teacher—Field probably felt that by learning the new technology of likeness making, he was following a correct and progressive path. When he returned to Massachusetts, he advertised himself as a daguerreotypist. He continued to paint portraits but he used photographs as models instead of people. Sometimes he produced likenesses that were photographs colored in with oils. The images created in this way, of course, were highly realistic, but surprisingly so were his paintings done from photographs (fig. 23). The art of photography evidently trained Field to understand more fully the process of vision. After he learned to look more objectively at his sitters he was able to resolve his problems with proportion, perspective, and anatomical form. While he still continued to render floors as if they were walls, the improvement in his technique can be realized by comparing the portraits of his brother Stillman done in 1836 and 1865.[34]

The bulk of Field's paintings after his return to Massachusetts consisted of pictures copied or adapted from books and engravings. He did, for example, a scene of the Garden of Eden which was inspired by a print entitled *The Temptation* by the British artist John Martin. A series of paintings about

22

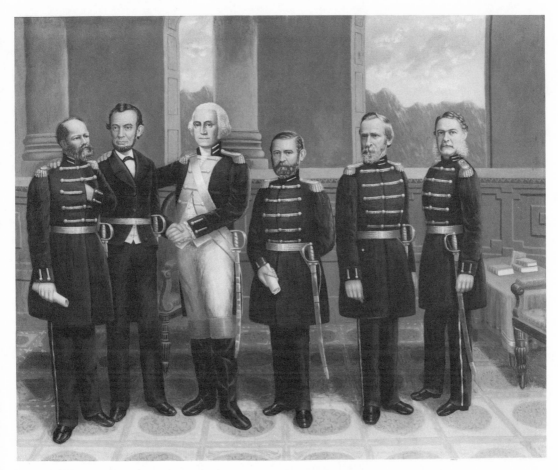

Fig. 24 Erastus Salisbury Field, *Lincoln with Washington and His Generals*, 1881, oil on canvas, 32″ × 39½″. Museum of Fine Arts, Springfield, Massachusetts; The Morgan Wesson Memorial Collection.

India was apparently taken from the illustrations in a book by James R. Young entitled *Around the World with General Grant* (1879). His *Ark of the Covenant* (ca. 1870) was copied from John Neagle's print based on M. Craig's *Philistines Send Back the Ark* (1820). The draftsmanship of this body of work is very inconsistent; the rendering of figures is often naive, but one can see a good deal of refinement in those paintings done after 1880. The perspective in his *Palace Façade with Landscape, India* (ca. 1880) is especially well resolved when compared to the tilt of his *Egyptian Scene* (ca. 1870). Nevertheless, practice in isolation is not a perfect teacher. In his allegory *Lincoln with Washington and His Generals* (1881, fig. 24), the heads are out of proportion to the bodies, even though the details of the uniforms, the perspective, and background are quite competent.

Field's greatest painting was also his largest: approximately nine by thirteen feet, his *Historical Monument of the American Republic* (fig. 25) was painted between 1865 and 1888. Done in response to the Civil War, it was initially intended to remind all Americans of their common historical

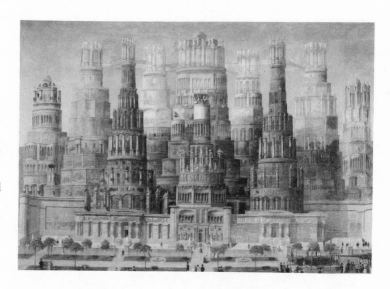

Fig. 25 Erastus Salisbury Field, *The Historical Monument of the American Republic*, 1867, ca. 1876, and 1888, oil on canvas, 9′3″ × 13′1″. Museum of Fine Arts, Springfield, Massachusetts; The Morgan Wesson Memorial Collection.

background and hence their basis for a healing unity. By 1876 Field thought that his hypothetical monument could actually be built at the Centennial Exhibition in Philadelphia, and so he painted in an exhibition hall atop the central towers. In 1888 he added more towers upon which he depicted more recent events in the history of the United States. Abraham A. Davidson refers to the images in this painting as "phantasmagorical buildings" that are "obviously bizarre." He notes that the world depicted by Field is unfamiliar, "a world of dreams, one divorced from wake-a-day reality."[35] Thus his vision is obscure, remote, and mysterious. However, specific elements in this painting tie this picture, despite all of its idiosyncrasies, back to the tradition of the academy. On some of Field's fantasy towers he presents bas-relief scenes taken directly from the works of notable American artists, including *The Battle of Bunker's Hill* by John Trumbull, *The Landing of Columbus* by John Vanderlyn, *Penn's Treaty with the Indians* by Benjamin West, and several others. The towers themselves, ethereal ziggurats of the imagination, seem to derive from the same view of ancient Greece Field used as the source of his *Embarkation of Ulysses* (fig. 22). Perhaps even more important is the source for a painting of this scale. Field planned to circulate his painting on a tour just as Morse had done with his *Old House of Representatives* and *Gallery of the Louvre*. During the 1840s, when Field was in New York, Morse was contemplating a large historical painting entitled "The Germ of the Republic." Subscriptions were solicited but no painting was ever done. However, the idea of that painting did materialize in part as Field's *Historical Monument*. Ironically, when Field was most on his own he came even closer to

24

studio ideals and to the training he had missed as a young man.

With the example of Field we see that the training needed to become an academic painter does not necessarily fully transform an artist. Exposure to the disciplines of fine art must be followed with acceptance. Its precepts must be internalized, and the degree to which that happens varies with the intensity of one's education and one's commitment to improvement. Critically important, of course, is the level of talent one possesses. Field remained a plain painter despite his extensive exposure to the fine arts. West, Copley, and Peale began at the same level as Field and within a few years became quite competent painters. They still had flaws or awkwardness in their works for a time, but with practice their mistakes of procedure or conceptualization were eliminated. In Field's case thirty years were required before he could render accurately, and even then he was not always faithful to reality in his drawing. If we can locate the line between plain and academic painters, we must say that Field moved back and forth across it throughout his career. He leaned to the plain side in his early portraits and to the academic side when he produced landscapes and biblical scenes by copying prints. His vision of the American Republic is definitely to be grouped with works of fine art, given all the aspects of concept and content that derive from the studio tradition. Yet it is so unique a work, without exact precedents, that one hesitates to claim it as fine art. It seems closer to the commercial theatrical tradition than to the academy—more like an eighty-foot-long moving panorama depicting a trip around the world.

Field never became a fine artist largely because he lacked the skill required. When he first sought to improve himself he was deprived of a complete course of instruction. Later he was sidetracked by the influences of photography and commercial prints. He was so overwhelmed by the ideas that circulated through New York's studios, salons, galleries, exhibitions, and bookstores that it was almost twenty years before his own style would reemerge. Finally, his New England clientele generally accepted his work regardless of obvious flaws, enabling him to remain content with a stunted level of development. Without constructive criticism Field continued to paint figures whose heads looked as if they had been joined to the wrong bodies. He learned too late the basic lessons that other student painters learned early on and so remained amateurish in his technique. Yet he was still able to bring admirable passion to his canvases. Field had what Robert Louis Stevenson called "the manly perseverance of the artist who does not know that he is conquered."[36] His achievement, then, is one of persistence

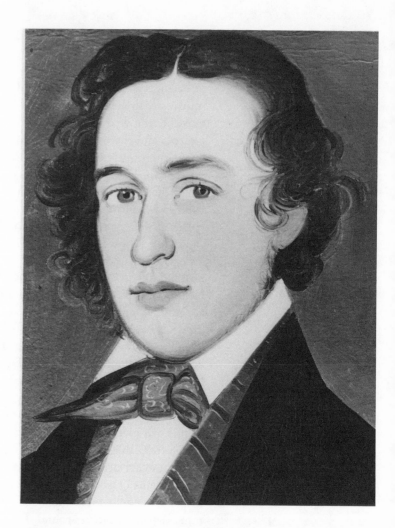

Fig. 26 William Matthew Prior, *Man of New Bedford*, ca. 1844, oil on artist board, 13½″ × 19″. Courtesy of the Fruitlands Museums, Harvard, Massachusetts.

and patience rather than outstanding talent. Field's works indicate that the virtues of plain painting are more likely to be discovered in the character of the painters rather than in their pictures.

William Matthew Prior

William Matthew Prior (1806–1873), born in Bath, Maine, is often cited as a true plain painter because he intentionally painted in a plain style.[37] His most ardently collected works are his "flat pictures" (fig. 26), two-dimensional portrait likenesses done deliberately in this manner. An advertisement of 1831 in the *Maine Inquirer* states Prior's intent: "Persons wishing for a flat picture can have a likeness without shade or shadow at one quarter price." The cost, including frame and glass, could total as little as $2.92; the lure of such works was clearly their affordability. Interest in these flat works has deflected attention away from Prior's competence at a higher

Fig. 27 William Matthew Prior, *Mr. Winslow Purinton*, 1835, oil on canvas, 31½″ × 27½″. Courtesy of the Fruitlands Museums, Harvard, Massachusetts.

level. At age eighteen he was already a capable face painter and he took to the road in search of clients. His portrait of Winslow Purinton (fig. 27), done in 1835, amply demonstrates his inclination and ability to follow the academic style. To develop and improve his technique Prior sought inspiration from the finest example he could imagine. Realizing that there was much to learn, he looked for an established authority to imitate—an obvious parallel with the career of Peale. There is no record of his training, but he seems to have been very much aware of the work of Gilbert Stuart, then the most prominent painter in America. Prior's portrait of a young man done in 1829 resembles Stuart's well-known impressionistic style of rendering faces against plain backgrounds. Prior's respect for this venerable master was confirmed in 1831 when he named his son Gilbert Stuart Prior and again in 1850 when he did copies on glass of Stuart's portrait of George Washington, which then was hanging in the Boston Athenaeum.

To procure work Prior advertised his abilities in many branches of painting. In 1827 he listed "ornamental painting; old trays, waiters rejapanned and ornamented in a very tasty style. Bronzing; oil guilding and varnishing." Later he added sign painting, machine drawings, and military and standard painting. Yet it is clear that he wanted most to be an artist, a painter of portraits and, later, of landscapes. For the last twenty-seven years of his career he lived in a house in Boston that he named "The Painting Garret." He turned out numerous likenesses including images of such famous people as Daniel Webster, Lincoln, and Napoleon, in addition to copying widely published prints. Nina Fletcher Little has said of these paintings, particularly of his *Mount Vernon and Washington's Tomb* (ca. 1855), that they are "not in any way distinguished" from many others of the period. Moreover, she concludes, "it may be fairly said that he [Prior] neither exhibited great artistic talent, nor excelled in imaginative composition."[38] But to say that he lacked exemplary talent is not to say that he was untalented. He doubtless learned much by his imitation of master works and gained some refinement of technique by completing hundreds of pragmatic commissions. Prior was hindered in his attempts to achieve greatness by catering to a clientele that spanned a wide economical gamut. He did cheap pictures for some customers and more costly canvases for others. The former, done quickly (often in less than an hour), lacked detail; the latter were more expertly modeled. One wonders what Prior might have become if he had concentrated on commissions that challenged his competence, if he had painted more pictures that utilized his full range of talents. Ironically, he is remembered mostly for paint-

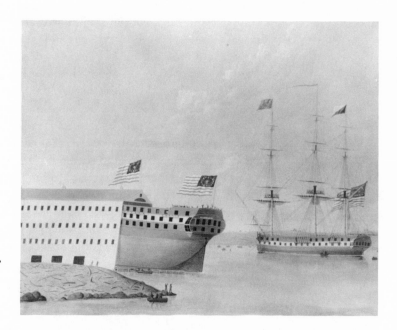

Fig. 28 John S. Blunt, *Launching of the U.S. Ship "Washington" at Portsmouth, October 1, 1814*, ca. 1815, oil on canvas, 47¾" × 57". Private collection.

ing less well than he might have. His flat pictures, while an interesting phenomenon, have little to intrigue what Virgil Barker has called the "twice-seeing eye."[39]

Prior's career illustrates how crucial the standards of fine art are to the evaluation of plain painting. The more command an artist has over certain techniques such as shading or foreshortening, the more likely he or she is to be identified as a studio artist. But what are we to make of a painter who willfully shuns the use of a complex technique? Prior's flat work appears naive, yet clearly he could do better; therefore, Prior should not be categorized solely on the basis of his flat paintings. These cheap pictures largely reflect the lengths to which he would go in order to procure work. Prior should be seen instead as a fine artist who, by deliberately slighting his abilities, was able to fill a perceived need for affordable portraits. Just as Field meandered back and forth over the line separating plain and polished painting, so too did Prior. In Field's case those moves were the result of his insufficient grasp of studio procedure and precedent. In Prior's career the boundary between plain painting and fine art was intentionally crossed to make a dollar.

John S. Blunt

Another angle of view on the question of skill in connection to plain paintings is provided in the example of John S. Blunt (1798–1835) of Portsmouth, New Hampshire.[40] As for Prior, little is known of the way in which he learned to paint. Yet we

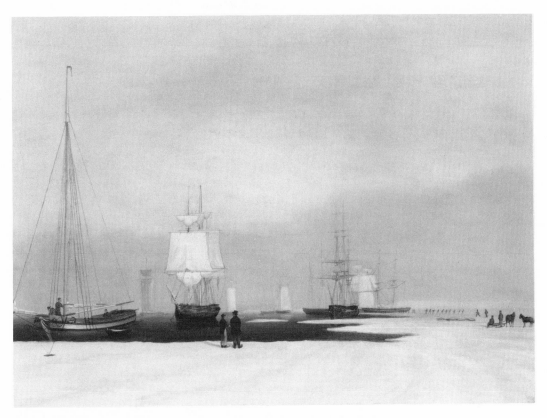

Fig. 29 John S. Blunt, *Boston Harbor*, 1835, oil on panel, 20½″ × 28″. Courtesy, Museum of Fine Arts, Boston, Massachusetts; Gift of Mrs. Maxim Karolik for the M. and M. Karolik Collection of American Paintings, 1815–1865.

can surmise that he was very much aware of the masters of fine art for he named his daughter after the noted Swiss neoclassical painter Angelica Kaufman and his son Michael Angelo after the famous Italian sculptor and painter. Growing up in a seaport as the son of a ship's captain, Blunt turned his attentions quite understandably to maritime scenery, and by the age of seventeen he was painting pictures of ships.[41] His *Launching of the U.S. Ship Washington at Portsmouth* (1815, fig. 28) is an interesting if amateurish effort that reveals his eye for detail and awareness of atmosphere. He correctly observed that all flags should fly in the same direction in a prevailing wind but lost his sense of scale and failed to shade the vessel's hull, making it look more like a paper cutout than a capital ship. His view of Boston Harbor (fig. 29), done twenty years later, reveals how much he had matured. His handling of ice, sky, and vessels is very competent, evoking well a moment's repose during the chill of winter, and compares favorably with the works of Fitz Hugh Lane, who three decades later would garner much fame for similar scenes of the same harbor.[42]

How Blunt made up the distance from awkward amateur to competent seascapist can be inferred from his career as a jack-of-all-trades painter. A series of newspaper advertisements

from Portsmouth in the 1820s shows that he continually expanded the range of commissions he undertook. He began in 1822 with pictures of various kinds: profiles, profile miniatures, and landscapes. A few years later he added oil painting on canvas and glass, watercolors, and pictures done in crayon. In 1827 he proclaimed his willingness to provide works in "THE FOLLOWING BRANCHES, VIZ Portrait and Miniature painting, Military Standard do., [ditto] Sign Painting, Plain and Ornamented, Landscape and Marine Painting, Masonic and Fancy do. Ships Ornaments Gilded and painted, Oil and Burnish Gilding, Bronzing, & c, & c."[43] This diverse background provided ample opportunity to refine his abilities in the areas of design, composition, color, brushwork, and other aspects of the painter's craft. His "schooling," then, consisted largely of the lessons of experience. But we may also assume that Blunt knew something of books and manuals if he knew and respected European masters well enough to name his children after them. In 1825 he offered to teach art classes, and the following year he staged an exhibition of his paintings which included six views of Niagara Falls as well as other pictures, probably landscapes of the sort commonly circulated via prints and engravings. One sign of Blunt's growing professionalism is that he charged admission to his exhibition: twelve and one-half cents per adult, twenty-five cents for a season ticket. In less than a decade he had progressed from small mementos to paintings that might be contemplated in a gallery. In 1828 he attempted to impress a more worldly urban audience by exhibiting a landscape entitled *View of Winnipiseoqee Lake* at the Boston Athenaeum. Certainly by this stage of his career he could no longer be called a plain painter.

Blunt nevertheless has come to be regarded as a folk artist. Robert C. Bishop has written of Blunt that "in nearly every portrait he comes close to creating a masterpiece of folk art." This claim is based on Blunt's apparent inability to render human anatomy. Bishop observes in Blunt's work "faces that are islands of realism" combined with "the willful disregard of perspective."[44] This situation is at first puzzling, since at the time of these portrait commissions Blunt was a competent painter of landscapes and seascapes. But these are different genres with different requirements, and a competent painter of scenery might well be an inept painter of portraits. Blunt simply mastered one genre more quickly than the other. He was more expert with views of the water than with closeup pictures of people, much as Morse was in his picture *The Landing of the Pilgrims* (fig. 16). While some artists perform commendably in several genres, by no means must painters have multiple talents before they can be considered as

Left: **Fig. 30** John S. Blunt, *Profile Portrait of a Lady*, ca. 1831, oil on bed ticking, 34¾″ × 29⅛″. The Museum of American Folk Art, New York; Permanent Collection; Gift of Mr. and Mrs. W. Wiltshire III. *Right:* **Fig. 31** John S. Blunt, *Mary Jenney Borden*, ca. 1835, oil on canvas, 33″ × 27½″. The Whaling Museum, New Bedford, Massachusetts.

participants in the academic tradition. Portrait painting requires a precise control of anatomy, a special ability that need not play a major role in landscape, in which attention to perspective, light, and atmosphere may yield a reasonable picture. In Blunt's portraits he was very good at rendering costumes and various props. His main problem was finding a way to blend reasonable semblances of faces, clothing, and backgrounds into convincing likenesses. Comparison of portraits done in 1830 (fig. 30) with some painted in 1835 (fig. 31) suggests that Blunt was working through his difficulty with the genre and gradually solving some of his problems. His death at sea in 1835 ended a career that was on the threshold of advancement.

The two styles one finds in Blunt's work—academicism in his land and seascapes and a plain style in most of his portraits—result from different levels of performance in the same studio tradition. He evidently acquired an early confidence for pictures of scenery and thus became more advanced in them, saving the portrait for a later phase of his career. If Blunt is to be considered a plain painter it can be only for his portraits, and one might guess that with more time he, like many well-known artists, would have outgrown his bad habits. The line between plain and fine painting in Blunt's case is also a line between genres, suggesting that plain qualities are mutable features of performance rather than fixed or inherited estates of mind. Plain painters are best understood as novices experimenting with a complex apparatus. Before they can learn to

manipulate properly all the knobs and switches of that apparatus, their work will appear plain. Learning in a catch-as-catch-can manner, Blunt did not immediately realize that different kinds of painting placed different demands on his ability. While he gained sophistication in one category, his skills in another languished.

CONCLUDING REMARKS

Plainness in easel painting results from a low level of expertise in handling the requirements of the studio tradition. It is a trait manifested in the careers of all painters, whether they are acknowledged masters or modest dabblers. Plainness generally stems from immaturity and represents the formative period in the development of talent. For West and Copley this period happened to coincide with their childhood years, and hence in their cases it is correct to refer to their plain paintings as childlike. But for Morse it was during his late teen years that he painted in a plain style, and Peale was still a plain painter at age twenty-five. All of these artists matured far beyond their initial levels of performance—some sooner and more confidently than the others, depending on their different experiences, opportunities, and abilities. Field's early works are no worse than those produced by Peale or Morse during what might be termed their apprentice phase. However, Field seems to have floundered for years trying to learn what the reputed fine artist learns relatively quickly. This difference owes more to differences in talent, artistic experiences, and social contexts than to intention. All the painters discussed here, fine or plain, followed the same trajectory of development using the same means to reach the same goal. Some moved toward that goal quickly, others more hesitantly, but their common desire was to capture convincingly the illusion of three-dimensional reality. The failed attempt often found in plain paintings does not imply a different objective. While some consider plainness as ineptness, it is more productive (if not more generous) to regard this trait as an indication that the primary rules of painting have been grasped and that further refinement will probably follow, as biographical study suggests. It is, then, not the nature of their works that sets plain painters apart from fine artists; it is a difference in the level of mastery over the conventions of technique.

Plainness in painting finally may relate most to an artist's pace in learning. Artists like West and Copley, who quickly acquired their painterly technique, easily progressed past the "primitive" stage and rarely have been viewed as anything

other than fine artists. A painter like Field, however, who was very slow to master the requisite skills, for decades produced paintings that conform to the current stereotype of "folk" performance. The same could be said of Blunt, whose portraits suggest a limited ability to capture a convincing likeness. Slow learners seem committed to qualities of plainness and therefore are often identified as plain painters. Their paintings have been understood as intentionally naive, but to come to such a conclusion one must ignore the full careers of these artists. Through books, popular prints, exhibitions, public demand, or training, plain painters learned of the studio tradition. Narratives of their artistic lives reveal the earnest desire to perfect their pictures after the example of established masters. However, for a variety of reasons they were usually hindered from improving quickly, and so became competent later rather than sooner. Those who designate these painters as a distinct class of folk artist usually consider only the paintings done early in their careers and overlook evidence of subsequent improvement. Their evaluations, then, utilize only that portion of the evidence that confirms their preconceptions.

There is no way to account for the existence of any easel painting without acknowledging the influence, however slight, of the academic tradition. Flexner implies as much when he writes, "Artists everywhere, even when they are in revolt, are connected with aesthetic forebears in a continuous chain of influence that goes back to the beginning of time."[45] The so-called folk tradition for painting is, in fact, a plain version of high-style practice, the best approximation of the studio tradition that a novice painter can produce. However, it is not as important to note how artists paint as it is to discern when in their careers they paint in a plain style. Once the chronology of their work is established, it can then be determined if their plain paintings represent a phase of growth or a symptom of stagnation, distraction, or confusion. The key to an accurate interpretation of plain painting resides in understanding the evolution of an artist's talents.

Art by the Book

America's first master artists availed themselves of the guidance found on the printed page as they began their training. It is hard to know how far an artist like Peale, for example, might have gotten without the advice he read in the pages of Robert Dossie's *The Handmaid to the Arts*, or what Morse would have done without the counsel of Reynolds's *Discourses*. We should not surmise, however, that only a few instructional guides were obtainable. As many as seven art manuals may have been available to the Puritan limners of New England.[1] Some thirty-two works on drawing and painting published during the eighteenth century were available in American libraries and bookstores; several of these titles were so popular that they went into multiple editions. *The Handmaid to the Arts*, the book that opened Peale's eyes to art, was published first in London in 1758, but it also appeared in twenty-nine American editions.[2] The intense desire for instruction in painting and drawing showed no signs of decline as the eighteenth century drew to an end. The popularity of books like *The Handmaid to the Arts* foreshadowed a national campaign for art education, a reform movement in which instructional manuals would play an important role in the development of many plain painters.

Eighteenth-century America is generally thought of as given more to pragmatics than aesthetics (a social equation still espoused today), yet a new attitude was forming. In 1780 John Adams wrote to his wife after he had visited the palaces and galleries of France, "I must study Politics and War that my sons may have liberty to study Mathematicks and Philosophy, Geography, natural History, Naval Architecture, navigation, Commerce and Agriculture, in order to give their children a right to study Painting, Poetry, Music, Architecture, Staining, Tapestry, and Porcelaine."[3] The shift posed by Adams from a concern for basic necessities to a decided enjoyment of

luxuries was one that many Americans were ready to enact. Previously there had been concern that art, because of its aristocratic associations, promoted corruption. If the despicable regimes of Europe used artworks to support their policies, then the United States would be better off, it was alleged, without paintings and sculpture. Adams himself had once preached that the fine arts could never promote civic virtue, since "from the dawn of history they have been prostituted to the service of superstition and despotism."[4] Benjamin Franklin refuted this line of argument by noting that if luxury was a sign of decay, then America would have collapsed long ago given all the great houses to be found in Boston, New York, Philadelphia, and along the banks of the James River. Artist William Dunlap was eventually to rally many to the cause of the fine arts by warning that where the arts languish, "tyranny and slavery exist."[5] A profound ideological clash thus underpinned the surge of artistic interest signaled by the publishing of numerous instructional manuals during the eighteenth century. Their very number was a tactical move by the art supporters; the simple availability of information on the techniques for drawing and painting would indicate to the populace that art was no threat to their well-being. Eventually the opponents of art converted to the belief that art was, in fact, a sign of political health—so long as art was presented as useful rather than only beautiful.

As early as 1749 Franklin wrote, in his *Proposal Relating to the Education of Youth in Pennsylvania*, "All should be taught to write in a fair Hand, and swift, as that is useful to All. And with it may be learnt some thing of Drawing, by imitation of Prints, and some of the first Principles of Perspective." Having allied drawing with writing, Franklin demonstrated clearly the practical utility of art. But this ploy exacted a toll: art was to be taught in a way that linked its application directly to various trades and professions. Commenting about drawing, Franklin observed, "All Boys have an early Inclination to this improvement, and begin to make Figures of Animals, Ships, Machines, & c. as soon as they can uses a Pen; But for want of a little Instruction at that time, generally are discouraged, and quit the Pursuit." Should this instinct be encouraged, said Franklin, America would produce a generation emboldened with "mechanical genius."[6] Franklin's concerns were precisely those voiced by Adams: he worried that the country, too advanced in its demand for luxury, was not well prepared in the "mechanic Arts." The need to justify art in terms of practical skills affected American art education well into the nineteenth century. In 1855 Rembrandt Peale, author of a very popular drawing manual (and

son of Charles Willson Peale), still felt it best to defend art with examples of artist-inventors:

It was a portrait painter, Robert Fulton, that gave us the power of steam navigation. It was a portrait painter, S.F.B. Morse, that devised the magic electric telegraph. It was a portrait painter, C.W. Peale, that first made porcelain teeth for himself and a few friends. And I, though a portrait painter, lighted the first city with gas. This is not boast, but may be accepted as an atonement for the practice of a luxurious art, which is now beginning to be appreciated.[7]

At the outset of the nineteenth century two important schools of professional art instruction were established: the New York Academy of the Fine Arts in 1801 by Robert R. Livingston and the Pennsylvania Academy of the Fine Arts in 1805 by Charles Willson Peale.[8] Other professional organizations, galleries, and museums were founded in rapid succession as city after city competed for the honor of being the "Athens of America."[9] The most far-reaching signal that the nation no longer feared or was suspicious of art was the activity of the publishers and booksellers. Peter Marzio estimates that between 1820 and 1860 more than 145 drawing manuals were published. Many of them went through several editions—Rembrandt Peale's *Graphics* (1834) enjoyed nineteen printings—and therefore as many as 145,000 copies of manuals were in circulation in the first half of the nineteenth century.[10]

Carl Drepperd, noted scholar of art books, has divided the various kinds of guides into three categories.[11] His first group consists of *instructors*, books that give technical information in a sequence of lessons. Representative titles of such works include: *Art of Colouring and Painting Landscapes in Water Colors* (1815), *Early Lessons in Perspective Including Instructions for Sketching from Nature* (1830), and the *Handbook of Young Artists and Amateurs in Oil Painting* (1845). A second category, *borderline instructors*, includes works on arts other than painting and magazines with sections on the arts. In this category are such works as *Dean's Universal Penman or Complete System for Writing with Accuracy* (1808), *Godey's Lady's Book* (1830–98), and *The Painter, Gilder, and Varnisher's Companion* (1851). A third class of works provides models to copy, sets of views to inspire the imagination; in today's parlance such books are called *swipe files*. Sample collections include *American Rural Sports* (1832), *Ladies' Book of Flowers* (1843), and *Quadrupeds of North America* (1845). In addition to book-format materials there also were

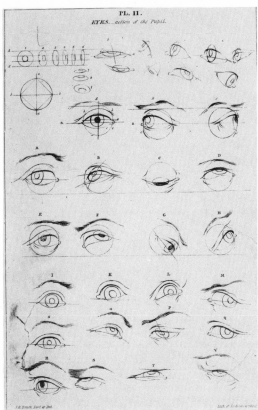

Fig. 32 Plates from John Rubens Smith, *A Key to the Art of Drawing the Human Figure*, 1831. Art and Architecture Collection, Miriam and Ira D. Wallach Division of Art, Prints and Photographs, the New York Public Library Astor, Lenox and Tilden Foundations.

sets of *drawing cards*—playing-card-sized images packaged in sets of up to twenty-four pictures. One set, *Abbott's Drawing Cards* (1845), contained two series entitled "Heads" and "Scenes."[12] These cards served the same function as the large steelplate engravings printed in magazines: they provided ideal images to copy. In addition to all of these materials, nineteenth-century newspapers, almanacs, and scientific journals frequently carried stories or ran columns devoted to painting, drawing, and the decorative arts. It was, then, difficult not to know that there was widespread excitement about art, particularly about pictures. The printing press had become a true handmaid to the arts, putting copious amounts of technical information as well as artistic inspiration within easy reach of anyone who desired them (fig. 32).

According to Marzio three men constituted the core of the movement to make the United States a nation of artists or at least of art appreciators: John Rubens Smith, Rembrandt Peale, and John Gadsby Chapman. All three produced art manuals that were complete courses of instruction; all agreed extensively on the meaning of art and the methods for creating it; and their works were received positively by other professional artists, teachers, and nonprofessionals. These three

author-artists actively took up the defense of art, denying the common charges of immorality and frivolity. Smith, for example, published nude models in his book, challenging the public fear of undraped form. He warned that the perception of evil was in the mind of the observer and that "it was impossible to draw a figure anyways clothed without understanding its construction, and equally impossible to draw . . . without a knowledge of the skeleton, both in its proportions and shape and articulation of the joints."[13] Strong arguments were needed to counter the charge of frivolity, a critique deeply embedded in eighteenth-century fears regarding the arts. Chapman wrote that drawing "gives strength to the arm of the mechanic, and taste and skill to the producer, not only of the embellishments, but actual necessities of life." He argued further that art was such an aid to invention that, with adequate artistic training, the nation could hope to "produce whatever the wants or tastes of society may require."[14] Smith concurred: "The various branches of our art constitute the universal language to the mechanic, the engineer's handmaid, the bosom friend of the naturalist, the architect's right hand, and the imperishable record of a nation's fame, in pictures and monuments of her deserving sons, as heroes, statesmen, & c."[15]

The tone of patriotism pervaded these manuals. Drawing and painting were promoted almost as if they were inalienable rights. The writers of art manuals envisioned a republic filled with competent sketchers of landscapes, designers of buildings, and decorators of household objects. Chapman saw "a vast and independent and intelligent people to appeal to: who need only to be shown the truth, to know and maintain it."[16] The truth for Chapman, of course, was the intrinsic value of art.

To convince their readers that artistic skills could be obtained easily, drawing was linked to literacy following the strategy used by Franklin a century earlier. Chapman placed on the cover of his book the motto: "Anyone who can learn to write, can learn to draw." Art was promoted as a basic, indispensable skill, an essential mode of communication no less important than reading and writing. This point of view emerges clearly in the sequence of subtitles to Peale's *Graphics*. In 1835 the work declared itself *A Manual of Drawing and Writing*; by 1850 the book's practical and pedagogical purposes were more extensively extolled in the subtitle, *The art of accurate delineation; a system of school exercise for the education of the eye and the training of the hand as auxiliary to writing, geography, and drawing*. As proof of his book's utility Peale offered the example of a student who, after following its instructions, "in fifteen minutes, drew from memory a large map of Europe correctly. . . . Another drew one of

Fig. 33 Illustrations from John Gadsby Chapman, *The American Drawing Book*, 1848.

South America in 8 minutes."[17] The twin virtues of utility and efficiency had obvious appeal to the American public.

The sequence of lessons in the books by Smith, Peale, and Chapman was essentially the same. Students began their program of training with exercises intended to develop control of lines, for lines were thought essential for recording form. Straight lines of various lengths, directions, and spacings were to be mastered first. Next, these lines were combined to produce angles and then geometrical forms and figures. These exercises were to be done without the aid of rulers, compasses, or squares, the idea being to develop a "compass in the eye." From straight lines the lessons moved on to curves, usually laid out within a grid of horizontal and perpendicular lines or shown as related to the base of a straight line. Once students had command over these two kinds of lines, they copied pictures of simple objects such as tables, chairs, buckets, and bowls. Exercises of this sort would make it clear how the basic skills led to useful abilities. From this point the pace of instruction accelerated and novice sketchers were sent to the natural world to capture landscapes and animal and human forms. In attempting these complex figures the advice was always to determine first the system of straight lines, then the angles, and finally the general curves that lay hidden in the visible world (fig. 33). To prevent awkward distortions of human form rules of proportion were provided, literal "rules of thumb." Chapman, among other directions, cautioned that

"the longest toe, the thumb, and the nose are of equal lengths."[18] Forewarned with lists of anatomical equivalents, students moved from copying pictures of ideal poses to capturing real life.

The real world, however, contains so many variations that general rules cannot cover all situations. As a basic solution to the problem of presenting a correct image the manuals stressed perspective. If figures could at least be situated in real space then perhaps they would appear more realistic, even if they were only formulaic compositions of trees, houses, animals, and people. Chapman devoted forty-three pages to the principles of perspective, explaining such aspects as vanishing point, horizon line, ground line, and parallel diagonals. The mathematics and geometry involved in laying out correct perspective often were complex. Authors of manuals could only admit that perspective was the most difficult part of the art of drawing and advise diligent practice. With perseverance, they counseled, the student might eventually realize how all the elements of a picture fit together to form a pleasing composition. At this point the bold promise that anyone could learn to draw became problematic. As Marzio notes, "Perspective was not a separate entity or a simple building block. It required a thorough rethinking of earlier lessons and a readiness to discard sure-fire rules for stiff figures. It was both mathematical and intuitive. It was not democratic—it demanded skill and intelligence."[19] The art manuals thus delivered students to the threshold of professional competence. A few were able to enter the professional ranks, but most learned that they had their limits and would never produce more than a few casual sketches.

JOSEPH WHITING STOCK AND HIS ART MANUALS

The beneficial impact of art manuals can be seen clearly in the career of Joseph Whiting Stock of Springfield, Massachusetts (1815–1855), a painter who worked in New England and New York. The printed word was one of the chief means by which he transformed himself from a minimally trained amateur into an adequate professional. His development as an artist is quite revealing not only of the phases of plain painting but also of the impact of the popular press on those phases.

Stock embarked on his artistic career in 1832. He eventually developed a command over several genres and enjoyed considerable success. His personal journal, which covers only the first fourteen years of his work, lists an astounding 912

Fig. 34 Joseph Whiting Stock, *Mary Abba Woodworth*, 1837, oil on canvas, 48¼″ × 33¼″. Museum of Fine Arts, Springfield, Massachusetts; Gift of Dr. William Barri Kirkham.

pictures. Adding to these the signed and attributed works dated after 1846, his output totaled more than a thousand paintings.[20] His work first emerged from obscurity when two of his paintings were included in Cahill's 1932 exhibition at the Museum of Modern Art, "American Folk Art." Stock was described simply as a self-taught painter, and it was assumed that certain technical deficiencies in his work—overall flatness and poor color—were unquestionable signs of folk status.[21] Even as recently as 1981 his paintings were characterized as error filled. Donald R. Walters and Carolyn J. Weekly listed the sorts of mistakes that usually mark folk paintings as inept yet charming: they lacked depth, had sitters that appear "rigid," and had floors (fig. 34) that were "curiously tilted."[22]

While the particular works presented by Cahill and by Walters and Weekly are indeed naive, it would be a serious mistake to assume that Stock himself was also naive. Ample

Fig. 35 Joseph Whiting Stock, *Self-Portrait*, 1842, oil on artist board, 10″ × 8″. Courtesy of the Connecticut Valley Historical Museum, Springfield, Massachusetts.

evidence shows that he was fully aware of the rules of fine art and that he eventually enacted them convincingly in his work (fig. 35). His will and an inventory of his estate drawn up in 1855 reveal that he had read extensively and collected an impressive number of books and manuals on art. At the time of his death his personal library included seventy titles, ranging in subject matter from works of literature to histories to geographies to medical magazines (see table 1). Books relating expressly to art included instruction manuals like Chapman's *American Drawing-Book* (1847) and Charles Davies's *A Treatise on Shades and Shadows and Linear Perspective* (1832). Stock also owned a number of volumes of artist's magazines, such as the *Bulletin of the American Art-Union*, as well as histories of art, such as Henry T. Tuckerman's *Artist-Life* (1847). Stock owned several collections of engravings; one of them, *American Scenery* (1840), was extremely popular with both amateur and professional artists for its views of the United States. Many popular magazines from the middle decades of the nineteenth century regularly featured similar pictures and for that reason Stock amassed a large number of them. The scrapbooks listed in Stock's inventory probably contained prints, broadsides, and newspaper and magazine illustrations that he found inspiring. There is no way to conclude, then, that Stock was unaware of the academic tradition in art, unless we assume that he never read any of the books and magazines he so assiduously gathered and moved from residence to residence.

TABLE ONE

Inventory of the Library of Joseph Whiting Stock, 1855

Books and Magazines Related to Art

Artist-Life by Tuckerman
Miscellaneous Scrap Book
American Phrenological Journal (bound 1851–1852)
Scrap Book
Phrenological Journal
Combe's Lecture on Phrenology
Scrap Book
Ladies Companion
Scientific American (bound)
Gems of Art
Pictures from Grahams (bound)
American Phrenological Journal (unbound)
History of the painters of all nations in 10 Nos unbound
Bulletin of the American Art Union (8 nos.) unbound
3 Numbers of Art Journal
Illustrated Magazine of Art
3 Numbers of Chapman's Drawing Book
Painting, Sculpture & Music
12 Numbers of American Scenery (unbound)
Landscape painting explained in letters
Gentlemen's Magazine Volumes 2–4
Graham's Magazine (bound) 1842, 1845–1848
National Portrait Gallery Vols. 3–4
Godey's Magazine (bound) 1848, 1850
Peterson's Magazine (bound) 1851–1852
Art of Painting
Davies Shades & Shadows

Books of Literature

Shakespeare's Plays
Young's Night Thoughts
Posephus
Wuthering Heights, in 2 volumes—Pamphlets
Bertha & Lily
Lights and Shadows of Scottish Life
Pilgrimage of a Pilgrim

Books on History and Religion

French Revolution in 2 volumes
History of the United States
Barber's Historical Collections Mass.
Napoleon & His Marshalls in 2 Vols.
Washington and His Generals in 2 Vols.
The Green Mountain Boys
An Argument for Christianity

Books on Health Matters

Water Cure Journal (bound) 1853
Water Cure by Bulwer Forbes & Houghton
Hydropathic Encyclopedia in 2 Vols.
Water Cure Manual
Results of Hydropathy
Consumption its prevention & cure by the water treatment
Discourses on a sober & temperate life
A system of vegetable diet
Tobacco, its history, nature & effects on mind & body
Water Cure Journal for 1854, unbound
Hydropathic Cookbook
Perieras-Treatise on food and diet

Reference Works

Webster's Large Dictionary
Gazetteer of Rhode Island & Connecticut
Haywood's Massachusetts Gazetteer
Grimes Mesmerism
Ten Numbers of the Industry of All Nations
Animal Chemistry
Natural Laws of man

Source: Juliette Tomlinson, ed., *The Paintings and the Journal of Joseph Whiting Stock* (Middletown, Conn.: Wesleyan University Press, 1976), pp. 52–59, especially pp. 55–57. All titles appear as printed in Stock's will.

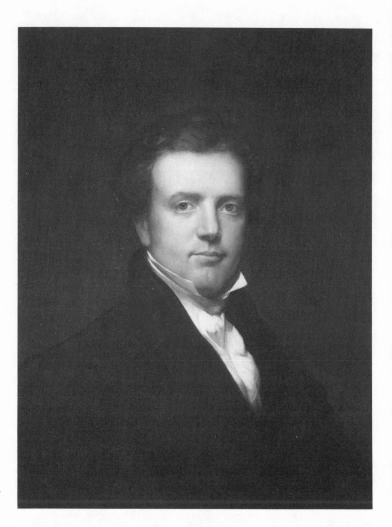

Fig. 36 Chester Harding, *Self-Portrait*, 1825, oil on canvas, 30″ × 25″. National Gallery of Art, Washington, D.C.; Andrew W. Mellon Collection.

Books were not the only influences on Stock, however. In 1830 the famous society portraitist Chester Harding moved to Springfield, Stock's hometown. Harding maintained a studio in Boston, but he kept his family home in Springfield for the rest of his life. He also painted a few of his pictures in borrowed rooms in Springfield when he found it inconvenient to return to Boston to finish certain commissions.[23] Well-known as a backwoodsman-turned-artist, Harding was famous during the nineteenth century as an example of the American "can do" spirit. Frances Trollope, in her book *Domestic Manners of the Americans* (1833), recounted that in Cincinnati she had heard Harding praised as a genius who was "perfectly self-taught."[24] In a mere six years Harding had progressed from painting signs and houses to accepting commissions to paint members of the British nobility, doubtless providing inspiration to many novice artists. Harding mused, "What freak of fortune is this which has raised me from the hut in my native

Fig. 37 Joseph Whiting Stock, *Frederick Merrick*, 1835, oil on canvas, 30″ × 25″. Private collection.

wilds to the table of a duke of the realm of Great Britain?" but those awestruck by his success simply resolved to apply themselves more diligently to their artistic exercises.[25] Harding was the sort of artist that amateurs would emulate, sensing that they were beginning at the same point and hoping to attain the same level of success.

While in Springfield Harding gave instruction to several local students, one of them being a Franklin White who, according to Stock, "called upon me frequently and showed me his manner of preparing and laying the pallet and lent me some portraits to copy."[26] Stock thus was a student of Harding's once removed. Harding left no indication that he ever knew of Stock's paintings, but Stock repeatedly and consciously followed Harding's example, as was most clearly revealed in 1834 when Stock painted a copy of Harding's self-portrait (fig. 36). Stock's compositional techniques also seem to derive from Harding's formulas (fig. 37). Most important, however, was the role model that Harding provided. Stock, born into a large working-class family and confined to a wheelchair from the age of eleven, had little opportunity to attend professional academies or to visit the studios of famous artists. Self-training was the only avenue of instruction available to him. He pursued the techniques of painting on his own as ardently as Harding apparently had during his early years of training.

Stock's first paintings in 1832 were copies of the pictures by his mentor Franklin White, but he also attempted a copy of a print distributed by Nathaniel Currier entitled *The Toilet*. The next year he produced fifty-five paintings, fifteen of which were copies from prints. Currier again appears to have been the prime source for his models. Several of the titles Stock lists—*Amelia*, *The Bouquet*, *The Sisters*—were big sellers for Currier's lithography company; *Amelia* was eventually published in four editions, *The Sisters* in six versions.[27] Stock's choice of subjects suggests that his sense of professionalism was firmly established. Rather than copy just any convenient picture that struck his fancy, he selected pictures that were extremely popular and most likely to sell. Stock also might have turned to Currier as his source for his likenesses of Napoleon and his wife Josephine, Andrew Jackson, and Sir Walter Scott, or he might have consulted his books *Napoleon and His Marshalls* or *Portrait Gallery of Distinguished Americans*. Alternatively he might have kept some engravings of these famous people in his scrapbooks. Without the actual paintings we can only speculate on where he got his models. Yet it is clear that Stock was still in the learning stages, since almost a fourth of his pictures were copy work. Another fifteen por-

traits were made of close relatives, who were easily available to pose as subjects and, more importantly, were likely to sit patiently through his first struggles with live sitters. Stock recalled that his family's bragging about his talent led to more commissions from the townspeople of Springfield. The pictures he produced were still, in his view, amateurish, and he realized that they were accepted as much in sympathy for his handicapped condition and his low prices as for any intrinsic merit: "My terms were very low and many were induced to patronize me from benevolent motives and as I gained more experience from observation, and the patronage thus bestowed upon me I soon acquired more skill and expertise in the use of the pencil and gave more perfect likeness."[28] The sequence of his first two years as a painter seems a natural and logical progression—pictures of pictures first, then paintings of relatives, then neighbors, then strangers—yet it is apparent that Stock was also heeding advice from drawing manuals, which advocated constant practice upon living subjects. In 1835 Harding advised one of his students, "Draw—draw—draw."[29] Perhaps the same advice had been given earlier to White and then passed on to Stock.

In 1834 Stock continued his usual mix of portraits of family members and local townspeople with an occasional likeness of a visitor from as far away as Hartford. A fancy piece, *My Dove*, also was attempted along with pictures of Andrew Jackson and Lafayette—which he sold for six dollars, one dollar more than his usual fee. That Stock had become fairly adept by this time is indicated by a commission from Dr. James Swan, Stock's personal physician, for thirty "anatomical illustrations." Stock was paid seventy-five dollars for these medical pictures, the largest fee he ever earned in his twenty-three years as a painter.

On May 3, 1836, Stock moved out of his family's home and boarded in a house in nearby Wilbraham, where he did some sixteen portraits. He subsequently moved from household to household, usually painting pictures of each member of the family. At this time he also began to experiment with miniatures and double portraits. Feeling that his technique had improved sufficiently, he raised his prices slightly; he now charged eight dollars for a half-length portrait but sometimes asked as much as eighteen dollars. Over the next ten years Stock's work pattern was essentially to travel in search of portrait commissions using Springfield as a home base. His visits would last as long as there was local business to occupy him. If he had some leisure time he would do some copy work, producing either pictures of political figures or inspirational scenery of the sort commonly published in popular magazines

or lithographs. Visiting new towns was quite exciting to Stock, since he previously had been confined to his room. He expressed his enjoyment of movement partly by attempting scenes of landscape—but instead of painting the sights around him he chose to copy from his books scenes of places he had never visited. Using as his models the engravings by W. H. Bartlett in *American Scenery*, he painted *Viaduct on the Baltimore & Washington Railroad*, *Niagara Falls*, and *Trenton Falls*. These were done during some idle time in Warren, Rhode Island. Moving on to Bristol, he again painted a copy of *Viaduct on the Baltimore & Washington Railroad* in addition to the *Columbia Bridge*, *Moonlight View of the Erie Canal*, *Black Mountain*, and *Caldwell Lighthouse*; these last four also were taken from *American Scenery*. A picture entitled *Pirate's Cave*, which he painted several times, does not appear in Bartlett's book and thus may be an original seascape of the Rhode Island or Massachusetts coast.

By 1843 Stock was charging between fifteen and twenty-five dollars per portrait. Even a miniature could run as high as nineteen dollars. Certainly his work was much improved. His self-portrait of 1842 (fig. 35) shows him to be quite adept at rendering even the slightest details and capturing a sitter's personality as well as likeness. It was crucial for Stock to develop his skills to such a high degree, for he now had to compete with the new technology of the daguerreotypist. That he thought himself equal to the challenge was shown in 1844 when he formed a partnership with his brother-in-law Otis H. Cooley to establish a "Portrait and Daguerian Gallery." Since Stock continued his pattern of itinerancy this enterprise was dissolved and reestablished several times before it finally disbanded in 1846. The venture nevertheless indicates that Stock was not isolated from the latest developments in likeness making.

For reasons unknown, in 1852 Stock thought it best to move on to New York State. He took up residence successively in three different Orange County towns—Middletown, Goshen, and Port Jervis—and he apparently did very well in his new surroundings. An advertisement in the Goshen *Independent Republican* in 1853 noted that Stock had done sixty portraits the previous year in Middletown. Also, in a letter from Port Jervis he told his brother-in-law, "I have engaged over $120 in portraits for some of the best families in the place so I think it will had in others. Mr. Farnum & wife, the one that own[s] the place with the Fountain which you will recollect of passing in coming to my room will have their portraits painted and should not be surprised if [I] had enough to last until Spring."[30] Stock commanded both ample and well-

Fig. 38 Joseph Whiting Stock, *Samuel B. Farnum*, 1855, oil on canvas, 35⅜″ × 28⅛″. Courtesy of the New-York Historical Society, New York.

placed patronage. The gentry, men with fountains in their yards, were willing to pay as much as forty dollars for a portrait and they readily sought his services. And they had good reason to do so: by 1855 Stock had become an adequate social portraitist (fig. 38). While not as outstanding as Harding, he was certainly superior to other local painters who hawked their services door to door.

Port Jervis witnessed in 1855 an art raffle staged by Stock. Many tickets were sold locally, but others went to Springfield and New Haven. It was so popular an event that all tickets had been sold by the time of the drawing. The prizes included a portrait of John C. Calhoun, two landscapes, an engraving (probably a view of Port Jervis), a crayon piece, and two shell-covered boxes. In putting on this event Stock showed his familiarity with the activities of professional arts organizations in major cities all over the United States at the time. The American Art-Union, founded in New York City in 1838, held an annual lottery in which winners were awarded

artworks as prizes. The scheme benefited both artists and pa-
trons; the artists were certain to get paid, and patrons got
valuable works of art for the mere price of a five-dollar
chance. By 1848 the Art-Union had 16,475 subscribers nation-
wide who got not only a chance at several hundred paintings
but also received gift engravings of such noteworthy pictures
as William Sidney Mount's *Farmer's Nooning* or Thomas
Cole's *The Voyage of Life*.[31] Stock realized that a lottery
would surely benefit him if all the prizes were drawn exclu-
sively from his own works. He knew of the Art-Union's
activities because he subscribed to its *Bulletin*; eight issues
were found in his library, and he may have owned others. It is
likely that he was a subscriber to the Art-Union for among the
unsold paintings in his estate was a picture entitled *The Horse
Bargain*, probably a copy of Mount's *Bargaining for a Horse*
painted in 1835 and engraved for distribution to Art-Union
subscribers in 1851.[32] Another picture in Stock's estate, *Lady
at the Bath*, may have been inspired by Luther Terry's *Roman
Girl Bathing*, which was included in the 1849 Art-Union lot-
tery. Similarly, Stock's *Spanish Peasant Boy* is most certainly a
copy of Bartolome Esteban Murillo's original; this work was
displayed in the Art-Union gallery in 1840 along with nine
other of his works, as well as with a copy of the *Peasant Boy*
by Victor Gifford Audubon. Member artists displayed no less
than six copies of Murillo's paintings in the Art-Union Gallery
over the fourteen years that it was in existence.[33] It would
seem that their collective example inspired Stock to paint his
own replica. Just as he had earlier selected the most popular
Currier and Ives prints to copy, he again chose what he
thought was the most fashionable of Old World masters for
his model. Stock's reading, then, bound him tightly to the pro-
fessional art world, providing not only suggestions of what to
paint but also a way to market his works.

What other insights about art Stock might have gained
from his reading are difficult to judge. But knowing something
of his personal circumstances and the way in which he learned
and practiced his profession, we can safely surmise which
statements probably affected him most strongly. In matters of
technique the two volumes of the *National Portrait Gallery of
Distinguished Americans* (1836) which he owned probably
helped him develop his own portrait likenesses. All of its illus-
trations were seated half-lengths with their subjects turned
three-quarters to the viewer, a standard portrait format. Stock
could have picked this mode up from any number of sources,
yet having on hand examples by Gilbert Stuart, John
Vanderlyn, Thomas Sully, John Trumbull and many other im-
portant painters no doubt was reassuring. Moreover, since

Fig. 39 Joseph Whiting Stock, *The Farnum Children*, 1855, oil on canvas, 49½″ × 39⅝″. Courtesy of the New-York Historical Society, New York.

these volumes included pictures by Chester Harding, his local role model, there was even more reason to consult this work when in doubt about matters of style and composition.

Any viewer can see that in Stock's earliest pictures he had problems in capturing correct perspective (fig. 34). Floors, for example, either tilt or rise vertically instead of receding away from the observer. But after 1840, in most instances he had conquered this problem. He even filled in some of his backgrounds with pleasing landscape scenery that featured rivers, hills, and foliage all arranged in the correct perspective and rendered in the proper scale (fig. 39). Two of his books could have offered specific help with the matter of perspective. The first was *A Treatise on Shades and Shadows and Linear Perspective* by Charles Davies, a professor of mathematics at West Point. While his book was oriented decidedly to the interests of engineers, Davies wrote of perspective a few lines to which Stock would have paid close attention: "It is this art which has stamped the canvas with the intelligence of the human countenance, and caused it to be looked upon as the

remembrancer of departed worth and the record of former times."[34] Certainly Stock wanted his work to be cherished, and his clients commissioned portraits in part to be remembered. In fact, a number of Stock's commissions were of recently deceased children and were intended, in a way, to bring them back from the dead. Consequently, we can safely assume that he followed closely the lessons laid out by Davies and must have taken careful note of "Problem 10," which showed how to render interior space and properly establish the lines of a receding floor.[35] Stock also could have turned to his copy of Chapman's *American Drawing-Book* for assistance, although by the time it was published he had overcome his earlier deficiency. Still, when Chapman warned "Art . . . will no longer suffer from the pedantry of traveled quackery," Stock was certain to think about the paintings he and his fellow itinerants were producing and wonder if the author's wrath was meant for him.[36] If, after such reflection, Stock did see signs of backsliding in his paintings, Chapman's book could provide handy advice on how to avoid further errors in draftsmanship.

The inventory of Stock's estate lists one volume of *Scientific American*. It is described as bound, but no volume number or date is given. We can surmise that Stock owned perhaps a year's run of weekly issues, each no more than eight pages long. Ten volumes of *Scientific American* were published between 1845 and 1855 and it is impossible to know which one Stock may have owned. However, if he went to the trouble of getting his issues bound, it is most likely that he had Volume One. It was this inaugural volume that carried a long series of columns on the various branches of drawing and painting. For almost fifty weeks editor Rufus Porter recounted his own experiences as a painter of ornamental designs, landscapes, and portraits. Well into his trade by 1845, Stock probably considered Porter's comments as rudimentary advice but being generally house bound, he probably saw his weekly issue of *Scientific American* as a way to interact with another artist. He may have been particularly intrigued by Porter's advice to take colors from nature, and he certainly would have been encouraged by Porter's claim that works by self-taught artists who used natural colors would "far surpass in excellence those of regular bred artists who have studied with the most popular Italian artists."[37] This open blast at such artists as Allston, Morse, Copley, and West, who had received considerable training in Rome, would have struck Stock as approval for his own program of self-instruction and improvement.

Stock had only to look to his copy of Tuckerman's *Artist-Life* to find glowing remarks on Chapman's instruction

manual: "It cannot fail to be eminently useful, and will serve as a standard authority in this department of education."[38] He was thus assured that he was moving along a reasonable path having selected the best printed advice available. In fact, Tuckerman's book contained passages that must have seemed like hymns of inspiration to Stock. Consider the likely impact of the following lines on a largely self-taught artist, confined for twenty-one years to a wheelchair and suffering from the early stages of tuberculosis: "There is a mechanical and a spiritual element in art, a body and a soul, a certain physical dexterity, adroitness, and tact, attainable through imitative and manual power."[39] If Tuckerman was right, painting offered Stock a therapeutic means for escaping the failings of his ruined body. At his easel he was no longer a disabled man with a hacking cough but an artist able to achieve the adroitness and dexterity Tuckerman had spoken of.

Another sort of publication that Stock collected seems on the surface to have little to do with art: works on phrenology, a pseudoscience that analyzed character on the basis of studying and interpreting the shape of various protuberances of the skull. After its introduction into the United States in 1832 by Dr. Francis Joseph Gall of Vienna a national fad for "bump reading" soon ensued.[40] For only one dollar one could obtain a year's subscription to the *American Phrenological Journal*, which regularly published maps of the human skull pinpointing the location of various faculties or departments of the brain such as Ideality or Amitiveness. Such information, it was said, could be very useful to artists; it was claimed that there were separate departments of the brain governing judgments of form, size, weight, color, and order—all faculties required for rendering an accurate likeness or landscape. Intriguingly, these discrete functions of the brain were located just behind the eyes. People could tell if they had the necessary talent to be artists, then, if their foreheads were sufficiently broad to enclose well-developed art faculties. Since Stock's forehead was considered well formed by phrenological standards, he could gloat about his natural superiority as an artist. He may also have known that his early idol Chester Harding was also a firm believer in the signs of phrenology. Harding had once noted that a certain pupil would never be a great painter because his head was not big enough but, Harding added, it was well his own was so large.[41] Stock thus had several reasons to believe in the assertions of phrenology: it confirmed his own personal abilities and connected him ideologically to his famous neighbor.

These phrenological journals also may have carried copies of his work. After Stock's death Fowler & Wells, publishers of

numerous phrenological guides, paid $166.63 to his estate.[42] Just what they had received for this rather large sum is not known, but Stock had previously done several sets of medical drawings—thirty-six anatomical illustrations, seven illustrations of the stomach, and two full-size skeletons—and so he might have drawn phrenological maps or perhaps portraits of famous people, because the heads of Napoleon, Andrew Jackson, and others of Stock's copy work subjects were commonly used as examples of particular personality types.

In sum, almost every book or magazine Stock kept had some impact on his career as a painter. This is important for our understanding of his work. Although today he is commonly referred to as a folk artist, his artistic ideals were powerfully shaped by the lessons provided by professional studio-trained artists, the critical commentaries of established brokers of elite taste, and popular illustrations. Where, in Stock's career, is the passage of information by informal, oral means, or the example of venerable formulas rooted in local custom that identify an artist as a participant in a folk tradition? They simply are not there. Stock's oral exchanges were with Franklin White, a studio-trained artist who taught him the fundamentals of the grand manner of social portraiture. Those formulas can be traced through Chester Harding back to Matthew Harris Jouett and ultimately to Gilbert Stuart, the main trendsetter for American portrait painting in the first half of the nineteenth century.[43]

Stock's tradition was the tradition of fine rather than folk art. White had given him only a general knowledge of painting, however; he was left to develop his mastery of fine art practice via a course of readings and experiments. At that point Stock was a plain painter. The books and manuals he read gave him a diffuse and somewhat simplistic version of painterly techniques and values, but they provided enough of the fundamentals that he could mature into a fine artist of moderate talent. In the ten years between 1832 and 1842 Stock moved through several levels of a plain painter's competence until he achieved a professional stature. By the 1850s he was patronized by clients who expected, and received, portraits in a fashionable studio idiom.

It is difficult to determine how unique Stock's case is. Few self-trained itinerant artists left behind such copious records. Yet it is hard to believe that other plain painters were not equally influenced by the printed word. With thousands of drawing and painting manuals in circulation, there had to be more than one receptive amateur artist who was willing and able to put these lessons into practice. It would be safe to conjecture that much of the rural North, the region with the

highest rate of literacy as well as the greatest concentration of artist-entrepreneurs, felt the full impact of the nineteenth-century art crusade.[44] The paintings created from this campaign of democratic art instruction should then be seen as statements of popular rather than folk culture, works descending from the highest social echelons to the middle ranks rather than arising from the everyday experience of the common people. To assert popular over folk sources does not in any way demean the importance of the art produced; it merely locates those artworks in their appropriate contexts and allows them to be interpreted in the most meaningful manner. Just as it makes little sense to identify Stock as a folk painter, it also makes little sense to think of most rural New England painters as folk artists. They were, for the most part, plain painters, enthusiastic amateurs polished lightly by the published teachings of a host of well-intentioned reformers.

"In a Very Tasty Style": Plain Painting in Nineteenth-Century America

Taste, according to Russell Lynes, is quixotic and subject to many social pressures and personal whims. It is therefore difficult to define precisely at any given time.[1] Yet in the first half of the nineteenth century, one aspect of middle-class taste was quite clear: an excessive fondness for pictures. The roots of this pictorial affection are traceable to eighteenth-century trendsetters, who used large numbers of paintings, prints, and other graphic forms as embellishments for their rooms. Inventories of the estates of the Boston elite, for example, show that pictures, items only occasionally encountered in seventeenth-century records, had become quite common. Consider the impact of entering the house of Dr. Thomas Bullfinch in 1761 and confronting thirty-eight pictures hanging in the staircase. Henry Vassal of Cambridge owned a total of eighty-four pictures in 1769, all of them on display and many of them framed and placed behind glass. While portraits were undoubtedly included in these private collections, the owners of these homes generally proved their refinement with sets of prints of works by or in the style of old masters. Images of the royal family, Roman emperors, Alexander's battles, English cathedrals, sailing ships, and "Raphael's Cartoons" filled the walls.[2] The principal message of such artistic accumulation was clear: pictures were objects that conferred prestige on their owners. A corollary to the equation between ownership of pictures and social rank was that a higher status could be signaled by a larger number of images. Similar social rules for art remain in force today.

The most important picture that an American could own was a self-portrait. So great was the demand for personal likeness in the last quarter of the eighteenth century that poet Philip Freneau was moved to fire off a round of pointed criticism. Assuming the persona of a noble Indian chief named Tomo-Cheeki, Freneau wrote:

Wherever we pass through these streets and narrow ways, we are not only gratified with the sight of the originals, but we see copies also, in profuse abundance suspended by way of sign from the houses; fixed over the doors as an invitation to come in; or attached to glass-windows as an article for sale. This is a sort of vanity or folly, that gives disgust to my heart. . . . Can the great white men do nothing for their country but the little people must be compelled to become minutely acquainted with the width of their faces; the lengths of their noses, the rotundity of their cheeks, the depression of their chins, or the elevation of their foreheads? . . . O Vanity! I find thee existing here in every shape, and under every guise.[3]

Freneau was incensed at what he took to be a frivolous preoccupation. To him, a portrait was a sign of arrogance, a device which allowed the sitter an undeserved claim to greatness. But, not surprisingly, because portraits were an important element in the social calculation of celebrity, Freneau's concerns went unheeded. Few Americans during the Federal era were prepared to defer the promises of advancement that constituted so much of the political rhetoric of the new republic.

At the outset of the nineteenth century a painter in the United States was most likely a portrait painter. The demand for personal likenesses was characterized by Aaron Burr in 1805 as "a rage for portraits," and he counseled his protégé John Vanderlyn to return at once from Paris to take advantage of the new, wide-open market for this genre of painting. The increasing desire for portraits was also noted by Washington Irving in 1807 in the *Salmagundi Paper*: "everyone is anxious to see his phiz. [i.e. physiognomy] on canvas, however stupid and ugly it may be."[4] Irving's comment indicates that the ownership of a picture could be more important than the picture's artistic merits, that social considerations might be more important than aesthetic criteria. The public's enthusiasm for portraits could justify any canvas even if it was mediocre or even terrible. Paul Svinin, a Russian diplomat who visited the United States between 1811 and 1813 and himself a competent sketch artist, observed that Americans had an overwhelming need for pictures of themselves. He added further, "For that reason portrait painters are constantly in demand and are well paid. The most wretched paint-slinger receives no less than twenty dollars for a bust portrait and some men get as much as a hundred."[5] The greatest portrait painter of the period, Gilbert Stuart, commanded a $100 fee. Many portraitists were plain painters who attempted to imitate Stuart's manner, either in style or technique. Flexner has observed of the usual results, "His followers produced some of the ugli-

est social portraits the western world has known."[6] Nevertheless, because these paintings were judged not on the basis of artistic merit but on social need, they were enthusiastically received even if ugly.

As the age of Jackson was dawning the demand for portraits showed no signs of decline. Reviewing the American scene in 1829, John Neal noted, "Our head-makers are without number and some without price," and further "they are . . . more than we know what to do with." He criticized the art-buying public for their fondness for "bad pictures" and observed that these paintings lacked the precious quality usually associated with artworks, being instead "things for everybody, familiar household furniture." And, he added:

Already are they quite as necessary as the chief of what goes to the embellishment of a house, and far more beautiful than most of the other furniture. If you cannot believe this, you have but to look at the multitude of portraits, wretched as they generally are, that may be found in every village of our country. You can hardly open the door of a best-room anywhere, without surprising or being surprised by, the picture of somebody, plastered to the wall and staring at you with both eyes and a bunch of flowers.[7]

Wide-eyed portraits, so named because the artists often worked excessively on the eyes, constitute the bulk of plain painting in nineteenth-century America. Awkward and unflattering, they nevertheless were accepted as objects of pride and, later, of familial devotion. Neal correctly sensed that the flaws found in plain painting owed as much to the public's indiscriminate acceptance of portraits as to the ineptitude of the painters: "People being much more ready to pay for a picture of themselves or their children than for a picture of anything else, the portrait branch is always overcrowded with adventurers and cheap workmen; outcasts and bankrupts from every other department of the business. Consequently the art is degraded, the prices lowered, and the judgment of the people, if they have any, corrupted."[8]

Neal suggests here a cycle of production and consumption that made portraits cheap and commonplace, yet the portrait remained a prestigious household item and face painters continued to demand high prices because of the supposed virtues of the genre. An editorial appearing in the *Western Sun and General Advertiser*, a newspaper published in Vincennes, Indiana, complained in 1822 of the wasteful extravagances of the local citizenry: "Instead of paying $12 or $1,500 to a portrait painter, why was not that sum appropriated to support a

clergy man whose character, whose interest, and whose hopes were identified with our own?"[9] A letter from itinerant artist Samuel S. Walker to his wife, written in 1841, similarly points to the financial successes of portraitists well into the second quarter of the nineteenth century. Walker reported of fellow artist J. Insco Williams that "his supereour as an artist is not to be found in the city of Cincinnati. . . . He painted pictures in Philadelphia at 100 dollars a piece, until he laid up 3,000 dollars—which he had loaned out at 10 per ct interest and holds mortgages or real estate for security."[10]

Neal's criticism of the public taste ultimately contained an optimistic appraisal of American art. From low beginnings, he predicted an impressive rise to excellence. Improvement was, he thought, embryonic in the taste for "bad pictures." But when Henry T. Tuckerman reviewed the development of American art in 1867, he found its growth still relatively stunted. He too noted promising signs, but he found the level of painting negatively affected by "imperfect training, the pressure of necessity, the hurry and hustle of life, the absence of a just and firm critical influence, and a carelessness." The majority of people, alleged Tuckerman, were easily fooled by the "so-called artist [who] will execute dazzling historical or allegorical works, sometimes on a large scale, and find their exhibition in rural districts amply remunerative." Portrait painters would "dash off likenesses cheap and fast," much to the public delight. But these artists had, he warned, only a "juvenile talent": "A 'knack of catching a likeness' has often been the whole capital of a popular limner, whose portraits, in many instances, are the sole memorials of endeared progenitors in family homes, and as such, cherished despite the violations of drawing, and absurdities of color, apparent to the least practiced eye."[11]

Many portraitists continued to find commissions even after the appearance of the daguerreotype in 1839. The utter realism of this new technology provided a challenging critique of the average painter's abilities, but the difference between the correct likeness of the camera and the presumed likeness of the brush often seemed not to matter. The high prestige associated with a painting was beyond question.

The paintings that ended up in middle-class homes in the first half of the nineteenth century, the period sometimes characterized as "the flowering of American folk art," are today much prized by collectors and purchased at auctions for thousands of dollars.[12] Usually described as having originality, vigor, and variety, these works are considered to represent the artistic productions of the common person in America. All the

effort expended in praising the aesthetic features of reputed folk paintings has deflected attention away from the opinions of this work expressed by contemporary nineteenth-century observers. The most common adjective used then was *wretched*. It would seem more appropriate, then, to regard these works as evidence of a failure at fine art. To say that this was less than fine art is not to say that it reflects what can correctly be termed a folk aesthetic; it was simply flawed work whose errors were excused. No quantity of high-toned adjectives can ever change the fact that this body of pictures contains numerous mistakes in design and execution. It is deceptive to argue that they are original when they were often copies, that they are innovative when they are in fact inept, and that they show variety when they are replete with redundancy. Referring to such attempts at painting as the equal of the greatest academic paintings can lead only to further confusion regarding the significance of this popular mode of art.[13] Plain painting, though fraught with deficiencies, possesses an interesting history that will only fall further from sight if this sort of art continues to receive ecstatic adoration. Plain paintings were works of art that were sometimes sold to the common folk, not art created by them. The most pressing question, then, concerns the popular motives for buying these paintings rather than their reputed artistic merits.

In *Life on the Mississippi*, a book in which Mark Twain closely recounts aspects of the southern domestic routine around 1850, a description is provided of the common furnishings for the average "two-story 'frame' house":

Over the middle of the mantle, engraving—Washington Crossing the Delaware; on the wall by the door, copy of it done in thunder-and-lightning crewels by one of the young ladies— work of art which would have made Washington hesitate about crossing, if he could have foreseen what advantage was going to be taken of it. . . . In big gilt frame, slander of the family in oil: papa holding a book ("Constitution of the United States"); guitar leaning against mamma; the young ladies as children, . . . both simpering up at mamma, who simpers back. Those persons all fresh, raw, and red— apparently skinned.[14]

Another work of art in the parlor he described as "frantic"; still another was "an outrage in water color." Twain's *Adventures of Huckleberry Finn*, a fictional account written in 1884, is set in the antebellum period and contains descriptions of the domestic style of the 1850s. Huck's visit to the Grangerford

home in Arkansas allowed Twain once again to critique middle-class taste in art. His memorable account describes a range of commercial prints, sketches, and mourning pictures:

They had pictures hung on the walls—mainly Washingtons and Lafayettes and battles, and Highland Marys, and one called "Signing the Declaration." There was some that they called crayons, which one of the daughters which was dead made her own self when she was only fifteen years old. They were different from any pictures I had ever seen before; blacker, mostly, than is common. One was a woman in a slim black dress, belted small under the arm-pits, with bulges like cabbage in the middle of the sleeves, and a large black scoop-shovel bonnet with a black veil, and white slim ankles crossed about with black tape, and very wee black slippers, like a chisel and she was leaning pensive on a tombstone at her right elbow, under a weeping willow, and her other hand hanging down her side holding a white handkerchief and a reticule, and underneath the picture it said "Shall I Never See Thee More Alas."[15]

The description details the contents of two additional mourning pictures with progressively more morose captions: "I Shall Never Hear Thy Sweet Chirrup More Alas" and "And Art Thou Gone? Yea Thou Art Gone Alas." Huck's final comment on these artworks no doubt presented Twain's attitude: "they always give me the fan-tods."

The satirical tone that permeates Twain's comments becomes even more merciless when he next turns to a picture hanging in the bedroom of a deceased Grangerford daughter. This work depicted a woman in a white dress about to jump off a bridge. She had three pairs of arms because the artist could not decide which looked the best—she had intended to erase two sets but died before she could do so. Huck reports that "The young woman in the picture had a kind of nice sweet face, but there was so many arms it made her look too spidery, seemed to me."[16]

Twain's writings as a journalist rather than a novelist leave no doubt regarding his dismay about plain painting. In an 1864 column for the *San Francisco Call* he declared, "California and Nevada Territory are flooded with distressed looking abortions done in oil . . . and in every substance that is malleable and chiselable or that can be marked on, or scratched on, or painted on, or which by its nature can be compelled to lend itself to a relentless and unholy persecution and distortion of the features." The world, Twain felt, would be a better place without the makers of "sleepy-looking pic-

tures" that were "blank, monotonous, over-fed, wretched counterfeits." He added, "There was no more life or expression in them than you may find in the soggy, upturned face of a pickled infant, dangling by the neck in a glass jar among the trophies of a doctor's back office, any day."[17]

Twain was not alone in his attack on plain painting, although few could rival his verbal agility in expressing their ire. As early as 1813 painter William Dunlap, the first historian of American art, offered the following view on the taste of the middle class:

A great house may be procured by the possession of wealth which shall be, if one does not interfere too much with his Architect, free from ridiculous misproportions or monstrous ornaments. Household furniture may be procured which shall be of the newest patterns from France or England and ostentatiously display, at first view, the costliness of their fashion & material, but after all this when you look for those indications of true taste which combine instruction with delight & approach the splendid frame in hopes of seeing an effort of art worthy of the ostensible wealth of the Host, you find a Chinese copy of an European colour'd print or some tawdry misshapen pieces of needlework figures with daubed faces or the awkward copies which Miss made from her drawing Master's models while at boarding school.[18]

As important as Dunlap's comments are in depicting early nineteenth-century domestic taste, they are equally significant for revealing that, when compared with Twain's accounts, middle-class taste remained very stable. For over fifty years amateurish pictures remained a common feature of American domestic interiors.

European visitors to America in the first half of the nineteenth century frequently were critical of American art and artists. Paul Svinin noted that "In every city there is bound to be a miniature painter, but none may lay claim to the name of a good artist." Focusing on the works of Rembrandt Peale of Baltimore, Svinin remarked that they "have the merit of resemblance, which is all that Americans require to call a painter great."[19] Frances Trollope made a similar comment on popular taste: "From all the conversations on painting which I listened to in America, I found that the finish of drapery was considered as the highest excellence, and next to this the resemblance in a portrait; I do not remember ever to have heard the words drawing or composition used in any conversation on the subject."[20] The American concern for verisimilitude found by Svinin, Trollope, and others was not always manifest

in finished works. In his *American Notes*, published in 1842, Charles Dickens mocked the results achieved by an Illinois painter whose work he encountered in the towns of Lebanon and Belleville: "In the best room were two portraits of the kit-cat size, representing the landlord and his infant son, both looking as bold as lions and staring out of the canvas with an intensity that would have been cheap at any price. They were painted, I think by the artist who had touched up the Belleville doors with red and gold; for I seemed to recognize his style immediately."[21] This critique recalls John Neal's earlier complaint about paintings "staring with both eyes."

While foreigners might be expected to poke fun at the inadequacies of the young, boastful American nation, even so thorough a patriot as Oliver Wendell Holmes referred to the itinerant artists who moved from town to town drumming up commissions as "wandering Thugs of Art." He charged them with "murderous doings with the brush [that] used frequently to involve whole families." Clearly disgruntled that people were so easily duped into sitting for these scoundrels, Holmes claimed that the painters "passed from one country tavern to another, eating and painting their way—feeding a week upon the landlord, another week upon the landlady, and two or three days apiece upon the children, as the walls of those hospitable edifices frequently testify even to the present day."[22] These artists were no doubt the same breed Tuckerman noted, "assiduous painters, who exhaust a town in a month in delineations of its leading citizens, fill their purses and inherit a crop of newspaper puffs; but give no local inhabitation or name to any idea, principle, sentiment, or rule of art." The general lack of good taste in art was to be blamed on these artists, who did "little to kindle aspiration, to refine the judgment or to hint the infinite possibilities of Art."[23] Plain painters, in his view, constituted not the source of an American tradition but a handicap to be overcome. He anticipated a time when there would be enough fine artists in the United States to outweigh their bad examples.

Encounters with such artists might prove so unsavory that the very category of art could become poisoned. William Dunlap, for example, reported that in some rural towns where his painting *Christ Rejected* was exhibited, sermons were preached against it as a blasphemy. Once when an admission fee was charged to view the painting, his agent was arrested for violating the local law requiring payment of a tax on puppet shows. Dunlap warned other artists that although in some places a painter might be encouraged, in others he or she ran the risk of "being received as a mountebank and insulted by a mob."[24] To some extent Dunlap's difficulties derived from the

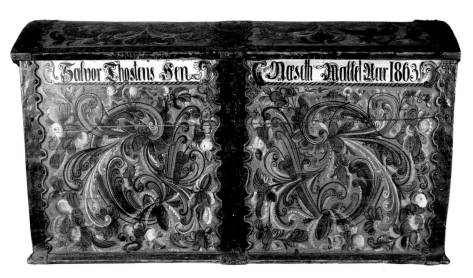

Plate I Painted decoration on
a wooden chest, Thomas
Luraas, ca. 1863. Norwegian-
American Museum, Decorah,
Iowa; Luther College Collec-
tion.

Plate II Erastus Salisbury
Field, *Elizabeth Billings
Ashley*, ca. 1825, oil on can-
vas, 24½″ × 22½″. Museum
of Fine Arts, Springfield, Mas-
sachusetts; The Morgan
Wesson Memorial Collection.

Plate III Joseph Whiting
Stock, *The Farnum Children*,
1855, oil on canvas, 49½″ ×
39⅝″. Courtesy of the New-
York Historical Society, New
York.

Plate IV William Matthew
Prior, *Unidentified Child in
Red*, ca. 1830–55, oil on can-
vas, 26¾″ × 21¾″. From the
Permanent Collection of the
Museum of American Folk
Art, New York; gift of Robert
Bishop.

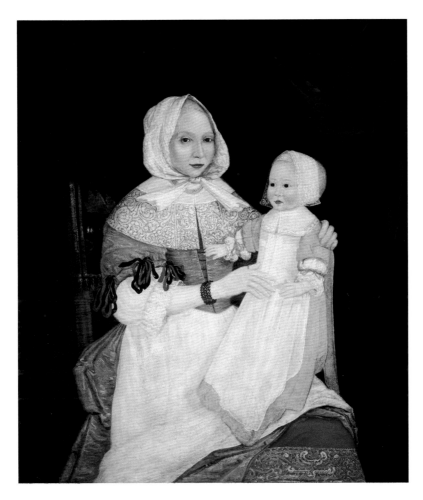

Plate V Freake Limner, *Mrs. Elizabeth Freake and Baby Mary*, 1674, oil on canvas, 42½″ × 36¾″. Worcester Art Museum, Worcester, Massachusetts.

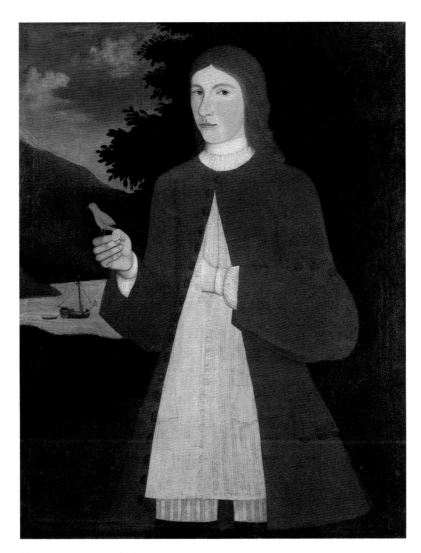

Plate VI Pieter Vanderlyn, *Pau De Wandelaer*, ca. 1725, oil on canvas, 48″ × 37″. Albany Institute of History and Art; Gift of Mrs. Abraham Lansing.

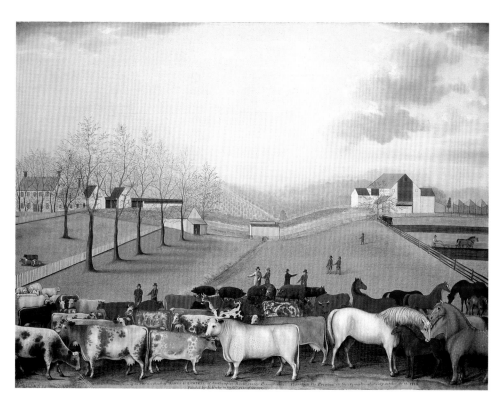

Plate VII Edward Hicks, *The Cornell Farm*, 1848, oil on canvas, 36¾″ × 49″. National Gallery of Art, Washington, D.C.; Gift of Edgar William and Bernice Chrysler Garbisch.

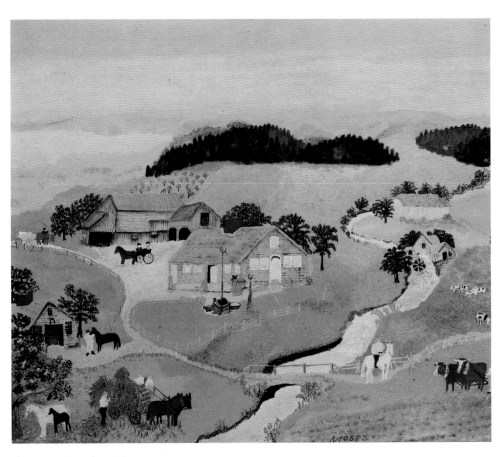

Plate VIII Grandma Moses,
*The Home of Hezekiah King,
1776*, 1943, casein on mason-
ite, 19″ × 23½″. Copyright
© 1973, Grandma Moses
Properties Co., New York.
Phoenix Art Museum, Phoe-
nix, Arizona; Gift of Mrs. N.
A. Bogdan, New York, in
Memory of Mr. Louis Cates.

performances of fly-by-night itinerants who had passed the same way before. These "quacks," as Samuel F. B. Morse termed them, made life tough for the genuine fine artist.[25] As early as 1796 the Litchfield, Connecticut, *Weekly Monitor* reported that amateur painters who attempted to satisfy the public's need for portraits were only "assuming pretenders" capable of "paultry daubs."[26] According to the newspaper, such artists were patronized not because of their talents but because of the unpredictable availability of noteworthy painters. Plain painters, then, sometimes were awarded commissions out of desperation, and the resulting paintings usually disappointed the sitters. Feeling burned once in the name of art, the locals were not willing to allow even an artist like Dunlap to demonstrate his abundant ability.

We might expect studio-trained artists, snobbish foreigners, and self-declared cultural experts to refer to plain painters as "wretched paint-slingers," "outcasts," "artistic lunatics," and "thugs," and their works as "cheap," "slanders," and "murderous," but it is surprising to discover that the plain painters' own accounts contain a similarly unflattering view. Not much testimony survives from this group, but what does exist is as harsh in its own way as anything Twain could muster. Chester Harding, who rose from obscure agricultural origins to become a noted society portraitist, recounted his beginnings in an autobiography he called *My Egotistigraphy*. Harding was working as a sign painter in Pittsburgh when he "fell in with a portrait painter by the name of Nelson—one of the primitive sort."[27] Primitive though he may have seemed, Nelson knew of the work of Sir Joshua Reynolds and used a copy of Reynolds's *Infant Artists* as his trade sign. Nelson's example inspired Harding to abandon the sign painting trade and become a portraitist.

After studying closely some likenesses Nelson had made of Harding and his wife, Harding reported that he "got a board and, with such colors as I had for use in my trade, I began a portrait of my wife. I made a thing that looked like her." Harding's neighbors thought his work was delightful. Emboldened by their praise, he set forth for Paris, Kentucky, where a local portrait painter was getting the "fabulous" price of fifty dollars a head. Harding recalled, "I painted nearly one hundred portraits, at twenty-five dollars a head. The first twenty-five I took rather disturbed the equanimity of my conscience. It did not seem to me that the portrait was intrinsically worth that money; now, I know it was not."[28] In retrospect Harding realized that he had inadvertently duped his clients with his novice attempts at painting (fig. 40). But his success led to such self-infatuation that he was temporarily

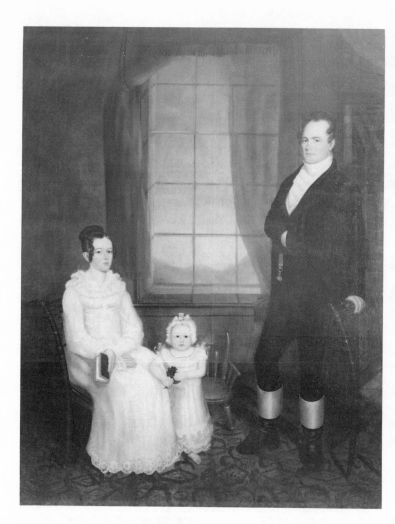

Fig. 40 Chester Harding, *The John Speed Smith Family*, 1819, oil on canvas, 100″ × 78″. Collection of the J.B. Speed Art Museum, Louisville, Kentucky.

blinded to the merits and weaknesses of his work. It took a trip to Philadelphia and a subsequent six-week stint of lessons at the Pennsylvania Academy, where he was exposed to the works of Stuart and Sully, to restore his critical faculties: "My own pictures did not look as well to my own eye as they did before I left Paris." Previously he had asserted that his work was superior to that of his local competitor Matthew Jouett, the favorite protégé of Stuart. But after exposure to studio procedures Harding gained new appreciation and respect for Jouett's paintings: "My estimation of them was very different now: I found they were so superior to mine that their excellence had been beyond my capacity of appreciation." Once Harding learned to discriminate between plain work and finished academic canvases, he embarked on a campaign of improvement that would eventually earn him international patronage. His work became the rage in Boston such that Stuart referred to the intense desire for his portraits as "Harding fever."[29]

Admission of artistic inadequacy also is found in the letters of John Toole, an itinerant painter from Virginia. He wrote in 1838, "I feel the want of instruction—and I have the Idea of taking an excursion through the land for the purpose of endeavoring to raise sufficient funds to secure me a good master either in Philadelphia or New York."[30] Toole failed in this particular plan but he was able to obtain prints by Sully which he copied to improve his composition. From these exercises as well as a partnership he formed with a daguerreotypist in Petersburg, Virginia, he eventually achieved greater competence in rendering accurate, convincing likenesses. Another honest admission of moderate talent was registered by an anonymous amateur painter who sent his work to the New York Art Union in 1847. He had created an image of Magdalene, probably a composition copied from a print. In the letter that accompanied his submission he wrote, "Although she's all my fancy paints her, I could wish she was painted a great deal better."[31]

The most revealing account of a nineteenth-century plain painter is found in the diary of James Guild, which intermittently covers his career from 1818 to 1824 (fig. 41). During this period he engaged in a range of professions, including peddler, tinker, wrestler, profile cutter, portrait painter, and penmanship teacher. His narrative is important because it reveals not only his views but also the attitudes of some of his clients. Guild's comments point to a public distrust of artistic entrepreneurs. For example, a tiff between himself and one of his customers occurred in the town of Manilus, New York, where Guild had started a small art school:

A young Lady who had her likeness drawn said she would not have it, for I asked to much. Very Well you may do as she please. She wanted it for half price and I would not let her have it, so I drew a long tail to it, and put it on the sign post and wrote these lines:
 Ladies and Gentlemen, to [thee]
 I do these lines address,
 Who do your profiles wish to see.
 Since I the art profess,
 As natural as life I did this take,
 And she the pay denied,
 Likewise a tail to it I [make],
 that she may never again serve me so.[32]

Because the validity of art depended as much on economics as on aesthetics in middle-class America, plain painters and their customers often argued over the matter of price. The following

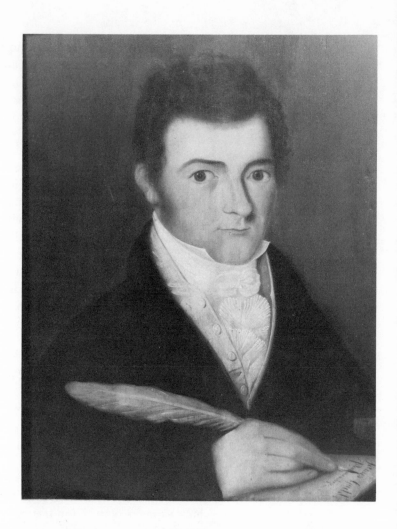

Fig. 41 James Guild, *Self-Portrait*, ca. 1820, oil on canvas. Private collection.

passage reveals the lengths some people were willing to go in order to get a good deal:

I saw a young lady who wanted I should give her my profile. O yes you may have my profile and welcome. The object was she thought if I give her my likeness, I would give her my frame, also being a little imprudent told one of my friends and he told me. So when I offered it to her, she says, O I wouldn't take it unless you give me the frame with it. Well, Marm, I thought you wanted my frame more than my likeness, and I did not give it to her.[33]

The young woman's scheme in this case was aimed at procuring a suitable means for displaying a likeness or picture which she already owned, a ruse which may indicate something about the quality of Guild's work.

Guild could be vengeful when his clients rejected him, and he could also become quite violent. In Bloomfield he con-

vinced the lady of the house, a Mrs. Marvin, to have pictures painted of her children. However, when Mr. Marvin came into the room and saw what had transpired, he flew into a rage and screamed:

Get out of my house in a minute, or I will horse whip you, you dam profiters and pedlers, you ought to have a good whipping by every one that sees you. Get out of my house you raskal. . . . Get out of enclosure, you rascal, or I will horse whip you and you shall leave the town in one hour or I will horse whip you all the way out. Stop . . . give me your name, I'll warn you out of town.

Marvin then grabbed Guild by the collar and dragged him into the yard. Then Guild turned on him: "Now was a good opportunity for me. I flew my hand round and caught him I no not where and droped on my back and with my foot pitched him over my head and the first that stuck was his face on a sharp board purposed for a goos pen and I gess he carrys the mark until this day."[34]

Certainly not all interactions between plain painters and their clients resulted in the sort of fisticuffs described here, but such encounters suggest that sham artists engendered deep feelings of hostility for both their behavior and their artworks. The beneficent image of a strolling itinerant artist who is happily received by eager rural folk could stand some revision.

Guild was a deceiver. By his own admission he had learned to paint in one day. Perceiving his profiles to be "mean," he paid a Mr. Goodwin, "one who painted likenesses," to show him "how to distinguish the colors." Guild gave five dollars for his lesson and the next day he was again on the road, using a picture by Goodwin as enticement to potential customers. He was soon to try out his newly acquired talent:

I put up at a tavern and told a Young Lady if she would wash my shirt, I would draw her likeness. Now then I was to exert my skill in painting. I operated once on her but it looked so like a [wretch] I throwed it away and tried again. The poor Girl sat nipped up so prim and look so smileing it makes me smile when I think of while I was daubing on paint on a piece of paper [—] it could not be called painting [—] for it looked more like a strangle cat than it did like her. However, I told her it looked like her and she believed it.[35]

The unnamed tavern girl was apparently not the only one to be willingly misled; Guild himself became taken with his abili-

ties. Upon attempting his first miniature on ivory, he wrote that it "went so much beyond my expectations that I thought I soon would be a dabster."[36]

Subsequent travels down the east coast brought Guild some commissions in North Carolina, where he earned $300 painting miniatures. His successes apparently stimulated serious reflection on his future as an artist. Perhaps a twinge of conscience disturbed him. Guild wrote in 1822, "I found I lacked very much for instruction, and I made up my mind to go to N.Y. and receive instruction from the first artists."[37] Guild was finally admitting that his career was based on deception. When Neal wrote that the painters who satisfied the public's demand for pictures were "adventurers and cheap workmen," he clearly had men like Guild in mind.

More criticisms of plain painting are found in the pages of *Godey's Lady's Magazine*. Published first in 1830, this monthly journal had an important impact on the public taste in art. It featured columns that detailed the methods of various painting techniques and outlined art projects to be tried out at home, and it reproduced high-quality engravings of genre scenes by such artists as Richard Westall, Thomas Lawrence, Samuel F. B. Morse, C. L. Eastlake, and William Sidney Mount. Editor Sarah Josepha Hale attempted to raise the artistic consciousness of her readers by printing reviews of art exhibitions and fiction that focused on artists as the chief protagonists. These short stories, romantic in tone, concluded with moral warnings to trust more in real life than in the depictions provided on canvas.[38]

A pointed essay on this issue appeared in 1832. In "My Portrait," Louisa H. Sheridan counseled that a woman should be content to appear on canvas as she actually is. Stylish costumes provided by artists to effect the looks of Swiss shepherdesses, English royalty, Grecian allegories, or saints were to be avoided. Sheridan advised that it was quite acceptable to "appear in our everyday position, and dress (like the Irish national vegetable) au naturel." Use of artistic props such as "an Italian greyhound and a missal," she cautioned, could be mistaken by some viewers for a "cat and a piece of gingerbread."[39] It was prudent, then, to regard artists with a degree of suspicion.

Some tales contained pointed criticism of popular trends in art collecting. One story by Cimabue Briggs presented the life of Theophilus Smudge, a representative "struggling" artist of the 1840s. In his search for success, Smudge encounters a dealer in fine art named Kidd who specializes in making contemporary paintings look like "old masters." Kidd takes Smudge into his workshop, where he transforms a picture of

St. Peter into a semblance of an Italian bandit by painting in new elements—a red stocking cap to cover his halo and a pistol in place of his symbolic keys of authority. He tells Smudge: "If you live by the public, you must cook the dish to the public palate."[40] He adds later, while antiquing a new Dutch landscape:

You see every purchaser hugs himself upon having one of the right sort. So soon as it is in his possession it becomes his pet, and like one of his children he sees it all beautiful; peculiarities regarded by his neighbors as objectionable, his self-devotion glazes into symbols of excellence—and that's where it is, only half the cheat is perpetuated for him, the remainder he himself perfects.[41]

As Smudge takes this all in, readers are put on their guard for fraud not only by artists but also in the art market in general.

A story that provides the richest details regarding the interactions of plain painters and their clients is "The Traveling Artist" by A. M. F. Buchanan. Granting that it is fiction and thus contrived to achieve a dramatic effect, this narrative nevertheless accords with what artists such as Guild and Harding had to say about their work. The litany of complaints by such critics as Neal, Twain, Holmes, and Tuckerman were apparently motivated by artists who approximated the behaviorial profile of Buchanan's painter villain. So revealing is this story that it is worth recounting in some detail.[42]

The opening scene presents the heroine, Cecilia, who is musing the possibility of having her portrait painted. A companion warns her that many artists are not to be trusted and provides her with a cautionary tale concerning an artist who presented himself as an itinerant Pole and eventually charmed a young woman into eloping with him. He turned out to be a "good-for-nothing French Jew, who beat her half to death within a week of their marriage." With this sinister image as background, artist B. Franklin Meredith enters the story.

He has an intriguing manner and Cecilia is immediately attracted to him. She comments that he has a "very respectable name" and, invoking a proverbial rule that "the handsomest painters provide the handsomest pictures," she decides to commission him to paint her portrait. After agonizing over which dress to wear, she appears at his rooms for her first sitting. The experience is exhilarating and Cecilia delights in the attention. However, she has a few misgivings when, during a discussion of West's *Death on a Pale Horse*, Meredith remarks, "It's no such great scratch, that I could see." Cecilia forces this comment from her mind even though she considers

West's painting a masterpiece. During the second sitting another danger signal rings out when the artist declares "I expect that dress of yours'll be pretty hard to paint, Miss. How do you like what we painters call—ah—fancy drapery?" Cecilia is flattered with the prospect that she will now appear in flowing Grecian robes and she accedes to Meredith's suggestions, ignoring the warnings that faithful readers of *Godey's Lady's Magazine* have heard many times before.

After a course of ten sittings the painting nears completion. Meredith has kept Cecilia from seeing her image on the pretense that she will enjoy it more when it is finished. The repeated sittings become tiresome, even a nuisance, but our heroine suffers patiently in the anticipation of her completed portrait. When the painting is finished Meredith's aunt, an earthy woman, appears in the studio. She yells out, upon seeing the picture on its easel with Cecilia behind it, "This is her! this is her! anybody could tell with half an eye who the portrait was took for!" Cecilia, however, must wait to see if she agrees with this spontaneous proclamation, since Meredith has promised an unveiling the next day at her home.

Before leaving the studio Meredith's aunt recounts to Cecilia the story of the artist's training. It seems that two itinerant artists had previously appeared at the inn she runs, "crazy fellows" who impressed Meredith by announcing that they commanded a hundred dollars for their drawings. Meredith then took off to the city for four weeks to learn the artist's trade and "came back, with his hair all hanging about his face, and a great broad brimmed hat on his head and a knapsack to carry on his back, looking as much like a painter as any of them." This tale only raises Cecilia's anxieties, but she decides that it would be best to wait at home for the delivery of her painting.

The next day, when a porter delivers the canvas, she cries out in shock, "Impossible! Can this be it!" The painting is more terrible than she could ever have imagined:

There was not the slightest vestige of anything in it by which it could have been recognized—not even in the costume. It exhibited an attempt at classic drapery; a sheet of white, stiff and shadowless as writing paper, rolled round the bust, with slits at the sides through which the arms stuck straight down like pieces of turned timber. The neck had the same wooden look, resembling nothing so much as the pyramidal lid of an old-fashioned pump, the round knob of the top of it resembling the head. The features were executed pretty much in accordance with Queen Elizabeth's idea, without shade; being lines out of all symmetry, with little or no perceptible relief;

*and the hair presented streaks of a numberless variety of hues.
In short, it would have been difficult to contrive a more lam-
entable and witless caricature.*[43]

Adding insult to injury, the porter reminds Cecilia that the art-
ist is in his studio waiting for his seventy-five dollars.
Trembling with rage and on the verge of tears, Cecilia is about
to faint when her true love, hitherto silent, bounds into the
house. When he sees the offending portrait he yells, "that
abominable daub! how did he dare—the ignoramus—the im-
postor!" He then runs to settle the account with Meredith and
warns him to get out of town. Meanwhile Cecilia tears the
portrait into little strips and burns them in the fireplace.

Cecilia and her true love are soon married and almost live
happily ever after. The tale ends with them accidentally en-
countering B. Franklin Meredith several years later, lounging
on the porch of an unkempt house and surrounded by a tribe
of squalling children and a shrewish wife. Over his head is a
sign proclaiming his trade as a portrait painter. Cecilia and
her husband nod silently at each other, remembering the pain-
ful lesson of bad art.

This tale conveys what some clients must have felt about
the paintings hawked in their communities. They expected to
receive fine art and were repeatedly disappointed. But these
lessons of experience never seemed to register very deeply with
the public; there were thousands of Cecilias waiting to be
swindled. For every Mr. Marvin who tried to throw the "ras-
cals" out there were ten sitters who could be convinced that
they actually looked like "strangled cats." During the nine-
teenth century the American public wanted works of art more
than they wanted artistry, and they would accept even bad
paintings.

The appeal of plain paintings was symptomatic of the per-
vasive materialism of early nineteenth-century America. Many
contemporary commentators noted that money and property
ranked highest among the concerns of American citizens.
Ralph Waldo Emerson stated, "You will hear that the first
duty is to get land and money, place and name."[44] The pursuit
of material gain was confirmed by the remark of a New York
state farmer who in 1828 is reported to have said, "I ain't
greedy for land. All I want is jist what jines mine"—that is,
the vast unclaimed territory of the western frontier.[45] French
visitor Michel Chevalier wrote in 1839, "At the bottom of all
that an American does is money, beneath every word, money.
. . . His motto is 'Victory or death!' But to him, victory is to
make money, to get the dollars, to make fortune out of noth-
ing."[46] This analysis restates the earlier observation of John

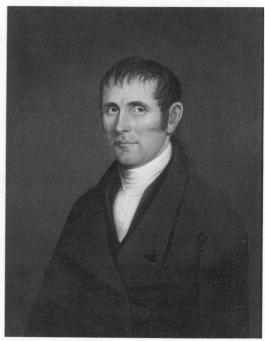

Left: **Fig. 42** Ammi Phillips, *Hannah Thompson*, 1824, oil on canvas. Henry E. Huntington Library and Art Gallery. *Right:* **Fig. 43** Ammi Phillips, *Alexander Thompson*, 1824, oil on canvas. Courtesy, Cheekwood Botanical Gardens and Fine Arts Center; Gift of Mr. and Mrs. Walter G. Knestrich.

Vanderlyn, a studio-trained artist of international repute who noted in 1825 of his Hudson Valley neighbors, "Property is after all the most important thing, in this country particularly. Fame is little thought of, money is all and ever the thing."[47] In such a social context, paintings were highly charged objects. They were proof that their owners had wealth, the basis for higher rank and its accompanying higher prestige. No wonder the anonymous tavern girl smiled as she sat for Guild; she was getting a likeness, a proof of success, just for washing a shirt. A painted likeness had the ritual power of transformation to boost one into a higher social class. While the tavern girl was obviously not going to become a member of high society simply by owning Guild's awkward picture of her, she could at least feel rich. Consequently she was happily deceived and accepted her unflattering portrait as if it were a masterpiece. The social thrill she experienced enabled her to overlook the picture's flaws.

A similar ritual of arrival was enacted by a farmer named Alexander Thompson in Orange County, New York, during the first quarter of the nineteenth century. In 1819 he had won the county prize for the most improved farm; in 1822 he redesigned his house adding "fancy rooms" for which he purchased all new furnishings in the latest style; in 1823 he and his wife had their tenth and last child and he accepted local elective office. The next year he and his wife had their portraits painted (figs. 42, 43). Thompson had secured all the ele-

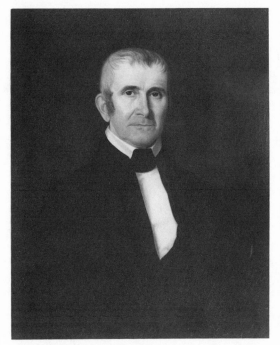 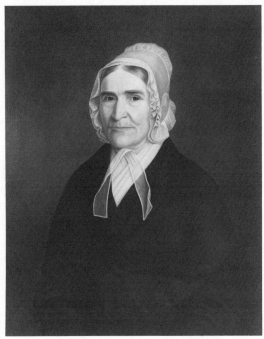

Left: **Fig. 44** John Vanderlyn, *Alexander Thompson,* 1848, oil on canvas. Neil and Lee Larson, Stuyvesant, New York. *Right:* **Fig. 45** John Vanderlyn, *Hannah Thompson,* 1848, oil on canvas. Neil and Lee Larson, Stuyvesant, New York.

ments of the Emersonian formula for success—land, money, place and name—and he underscored his achievement with portraits to be hung with pride in the new parlor. The artist he chose was Ammi Phillips, a noted itinerant who worked the border lands of Connecticut and Massachusetts—a painter whose works Vanderlyn described as cheap and slight. Still the brushwork was very careful, and the paintings were judged suitable enough for their purpose. In fact, Thompson recommended Phillips to all his kinfolk in the county; the itinerant artist painted his way door to door, capturing the likenesses of the entire Thompson clan. If we follow Thompson's career for a few more decades, we find that he acts with less expedience. In 1848 when he retired from an eleven-year term as town supervisor, he and his wife had their portraits painted again, but this time by John Vanderlyn (figs. 44, 45). Thus as Thompson climbed the social ladder of success, he also moved up through the hierarchy of art.[48] His taste for plain painting had been replaced by a preference for work that would clearly be perceived as fine art.

Social climbing, a hallmark of the Jacksonian age, was effectively captured in an apocryphal tale reported by Godfrey T. Vigne in 1833: "The captain of a steamboat [during supper] . . . happened to ask rather loudly, 'General, a little fish?' and was immediately answered in the affirmative by twenty-five of the thirty gentlemen that were present."[49] The country was full of pretenders to greatness, and one of the

most common strategies was to imitate the behavior of a local grandee. We have already seen that Alexander Thompson's less prominent kin followed his lead and commissioned portraits from Phillips. Chester Harding reported a similar copy-cat syndrome in Kentucky. When he began to paint portraits, he first did a painting of a "very popular young man, and made a hit." He was then thrown in with the "tip-top of society" and found himself besieged with requests to paint more portraits.[50] Since these were likenesses Harding would later judge inferior, it is certain that his work was solicited mainly because of the prestige associated with that first sitter rather than the quality of the portraits. An 1840 newspaper article from the Richmond, Indiana, *Palladium* counseled "ladies and gentlemen of taste and fashion" to patronize S. S. Walker, a portrait painter then visiting that city. The reporter noted that an economic depression had created a scarcity of money, but the "finer feelings of our nature" merited indulgence.[51] He essentially dared the well-to-do of Richmond to spend their limited funds on art in order to validate their claim to high social position. In such circumstances the act of commissioning a painting is more significant than the painting itself.

Another set of motivations behind the demand for plain paintings involved the nature and function of the family. The family was the most prominent social institution in America in the first half of the nineteenth century. The young nation had few ways to provide for the welfare of its citizens, so the household rather than the state, county, town, or parish looked after the interests of the individual. The family provided identity, nurturance, guidance, and first opportunity essential for advancement. Social success during the nineteenth century was, as Alan Gowans indicates, "family success—not career success of the head of the house."[52] The family-run farm was a shared enterprise, even if patriarchal social customs made men more prominent than women. The centrality of the family as an institution also had an impact on the content and use of plain paintings. These pictures, generally portraits of both husband and wife, depicted the matrimonial union from whence families were established. A household had both a founding father and a founding mother—a critical social fact signaled to all by the portraits that might be displayed prominently in the home. Since the domestic roles of women were hidden from public view, it became all the more crucial that the parlor be converted into a familial shrine in which the mantel over the fireplace displayed respectful images of father *and* mother. Gowans comments:

Such front parlors, statements of family establishment, remained features of farm houses right into the twentieth

century. A house with no other evidences of culture would have its horse hair sofa, its fireplace with ledge and paneling on which were displayed tin types of ancestors, mementos of honeymoons to Niagara Falls or a grand trip to San Francisco. Only gradually, in the 1920s did this feature begin to fade out of American houses, its disappearance corresponding to and manifesting erosion of the concept of the landed family or indeed of family solidarity at all.[53]

Twain mocked middle-class Americans for keeping "slanders of the family in oil," but for those families no slander was intended or noted. In fact, quite the reverse was expressed. Among landed families during the first half of the nineteenth century, continuity was insured by gathering to the household more members, more land, more wealth. Some of these families, of course, were more successful than others, yet all might attempt claims to superiority via similar signs of stability, longevity, wealth, and power. An oil portrait, even a seemingly slanderous one, gestured towards all of these attributes; it was a visual sign that proclaimed the validity of the family lineage. "Families," notes Gowans, "who have the same recent origins as their neighbors but believe themselves superior, require the visual metaphor of a building similar in type to their neighbors' . . . but proclaiming superiority by being larger, solider, and above all showier."[54] When the visual metaphor selected is a two-dimensional image, a large oil painting in a gilt frame easily outdistances a daguerreotype in conferring honor not only to the people depicted but also to the household in which it is displayed. Moreover, it was much easier—and cheaper—to commission a painting than to rebuild one's home. Owning paintings allowed people from the lower end of the property-holding class to pretend to be richer than they actually were.

Another set of domestic rituals that gave sanction to what can be considered poor paintings involved memorials for deceased children. The custom of displaying posthumous mourning portraits flourished among leading families in the United States from 1830 to 1860. These paintings, commissioned upon the death of a child, attempted to provide a lively image and thus deny the power of death to end life. While this may seem a desperate or pathetic gesture, the custom indicated the optimism of an age when no defeat was willingly accepted. In an era of relentless materialism there was a refusal to let go of the tangible; it was considered both noble and romantic to resist death.[55] The living child was held alive in the family if only in effigy form.[56]

But if the child is shown as if alive, how can one know if a picture served a mourning function? The message of death

was conveyed by a complex iconography involving color, floral imagery, and other emblems of transition like boats, keepsake books, or storm clouds.[57] This iconography, now largely forgotten, was widely known in the nineteenth century. If we could recall that system of symbols, many of the surviving portraits of children would assume a new significance. In fact, it is estimated that seventy-five percent of all paintings of children done in the nineteenth century were posthumous portraits.[58]

One of the keys to recognizing such paintings is the color of a sitter's clothing. Red was often chosen because it was a color of mourning along with white and black. The custom derives from the Christian tradition of draping the coffin with a red pall.[59] Clinging vines, symbolizing a tenacious hold on life, together with dead trees, representing the end of life, might occupy the background. A departing ship sailing out of the picture might recall the end of the voyage of life. A painting by William Matthew Prior, known today simply as *Unidentified Child in Red* (ca. 1830–55, fig. 46), has all of these features and is unquestionably a death portrait. Done in his flat style, it is far from being a convincing lively likeness. It may have been done in this flat manner because it cost less if done that way, but the painting was sure to be accepted because it was an important element of the grieving process. In the inevitable sorrow over the loss of a child no parent is likely to quibble over the fine points of perspective and chiaroscuro. After Prior's conversion in 1841 to Millerism, a sect that held that the end of the world would come in April 1843, he said he had the power to see into the spirit world.[60] Prior used this claim to attract commissions for posthumous portraits of children—a ploy that certainly must have appealed to bereaved parents, anxious to reattach themselves to their babies by any means. One might even argue that the flat style was appropriate for such pictures because they were images of spirits and hence beings without substance. Prior's paintings, however, ignored the conventions of posthumous portraits, which required a lifelike presentation. That he found an active market for his services suggests that he could have sold clients any likeness in their moment of deepest grief, so long as it included enough of the correct visual cues.

Beyond the coercion of the moral forces accompanying secular family rituals, the American public consumed plain paintings for less serious reasons as well. The very idea of art was charged with excitement; crowds simply turned out to look at and be in the presence of art. The Art Union of New York held exhibitions between 1839 and 1851 that drew an annual average attendance of over fifty-seven percent of the

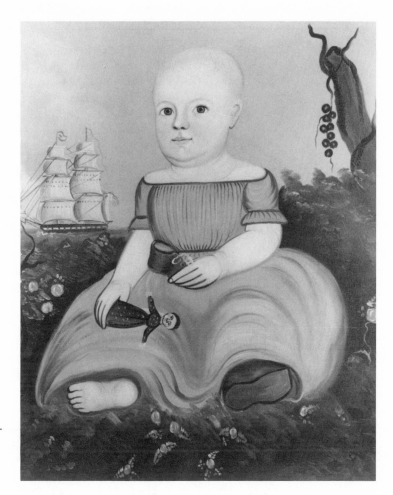

Fig. 46 William Matthew Prior, *Unidentified Child in Red*, ca. 1830–55, oil on canvas, 26¾″ × 21¾″. Museum of American Folk Art, New York; gift of Robert Bishop.

city's population.[61] In 1848 the *Knickerbocker Magazine* noted that the Free Gallery was visited by children, merchants, strangers from the country, gentlemen and fashionable ladies, and working men in "uneasy Sunday coats" accompanied by their families—in short, all people from all classes.[62] This meant that more commoners than members of the social elite found their way to the world of art. It was easy for them to do so, for New York was then "flooded with pictures" and galleries were "crowded from morning until night [with] heterogeneous throngs of people that constantly come and go." Russell Lynes aptly summarizes this throng's behavior:

Old ladies, especially, came to galleries, and though they didn't pay much attention to the paintings, they would sit around the store and look at the catalogue and at each other. Young women came to show off their new clothes, and men who seemed "to have no idea upon art beyond the commercial one" would stand very close to the pictures and occasionally

touch them "as if to test the soundness of the dry goods" on which they were painted.[63]

Looking at paintings was a social event much akin to a parade or a circus. People went for the spectacle and ogled each other as well as the artworks. Some critics lamented that these huge crowds remained naive about art, but importantly, a positive association was developing around the idea of art. Even in rural communities art could create a commotion. Ammi Ruhamah of Norfolk, Connecticut, wrote in 1812 upon the unveiling of a series of his family's portraits, "our [people] come in plenty, day after day as into a Museum."[64] Such curiosity would continue to build throughout the first half of the nineteenth century with touring exhibitions of master paintings, displays of panoramas, and the repeated arrival of itinerants promising correct likenesses for only a little money.

A glamorous reputation often preceded the arrival of a traveling artist despite the warnings of previously duped patrons and the cultural guidance of magazines. Painters with modest skill were likely to be welcomed, particularly after 1850, when pictures were perceived as necessary elements of interior decoration. By then over seventy-five lithography companies were producing cheap prints of all sorts of scenes and subjects. According to Clive Bush, "Traveling salesmen haunted the doorsteps of the housewives with such gems as *No, no Fido, Will he bite?* and *The Highland Boy.*"[65] Works of this sort not only met the popular demand for pictures but also boosted the demand for "original" works as well. By midcentury the art business had developed considerable momentum. At first people needed paintings to flatter themselves; eventually they learned to keep paintings for their own sake, to enjoy their entertainment value.

Rufus Porter's success as a painter may well have owed more to the attractive, entertaining hoopla that announced his arrival than to his paintings. Working with a camera obscura, a large box fitted with lenses which allowed him to trace quickly the major features of his subjects, he astonished crowds with fifteen-minute portraits. He adorned his camera box with bright colors and flags and mounted the contraption on a hand cart. This gallery-on-wheels drew quick attention in the small towns Porter visited on a tour in 1820. In his own account, written in 1884, he claimed he was welcomed in every village.[66] This was no doubt true, for his little rig tricked out in a carnivalesque motif and his sales routine certainly added some spice to the bland routines of the farming towns he visited; moreover, since he only charged a dollar for a likeness, he was sure to attract many customers. With all of these

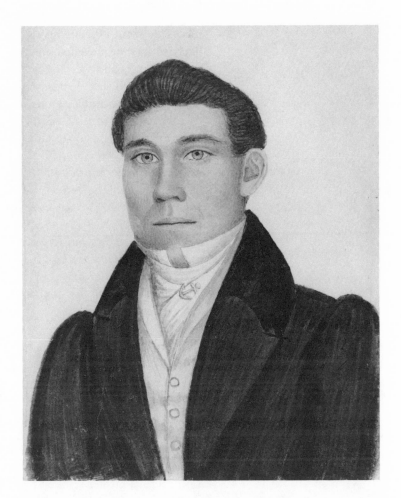

Fig. 47 Rufus Porter, *Portrait of a Man*, ca. 1820, watercolor and ink on paper, 4″ × 3″. Abby Aldrich Rockefeller Folk Art Center, Williamsburg, Virginia.

attractions his clients probably overlooked the meager results that sometimes featured faces shown in three-quarter perspective but with ears shown in profile (fig. 47).

As art became more popular as a commodity it was done more often at home, usually by the young ladies of the household. Consequently the market for run-of-the-mill itinerants declined in some places as professional plain painters were replaced by domestic plain painters. This shift occurred partly in response to the idea that art confers on its makers a reputation for refinement—a highly desirable attribute for young women, making them more attractive as spouses. Svinin noted in 1813, "Already mothers boast of their daughters' talent for drawing and show the products of their brushes to each other. Many Americans of the fair sex even work in oils and declare themselves patronesses of the Arts."[67] A German painter reaching Cincinnati in 1825 soon learned that there was no market for his skills: "I found a lady artist in every Family."[68] Twain's descriptions of Mississippi Valley homes also mention the prominent place of schoolgirl exercises in middle-class par-

lors. This work less often consisted of portraits and was more likely to include stenciled bowls of fruit and mourning pictures featuring urns and weeping willows. The more ambitious occasionally tried their hands at allegories or landscapes but rarely with memorable results. In *Little Women*, Louisa May Alcott vividly describes, via the efforts of her character Amy, what many earnest young ladies achieved:

An artist friend outfitted her [Amy] with cast-off palettes, brushes, and colors; and she daubed away, producing pastoral and marine views such as were never seen on land or sea. Her monstrosities in the way of cattle would never have taken prizes at an agricultural fair; and the perilous pitching of her vessels would have produced seasickness in the most nautical observer if the utter disregard to all known rules of shipbuilding and rigging had not convulsed him with laughter at the first glance.[69]

These schoolgirl projects did change the looks of many American interiors. Instances of this transformation are provided by John L. Krimmel, a German painter who resided in Philadelphia in the 1820s. Two highly detailed paintings, *Departure for Boarding School* (fig. 48) and *Return from Boarding School* (fig. 49), are replete with information on the artistic habits of early-nineteenth-century social climbers, the prime consumers of plain paintings. The first painting depicts a prosperous farmer sending his daughter off to be "finished." Over the parlor mantel is a framed biblical scene, perhaps *The Temptation of Adam and Eve*, and two unframed prints of animals. Near the fireplace also hang a framed house blessing and an unframed print of a prize bull, perhaps a page from an almanac. In the second painting the same room has a new set of pictures, presumably done by the daughter while at school. Now over the mantel there hangs a large painting of a young woman in pastoral reverie. The scene is placed in a horizontal oval within a heavy rectangular frame. This picture is flanked by two sketches of heads, apparently copies from prints. The daughter holds a cameo miniature in her hand, and at her foot is an open sketch book with pictures of flowers and rural buildings. Since Krimmel for a time taught art classes to young women, we can take the pictures he places in his painting as accurate representations of the sort of works young ladies actually created. Other new accoutrements in the house, including a piano, a large mirror, a peacock feather, a porcelain basket, a memorial obelisk, and a carpet, are grouped near the young woman, suggesting that she is now suitably fashionable. Krimmel, however, indicates that all is not well:

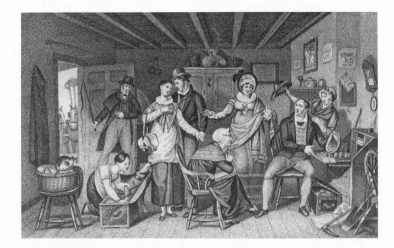

Fig. 48 John Lewis Krimmel, *Departure for Boarding School*, 1820. Lithograph appearing in *The Analectist*. Courtesy of the New-York Historical Society, New York.

Fig. 49 John Lewis Krimmel, *Return from Boarding School*, 1820. Lithograph appearing in *The Analectist*. Courtesy of the New-York Historical Society, New York.

the anguished father holds a "bill of tuition" in his hand, a sharp contrast with the bag of coins he held in the first painting.

The artist thus raises a question concerning the benefits of finishing schools and female seminaries. In their rush to be fashionable, some families no doubt sent their girls to high-priced schools and in return found themselves short of funds and stuck with a daughter with whom they could no longer communicate. Yet art education for young women remained popular, and their works decorated American homes well past the middle of the nineteenth century. Moreover, the most popular ladies' guide of the nineteenth century, Frances Byerly Parke's *Domestic Duties* (already in its tenth printing by 1846), advocated drawing as an appropriate "morning activity" for women of taste.[70] Even if training proved costly, the status associated with artistic ability remained desirable and was ample cause to spend one's money extravagantly.

We can now see that there were plenty of reasons for the

ordinary citizen of the Jacksonian era to accept plain paintings. They were after all often common pictures delivered to their doorsteps. However, the widespread acceptance of plain painting was connected to matters much more complex than the simple path of least resistance. Most histories characterize the period roughly from 1830 to 1850 as a time of the prominence of the ordinary citizen, as an age of egalitarianism. Ironically, what the supposedly egalitarian, democratic art of the populace actually demonstrates is competition for position and the reinforcement of strict class boundaries. So powerful was the general desire for advancement through acquisition of property that art became one of the prime means of brokering one's movement in society. Any artwork, fine or plain, simply by being in the category of art, possessed sufficient charm to flatter the ego of its owner. For this reason unsophisticated and awkward portraits could be willingly accepted. They may not have looked like fine art, but they worked like it: they seemed to allow entry into a world of prestigious consumer goods. Plain paintings were indeed elements of family ritual, but more significant was their promise of personal advancement in the realm of taste and fashion. Plain painters constantly emphasized the matter of status in their advertisements. William Matthew Prior offered works "in a very tasty style"; R. B. Crafft promised portraits "in a superior style"; Ezra Ames vowed, early in his career, to work "in the best manner."[71] Usually customers were referred to as gentlemen and ladies. This was a time when, as Dickens noted, Americans had a predilection for high-toned language: working girls earned *compensation*, not wages; household cats might be called *quadruped members of our establishment*; and women could happily name their sons Altamount.[72] Plain painters and the paintings themselves employed the rhetoric of advancement, but in fact the consumers of those paintings were held in place, victims of a deception that they were getting better.

Between 1825 and 1850 the highest echelon of society tightened its control over the United States. By midcentury one percent of the population controlled close to fifty percent of the nation's wealth. This increase, up from twenty-five percent, was generally at the expense of the middle classes who were severely affected by the disastrous economic depressions in the 1830s.[73] The statistics are exceedingly dreary: in 1850, when the mean value of individual real estate holdings was $1,001, seventy-eight percent of the population was below the mean.[74] Fifty percent of the white males in America in 1850 owned no land, and one man out of every three had only his clothes and a small amount of petty cash.[75] For most Americans, close to seventeen million, the age of Jackson was an age

of ruin, a period during which the basis for middle-class status evaporated while political orators provided a constant flow of smooth and reassuring promises. Plain paintings were drawn into this process of appeasement because they provided images of success in an era of crisis, thereby serving as extensions of the propaganda about general well-being. Plain paintings became, in the end, devices of social control: in satisfying their owners' perceived needs for luxurious property, they deflected potential criticism away from the elite group determined to keep the common people under their command. Therefore, we should read in these pictures not the celebration but the desperation of the common person.

Edward Pessen has written, "An expanding capitalistic society everywhere dips into the less privileged strata to provide some of the manpower it requires for entrepreneurial leadership."[76] A few may advance, but most stay put where they are or actually fall to a lower status. The grandeur that accompanied ownership of a plain portrait served mainly to anchor the middle class more firmly in a subordinate position. This group regarded their pictures, particularly their portraits, as images that saluted their industrious habits, aggressive thrift, and new aesthetic discernment. However, these paintings were actually failed works of art that reinforced the hegemony of the old-money elite—cultural as well as political. As long as ordinary people consumed plain paintings, they were liable to be lampooned and mocked for their "bad" taste. Plain painting thus had little to do with the maintenance of folk tradition or identity.[77] This art derived from high culture and was used in the hope of identifying with the social elite.

The academic roots of plain painting can be best shown by considering the paintings of Ammi Phillips, trumpeted as the greatest American folk master (his paintings have recently drawn bids of over a million dollars at auction). The acknowledged sources of his style are J. Brown, who painted portraits of several Massachusetts families, and Ezra Ames of Albany, New York.[78] Yet Brown's style derives from the work of Ralph Earl, a student of West, and hence ultimately from the Royal Academy. Ames may have observed Stuart at work in person in 1793, and he later copied a number of Stuart's portraits.[79] Thus he acquired a studio manner that again is traceable to British conventions although much tempered by Stuart's own genius. It was no fluke of chance that Ames chose to imitate the work of Stuart or that Phillips selected Ames's paintings as a way to learn Stuart's style. Stuart was the most celebrated American portraitist during the first quarter of the nineteenth century. John Neal wrote of him in 1824, "he is old now, but unquestionably at the head of American painters. In fact, they

Fig. 50 Gilbert Stuart, *John Adams*, 1825, oil on canvas, 26" × 23⅜". National Gallery of Art, Washington, D.C.; Ailsa Mellon Bruce Fund.

all bow to his opinion as authority. Some notion of his pro-digious power may be gained from this fact."[80] What one finds, then, in Phillips's paintings is a very diluted version of Stuart's vision. The old master, anticipating by decades the Impressionist mode, had the ability to capture the personality of his sitters with a flurry of messy brush strokes. He concen-trated on faces, roughed in the clothing and props, and left his backgrounds blank (fig. 50). He strove to catch expression be-cause, he counseled, "when a general expression prevails, 'tis of singular service in producing pleasing emotion."[81] When Phillips set himself to this same task he was capable only of hard-edge images flattened against monochromatic back-grounds (fig. 51). He gave a good deal of attention to faces and rendered costume along simple lines as did Stuart, but Phillips's clients got far less than a Stuart even though their pictures had Stuart's conventions.

Phillips had the good fortune to be working when two fashions conspired in his favor. First, Stuart's "impressionis-

Fig. 51 Ammi Phillips, *Mr. Day*, ca. 1835, oil on canvas, 32⅝″ × 28″. National Gallery of Art, Washington, D.C.; Gift of Edgar William and Bernice Chrysler Garbisch.

tic" style was in vogue allowing both artists and audiences some latitude in interpretation. It was lucky for Phillips that in Stuart's mode of painting realism was not demanded.[82] Second, the general public was eager for likenesses, however approximate; a painter could then get by with less than masterly skills. Thus in the court of public taste Phillips's portraits were acceptable, even fashionable in contexts such as Alexander Thompson's Orange County parlor (figs. 42,43). Painted to serve the public's desire for the new and the stylish, his pictures should be interpreted as approximations of a mode that was beyond his ability.

In summary, it is appropriate to rethink the claim that the first half of the nineteenth century saw the flowering of American folk art. As an image of a lone individual manifesting a strong sense of ego, a personal likeness hardly expresses communal folk concerns. Rather, a portrait demonstrates a desire for personal advancement and has long been considered a signal of achievement and social status. It is not only a symbol of social hierarchy but also an instrument by which art patrons

elevate themselves above others. Plain paintings thus signal the slackening of communal allegiance, yet the prevailing interpretation is that they reflect a unifying national heritage.

Rather than admit that the rapid growth of plain painting in the United States represented the pursuit of change, folk art collectors have preferred to read these works as evidence of a stable, conflict-free past. Faces rendered with bold outlines, bright color, and little attention to the shading that would indicate a three-dimensional presence have been seen as symbols of a simpler era. The America of these portraits suggests honest rural virtue in place of contemporary urban corruption, innocence in place of sophistication, handmade uniqueness in place of machine-made repetition. In short, the America of these paintings is a peaceful, idyllic place, a romantic escape from the discontents of modern civilization.

The main problem with such an interpretation is that it suggests a false context for plain painting. Kenneth L. Ames has written, "Folk art enthusiasts have created a communal fantasy world that distorts the integrity of both the objects and people originally associated with them."[83] If this is so, then plain painting will be correctly understood only if we can reconnect these pictures to their appropriate original contexts, and if we search out the meanings and associations they held for the people who first created and used them.

Spanning the four centuries of American art history, the following four chapters present biographical vignettes of painters who are all celebrities in the folk art canon. The literature on folk painting has concentrated more on artworks than on artists, so the meaning of these paintings is more often attributed than discovered. Although focusing on only four artists may obscure much of the saga of plain painting, in-depth examination of this kind provides the original context, values, meanings, and functions of plain painting.

The Seventeenth Century: The Freake Limner

In 1913 two seventeenth-century portraits were put before the public at the Worcester Museum in Massachusetts. Twenty-one years later they inspired a full-scale exhibition and catalogue by Louisa Dresser entitled *Seventeenth-Century Painting in New England.*[1] These pictures of John and Elizabeth Freake (figs. 52, 53) were judged to be the outstanding examples of Puritan portraiture. During the two decades that passed between the discovery of these paintings and their subsequent investigation another significant development had occurred in the art world: folk art fever struck the Northeast.[2] The first cases were reported along the coast of Maine and soon the delirium spread as far west as New York City. One of the prime carriers of this enthusiasm was Holger Cahill, who organized three major folk art exhibitions between 1929 and 1932.[3] By the time Dresser penned her authoritative com-

Left: **Fig. 52** Freake Limner, *John Freake*, 1671, oil on canvas, 42½″ × 36¾″. Worcester Art Museum, Worcester, Massachusetts. *Right:* **Fig. 53** Freake Limner, *Mrs. Elizabeth Freake and Baby Mary*, 1674, oil on canvas, 42½″ × 36¾″. Worcester Art Museum, Worcester, Massachusetts.

ments, folk art fever evidently had heated the air in
Massachusetts. She observed that the two-dimensional render-
ings produced by New England artists late in the seventeenth
century were similar to the nineteenth-century portraits Cahill
had recently asserted to be the representative genre of Ameri-
can folk art. At least both sets of paintings shared a lack of
depth and hence were, for the most part, flat outlines of their
subjects. Dresser went so far as to suggest that the works
Cahill selected from the nineteenth century derived from those
of early Boston, that anonymous artists like the Freake limner
had laid the foundation for the new-found American tradition
of folk painting.[4]

This notion has proved to be very attractive to commen-
tators on folk painting. Whenever a broad historical survey
of the genre is mounted the first examples are always from
seventeenth-century New England, and the "Puritan
Madonna," Mrs. Freake, is most frequently used as an
illustration.[5] The linkage between Puritan portraiture and sub-
sequent popular painting in New England is never questioned
or explained; it is simply asserted that later two-dimensional
images must derive from earlier ones. In fact, there is no con-
nection between these sets of pictures. Their resemblances are
only incidental and fortuitous.

Very few works from seventeenth-century New England
survive today. Indeed, there may have been very few paintings
to begin with. Yet among those canvases that remain, one

Left: **Fig. 54** Freake Limner, *Robert Gibbs*, 1670, oil on canvas, 40″ × 33″. Courtesy, Museum of Fine Arts, Boston, Massachusetts; Gift of Maxim Karolik to the M. and M. Karolik Collection of American Paintings, 1815–1865. *Middle:* **Fig. 55** Freake Limner, *Margaret Gibbs*, 1670, oil on canvas, 40″ × 33″. Private collection. Photo: Courtesy of the Museum of Fine Arts, Boston, Massachusetts. *Right:* **Fig. 56** Freake Limner, *Henry Gibbs*, 1670, oil on canvas, 40″ × 33″. Private collection. Photo: Courtesy of the Museum of Fine Arts, Boston, Massachusetts.

group seems to be by one hand. The portraits ascribed to the Freake limner were painted in the 1670s, presumably in Boston. These include not only the likenesses of John Freake and his wife and child but also three portraits of the Gibbs children (figs. 54–56). Another set of pictures, depicting the Mason children, closely resembles the Gibbs portraits, but most scholars agree that they are by a different artist who was familiar with the style and technique of the Freake limner. The painter of Edward Rawson and his daughter Rebecca also seems to have known the Freake limner's work.[6] The painter of the Freakes and Gibbses depicted his subjects in a consistent manner that emphasized overall patterns of design and color at the expense of a convincing three-dimensionality. Dresser writes of the Freake limner:

His conception was decidedly two-dimensional but he knew instinctively how to place a figure on the canvas and how to make telling use of brilliant, decorative, local color. He had no idea of having his figures exist in space. In his portrait of Mrs. Freake and Baby Mary a chair is shown and it may be assumed that Mrs. Freake is seated on it but her knees seem no nearer the spectator than the rest of her body and the baby on her lap has no more volume than a paper doll. In fact, both figures might have been cut out of paper, so distinctive are their outlines against the dark background, and this same flat quality is evident in the other paintings of the group.[7]

The flatness of the Freake limner's composition yields an image Alexander Eliot has called a "stylized map of a sitter," a likeness with little lifelikeness. Yet such a portrait has an attractive appeal. Eliot himself notes that the painting of Margaret Gibbs is "superb." Her figure dominates the picture effortlessly, he says, as "she stands quiet and assured, with soft gestures and thinking eyes."[8] Oliver Larkin similarly praises the work of the Freake limner, observing of the three portraits of the Gibbs children that they were posed with dignity, were drawn with clarity, possessed a fragile charm, and were rendered in lively color.[9] It should be apparent, then, that the flatness of the Freake limner's work is not a shortcoming or a fault. He was a sure-handed and adept painter, fully in control of his abilities, who achieved the effect he desired.

The two portraits for which the Freake limner is best known not only demonstrate his technique but also provide insights regarding the nature of New England life. While many people have imagined the Pilgrim fathers and mothers as a stern, art-denying group, the existence of such refined and delicately conceived pictures as those painted by the Freake limner challenges such an assessment. It is a matter of record that some Puritan leaders declined to have their likenesses captured on canvas. Cotton Mather wrote that John Wilson, a noted preacher, refused repeatedly to sit for a portrait, crying out " 'What! Such a Poor, Vile creature as I am! Shall my picture be drawn? I say, No; it never shall'—no Importunity could ever obtain it from him."[10] The Freakes, however, were not afflicted with such modesty, as is evident from both the existence and the content of their portraits. The Freakes were quite wealthy; John Freake was an attorney as well as a merchant. His estate including six ships, a brew house, and two homes was listed as worth £2,391 at the time of his death in 1675.[11] In his portrait (fig. 52) he is wearing a large brown coat decorated with silver buttons, and the buttonholes are edged with braid. The plain color of the coat serves as an excellent background to show off his exquisite lace collar, believed to be the "Spanish" type of Venetian needlepoint. Freake holds in his right hand the gloves of a gentleman. His high social rank is further underscored by a gold ring and a pendant which he fingers with his left hand. Rendered in silver tones, Mr. Freake stands out assuredly from the dark background of the canvas, a model figure of success. He is rendered as a man whose life embodied the Puritan belief in earthly reward for righteous moral behavior.[12]

The companion portrait of Mrs. Freake and Baby Mary also provides visual proof that the Freakes lived what their peers considered "the good life." Mrs. Freake sits upon a

chair upholstered with "turkeywork," elaborate woven designs imitating Turkish carpets. Such a finely appointed piece of furniture strongly indicates the high station of its owners, and the Freakes are known to have owned twelve turkeywork chairs.[13] Mrs. Freake is also richly attired in a dress of green moire or taffeta that features a large lace collar and puffed sleeves decorated with red and black ribbons. She also wears a sheer white Holland hood and a lawn apron. To make sure the viewer knows that Mrs. Freake is wealthy, her hem is raised to reveal a red underskirt edged with delicate white and gold embroidery. Like her husband, she wears various items of jewelry: a ring on her thumb, four strands of black beads on her wrist, and two strands of pearls around her neck. The child in her lap is also elaborately dressed: she wears a dress of the same design and type of cloth, except it is lemon yellow; the lace on her cap and collar is of a simpler design than that in her mother's costume. The limner, however, has not made Mrs. Freake seem proud and confident. She is presented as a Puritan heroine by focusing on her maternal role. Larkin notes that while her face appears not to be correctly drawn, it is "drawn with expressive tenderness."[14] Abraham A. Davidson further observes, "The mother is holding the child lightly yet securely. She looks absently away from Baby Mary toward the spectator, and in her expression there is the slightest shade of resentment at the invasion of their privacy. . . . The group is comfortably situated in the ample space of the canvas. Infant and mother are together, and their world is complete. The relationship is one of protective love."[15] One might conclude that good wife Elizabeth Freake is shown tending to her proper social role. The fancy clothes and furnishings, then, signal the just deserts of satisfactorily performing one's expected duties.

The Freake limner was not merely struggling, as some have alleged, to capture a correct, realistic likeness. This unknown painter had a definite ideal in mind as he went about his work. Matthew Baigell has written of the New England limners of the seventeenth century that they were "gifted and competent artists, who although working in an old-fashioned tradition, were able to indicate fine detail with clarity and precision and who seem to have understood the limitations of their style and ability quite thoroughly."[16] The quality of their work serves as perhaps the strongest denial of charges that limners were only sign painters who were engaged to paint portraits and then found themselves working beyond their abilities. The flatness of the limners' images, their use of broad areas of color, and their excessive attention to secondary elements do not derive from the fact that they may occasionally have painted houses or signboards. A contrasting example that

Fig. 57 John Foster, *John Davenport*, 1670, oil on canvas, 27⅛" × 23". Yale University Art Gallery, New Haven, Connecticut.

Fig. 58 Nicholas Hilliard, *Elizabeth I*, ca. 1575, oil on canvas. National Museums and Galleries on Merseyside, Walker Art Gallery, Liverpool, England.

is considerably less expressive, even crude and amateurish, is the portrait of John Davenport (fig. 57), whose painter is thought to be John Foster of Dorchester, Massachusetts, a noted Puritan printer.[17] Alan Burroughs found his brush work messy and repetitious, his technique rough, and his hand erratic. Overall, he claimed, the painting of Davenport presents a "naive brand of artistry."[18] The painter of this portrait clearly lacked the expertise to paint a reasonable likeness, but the Freake limner presents another situation altogether. He was a professional painter who placed on his canvases the images he wanted.

Art historians often attribute the manner of limner paintings to an older English style of painting that was common in the court of Elizabeth I. The late Tudor tradition of portraiture featured a flat, decorative treatment of the sitter, who looked less like a person and more like an outline of a person—what Roy Strong has called an "English icon."[19] These paintings were conceived more as an effort to reinforce a social regime than an attempt to capture creatively the image of a person. According to Lucy Baldwin Smith, the intent of this

92

Fig. 59 Unknown artist, *Jane, first wife of John Tradescant the Younger*, ca. 1645, oil on canvas, 24″ × 28″. The Ashmolean Museum, Oxford.

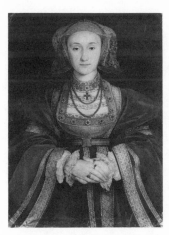

Fig. 60 Hans Holbein, *Anne of Cleves*, 1539, oil on canvas. Musée du Louvre, Paris, France.

kind of painting was to "immortalize heroism rather than depict the hero, whose individual face was largely irrelevant." She adds that this didactic mission caused "Tudor portraits [to] bear about as much resemblance to their subjects as elephants to prunes which at least have their wrinkled skins in common."[20] The lack of verisimilitude did not necessarily make Tudor paintings ugly, although it would certainly be safe to characterize them as austere and stern. A number of canvases of the 1560s are, in Strong's estimation, "pretty portraits of ladies wearing gowns of velvet and embroidered gauze festooned with jeweled chains."[21] Such works (fig. 58) seem to be the direct historical antecedents of the Freake limner's portraits of Mrs. Freake and the Gibbs children.

When bearers of the Tudor aesthetic reached the shores of New England the limner technique was still in vogue in many parts of England, even though realism came back into favor in the court after 1632 with the advent of Van Dyck. As late as the last quarter of the seventeenth century Elizabethan portraits were being commissioned by the guild halls of London and elsewhere in rural areas.[22] The strong resemblance between the English portrait of Jane, first wife of John Tradescant the Younger (ca. 1645, fig. 59), and Mrs. Freake suggests that the Freake limner may have been trained to paint such likenesses in England before migrating to Boston.[23]

The Elizabethan mode of painting derives from the sixteenth century's rekindling of affection for the Gothic age. Holbein signaled the onset of this trend in a number of paintings, especially his portrait of Anne of Cleves (fig. 60) done in 1539. A sequence of artists copied much of the style of Holbein's last phase, leading to the emergence in 1572 of Nicholas Hilliard's bright, two-dimensional, flower-colored images of royalty (fig. 58). His neomedieval paintings were consistent with the court's preference for spiky Gothic dress, great castles, costumed jousts, and chivalric romances. The whole ensemble of artistic expressions was designed to "glorify an ageing Queen."[24] The Gothicism of Elizabethan portraits thus was an element of fantasy reflecting courtly tastes, not a national tradition.

Once we recognize that New England portraits functioned as markers of status, we can see that their painters did not shun realism but instead transformed realism into materialism. In the place of accurate physiognomy they substituted an idealized visage and a faithful record of personal possessions. This "cataloguing care," as Eliot terms it, stems not from any attempt to avoid the real world or an inability to capture it on canvas but from trying so hard to do so.[25] Rather than hiding some part of a sitter's riches in shadow, the limner preferred

to show every embellishing thread, every silver button, every facet of a jewel, every fold of satin. The resulting brightness of colors and lack of shadowing has made these portraits appear primitive in their lack of visual depth. But this two-dimensionality results, as Hagen notes, not from "plane-boundedness" but from "plane-consciousness," that is, not from an inability to depict depth but from a preference to highlight surface.[26] Limner portraits do not, then, fail to capture reality; they emphasize reality according to their sitters' preference. The Freake limner, using what was essentially a miniaturist's technique, carefully controlled his brushstrokes to create smooth, even edges where his colors met. He provided only the slightest hint of shadow, following the practice of the court painter Hilliard, who suggested that a sitter be presented as if in open sunlight. Mr. Freake casts a casual sideways glance and Mrs. Freake looks away from her child for a brief moment, honoring Hilliard's recommendation that painters should capture "those stolen glances which suddenly like lightning pass and another countenance taketh place."[27] The paintings of the Freake limner achieve a good deal of corporeality, but not in the way we might expect. Instead of creating a sense of depth, the painter brings the sitter forward from the canvas by giving bright, lustrous accents to those elements of the subject that naturally project forward, such as the nose and chin. The end results are these splendid portraits, which have inspired one art historian to rank the Freake limner with the most sensitive designers and colorists of fourteenth-century France and fifteenth-century England.[28]

The positive qualities of the Freake limner's works stem from his professionalism rather than his status as an amateur artisan, as he is often portrayed.[29] E. P. Richardson observed in his portraits an "instinctive sense of elegance, sweetness of sentiment, graceful elaboration of lineal pattern, fastidious delicacy in the harmonies of the flat color areas" and concluded, "these are no small virtues."[30] Indeed, these virtues are the basis for recognizing the Freake limner's connections to academic practice. While early New England artists had some "hesitancy to taste the real flesh of painting," certainly the Freake limner had eaten his fill at the banquet table of the academy.[31] Barbara Novak has written that limner work displayed "the intent to learn, to divine the mystery of academic formulae that more closely approximated the appearance of reality."[32]

The very fact that Puritans regarded art with what John McCoubrey calls a "covert affection" signaled the potential for increased appreciation. When creativity is stimulated by patronage and new information the boundaries of art are

Fig. 61 Thomas Smith, *Self-Portrait*, ca. 1691, oil on canvas, 24″ × 23¾″. Worcester Art Museum, Worcester, Massachusetts.

likely to expand, and covert affection can be transformed into overt enthusiasm. This enthusiasm registered in New England by a shift in painting style in the late seventeenth century. As early as 1679, paintings that used baroque techniques for capturing a three-dimensional environment appeared in Boston.[33] Presenting solid bodies in real rooms, artists began to explore a novel approach to painting that concentrated on the personality of the sitter rather than his or her belongings. Yet these paintings were not completely novel. Thomas Smith's self-portrait (fig. 61), for example, is essentially an updated version of the *memento mori* theme common in Tudor England and well-known in New England funerary traditions.[34] The skull upon which Smith rests his hand more closely resembles the death's heads found on New England gravestones than an actual skeleton skull. Thus even as remarkable progressive changes were occurring, older attitudes were preserved and earlier functions were maintained. But while artists such as Thomas Smith, who were working in an early Georgian mode, moved toward the iconic limner format, artists like the Freake limner were "groping toward illusionism . . . impelled to produce more accurately what they see."[35] This was first recognized by Oskar Hagen, who noted that the limner portrait of *Mrs. Freake and Baby Mary* and the mannerist treatment of *Mrs. Martha Patteshall and child* (1679)[36] had

Fig. 62 David Findley, Line drawings of *John Freake*. Courtesy of Worcester Art Museum *Journal*.

much in common. He found them equally rectilinear, angular, and rigid, even though the Freake picture was claimed as English in origin and the Patteshall portrait was considered to stem from a Dutch tradition.[37] The two paintings did stem from different styles, but in the context of late-seventeenth-century Boston these styles were more likely to merge than to remain distinct.

Striking evidence of a shift from linear treatment to more realistic portrayal is embedded in the Freake portraits: x-rays of these canvases show that they were extensively repainted around 1674.[38] Comparison of the portraits that lay below the later layers of paint with what is now visible reveals that the Freake limner consciously sought to improve his compositions. Apparently dissatisfied with his first efforts, his sitters requested that he make a number of slight but significant adjustments. The earlier version of Mr. Freake (fig. 62) showed him with his hair falling behind his shoulders and with a glove clutched in each hand. In the repainted version the two gloves are held in the right hand while the left now toys with a marvelously jeweled pendant hanging from his neck. A ring appears on the last finger of the left hand, and the shift of that hand upward and the removal of the previous glove has allowed or required the painter to add nine more silver buttons and braided buttonholes to the coat. These modifications present a wealthier John Freake—showing more of his riches—and a more plausible likeness as well. The earlier portrait of a man with a glove in each hand strikes one as stiff and rigid, an unflattering way to memorialize a gentleman. It made more of

Mr. Freake's gloves than was called for, even though the inventory of his estate shows that he owned ten pairs. The second version presents Freake more at ease and in command of his affairs. The left hand, now tilted upwards, directs the viewer to focus on Freake's face, which also was modified. The eyes have been lowered three-eighths of an inch, the face broadened, and the collar lowered, making the line of the chin more pronounced. The hair is combed more forward so that it falls, slightly curly, over his forehead. While it is possible that Freake changed his hair style between the painting of the first and second pictures, it is more likely that the less severe rendering aimed to capture the personality of the sitter. The new hair style is more realistic, and its wavy lines add action to the portrait near the face and help to hold one's vision there, as do the lines of the coat, collar, and left forearm. These changes affected all areas of the canvas and resulted in a portrait with a substantially different feeling.

Changes in the portrait of Mrs. Freake are even more striking, for in the artist's repainting of this portrait he adds the figure of Baby Mary. This revision is important, but the other modifications also are telling. The 1671 version of Mrs. Freake (fig. 63) presented her in a rather stiff manner analogous to the first posture of her husband. She was seated with her hands crossed on her lap while holding a fan in her right hand. The severity of her attitude was mirrored in her costume, which was a study in lines and angles. Her collar jutted out beyond her shoulders and a doublepointed neckerchief plunged down over it, reaching to her waist. The sleeves of her

Fig. 63 Carol Greger, Line drawings of *Mrs. Elizabeth Freake and Baby Mary.* Courtesy of Worcester Art Museum *Journal.*

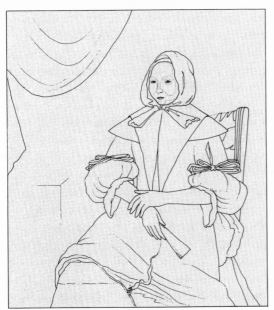
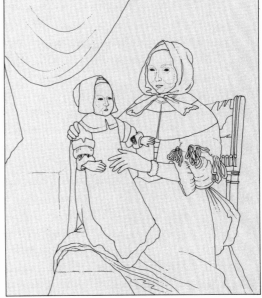

97

dress puffed out into enormous billows that extended below to the elbows and were tied with gravity-defying bows. The realism the Freake limner was searching for in 1764 is seen principally in the changes he makes to Mrs. Freake's costume. The collar becomes more rounded, following the curve of her shoulders. The neckerchief is removed and the dress is given a laced bodice. This alteration not only improves the lines of her costume but also reveals more of her neck, now graced with two strands of pearls. Such alterations were intended to display more of the Freakes' wealth, as is further underscored by the addition of a ring and a bracelet to her left hand and wrist. Also important is that the color of her dress is changed from black to light green, brightening the portrait considerably.[39] These changes convey a greater sense of realism, emphasizing an actual body rather than a vague form hidden under yards of cloth. The desire to create a convincing illusion of reality is shown especially in the new treatment of the sleeves of the dress, which are reduced in size and given bows that hang as gravity dictates. However, the importance of documenting the sitter's wealth was never far from the Freake limner's consciousness—in adjusting the sleeve, he shows more of the turkeywork chair in which Mrs. Freake is sitting.

The most important change is, of course, the addition of the child believed to be the Freakes' daughter Mary, born in 1674, although it is possible that the child is an older daughter named Mehetable. In any case, the baby was painted in several ways when she was added to the portrait. Placed to the left of Mrs. Freake in the generally open portion of the picture, she stands in Mrs. Freake's lap. Mrs. Freake's right hand is now raised behind the child to support her, and her fingers firmly hold the child's right shoulder. The limner then experimented with several positions for the baby's arms. First, she had both arms in front of her and seemed to clutch something in her hand. Finally her left arm was raised to reach back toward her mother, counterpointing the left arm of Mrs. Freake, which reaches for the child. This final set of gestures helps to tie the two figures together and integrates the new figure convincingly into the painting. So successful is the new arrangement that without the benefit of x-ray machines the series of changes and adjustments could hardly be guessed. In the end, the limner showed a woman of fortunate circumstances and an attentive mother. Clearly he thought carefully about how he might convey this attitude and he arranged his sitters accordingly. While his paintings were still iconic in feeling, the Freake limner was working deliberately to make them more realistic. His choices of a diagonal format and of a

draped interior in the portrait of Mrs. Freake indicate that he was aware of the newer realistic style.

Other features of the Freake limner's technique can best be accounted for by hypothesizing that he knew something of Renaissance concepts of painting. For example, his treatment of countenances, often praised for their "delicate and refined" flesh tones, probably derives from the instructions printed in a number of books on art.[40] John Bates's *The Mysteries of Nature and Art* (1653) instructs the would-be painter on how to render substance: "to round a work [it] cannot be without some shadows, but to shadow as if it were not shadowed, is best of all."[41] The Freake limner seems to have heeded this advice. He provides luminous shadows that cause his sitters' faces to give off an almost beatific glow while at the same time he manages to delineate the planes of the cheekbones, forehead, nose, and chin. He provides, in effect, shadow that is not really shadow. This notion, current in England at the time the Freake limner must have been an apprentice, can be traced back through the writings of Hilliard (1598) to Giovanni Paolo Lomazzo's *Trattato della Pittura* (1584).[42] Although the Freake limner may have understood this technique as a feature of English painting, it was grounded in Italian artistic philosophy. Furthermore, the pyramidal composition clearly seen in the portrait of Mr. Freake might be interpreted as the characteristic known as *contrapposto* and may derive ultimately from the advice of Michelangelo, who suggested that figures be drawn in a pyramidal composition and given a serpentine motion. One can trace such movement in Mr. Freake by following a line from his left shoulder down to the elbow of his left arm, then up the forearm to the right shoulder, back down to the right elbow and across the body following the downward slant of the right forearm. The first painting of Mrs. Freake was equally pyramidal, but the pattern of its composition became more rectilinear when the child was added and the position of Mrs. Freake's arms and costume was changed. Close measurement of the portrait of Mrs. Freake by Jonathan Fairbanks has revealed that her overall height if standing would be approximately eight facial lengths, a height that is average by today's standards but monumental in the seventeenth century.[43] Mrs. Freake may have been a tall woman, but it is more likely that she was depicted as a tall person to underscore her social rank. Again there is ample precedent for this concept in Italian mannerist painting, which stressed grand, dramatic gesture.[44]

A convincing illusion of three dimensions, of real space, was a signal feature of fashionable art in the late seventeenth

century. This characteristic depends on understanding the principles of perspective: things far away appear smaller while closer things appear larger, and objects in the background are higher or lower in the field of vision depending on the position of the viewer. When painting a face that is turned three-quarters to the artist, the near eye should be larger than the far one. The far eye should also be higher if the artist is looking up at the sitter but lower if looking down. The Freake limner knew something of these rules, for he does vary the level of the eyes for his sitters, but he presents them both at the same size. Consequently there is simultaneously three-quarter and frontal appearance or perspective without perspective, a condition that may indicate the painter's mixed sources of influence: old English neomedieval icons and new Georgian paintings.

The same combination is seen in his pictures of the Gibbs children (figs. 54-56). In these paintings a sense of depth is achieved by creating a checkerboard floor with tiles that diminish in size as they recede from the viewer. The lines of the tiles, if carried back from the viewer, converge a few inches above the heads of the figures and thus focus attention on the children's faces. Indeed this seems to be why they have been used, since no other element of these paintings shares the same lines of perspective. The figures stand parallel to the plane of the canvas even though they are turned three-quarters to the viewer. They are two-dimensional in a three-dimensional setting. Eliot has said of Margaret Gibbs's portrait, "Her body looks no thicker than a dress on a clothes hanger."[45] The Gibbs children are all composed in the same pyramidal manner as the Freakes, an arrangement that draws attention to the head and face. Diagonal gestures are then created within the triangular outline by the positions of the arms. The zig-zag lines that cross the bodies are complemented by the lines and angles of the floor. In these ways the Freake limner used perspective to reinforce composition rather than to establish visual depth.

The complex techniques the Freake limner employed in painting with oils reveal that professionalism undergirded his practice. Layers of pigment were built up, the semiopaque over or next to the semitranslucent. Understanding the mysteries of color, he laid down first a shadowy but luminous background and made faces, hands, and clothing emerge by pulling them forward with light pigments. Fairbanks summarizes how this technique was put into practice:

By increasing the proportion of white mixed with yellow, red, and green for the fleshtones, the artist was able to achieve a

more opaque tint. The pigment's ability to cover underneath layers was essential for "pulling" forward the most projecting features of the face and figure. Impasto areas were built up on the most forward features of composition. Mixtures of light-colored opaque pigments, like vermilion and white, yielded the warm-tinted whites used to highlight fleshtones. Semi-translucent and darker pigments . . . were customarily glazed over or mixed with white or brownish white tints. The receding borders were formed with glazes blended by a fan-shaped brush made of badger hair.[46]

The intricacies of the interaction of pigment, solvent, resin, and varnish as well as the specialized brush techniques found in New England oil paintings require a level of competence that far surpasses the knowledge of amateurs. Moreover, one cannot know all that is required to paint in oil if one is only self-taught. The very pigments applied to New England canvases indicate full awareness of the studio practices of Europe. The combination of yellow, red, and green found in the portrait of Mrs. Freake and Baby Mary is consistent with the color system of mannerist painting. Fairbanks concludes of the New England limner's colors that they were "professional colors of the same composition as those used in Europe; there is no indication of provinciality in the materials analyzed."[47]

The claim that the work of New England limners represents a form of folk art has no basis. Their connections to the high style of Elizabethan England cannot be denied, nor can the Freake limner's efforts to portray sitters in a realistic manner. The claim for folk qualities in these works generally is based on the most superficial of comparisons. A casual look at the works of the Freake limner registers a bright, flat, two-dimensional image, regarded as the hallmark of either primitive or Abstract Expressionist painting. Since seventeenth-century canvases obviously are not modern, collectors of folk art connected these paintings to the newly discovered American primitives. Limner portraits were then regarded as the work of "simple people with no academic training and little book learning in art."[48] By now it is clear, surely, that the Freake limner was a professional artist. His use of color, brushwork, design, gesture, light, and composition all show this to be so. Further, he was very much aware of changing aesthetic preferences in the universe of studio art and he sought to improve his paintings whenever possible, altering them to follow more closely the latest fashions. While we have no proof that he actually read any books, principles and techniques published in art books since the early fifteenth century do appear in his work, indicating at least an indirect impact of

the printed word on his art.[49] He knew something of how the Renaissance masters had designed their compositions, and he invoked their rules of perspective and proportion. The known results of his negotiation between conservative and progressive trends are an interesting hybrid: artworks in transition, faithful to two styles and yet successful in their own time and place. The Freake limner found himself in a changing society and his art accurately mirrors the demands of those changes.

Seventeenth-century New Englanders often are considered an art-denying people, but they certainly were not devoid of aesthetic sentiments. These feelings were expressed in their religious rhetoric, poetry, furnishings, and architecture. The paintings discussed here show a taste for elaborately worked textiles that were brightly colored—at least for women and children. Abbott Lowell Cummings has discovered that New England interiors were painted in a riot of colors—there were red, green, white, and purple rooms; moreover, structural details such as joists and posts might be picked out in contrasting colors and walls and ceilings decorated with dots.[50] Yet there was restraint in the Puritan demeanor; there could be no art expressly for art's sake. The portrait thus became the most popular genre of painting for it was artwork with a strong educational function. It recorded part of a genealogy and thus helped to preserve the family, a fundamental institution in the Puritan world.[51] Pictures of leaders, scholars, and clergy were set forth to remind the Puritans of saintly lives to emulate. A portrait's moral service presumably toned down its aesthetic function so that it supported the sacred mission of Puritan life.

As David Hall has explained, for the Puritans plainness had much to do with arriving at important truths. In their writings Puritan ministers labored to find efficient and telling images. Richard Mather, for example, sought words for his sermons that were "plain, aiming to shoot his arrows not over his people's heads, but into their hearts and consciences."[52] Similarly, the New England plain portrait made the face easily visible and clearly rendered those possessions that were understood as emblems of status. Artifice was therefore restricted and iconic symbolism was emphasized. At a glance one knows the children of privilege, the gentleman or gentlewoman, the doctor, the clergyman, the soldier, the governor. Hall summarizes the core values of Puritan writings: "colonists wanted plainness, but not at the expense of being dull or clumsy."[53] These requirements are realized in the works of the Freake limner, who provided his community with elegant images rich in detail but with only slight hints of personality. He was a plain painter who fully understood the cultural style that per-

102

meated his society. If art was to be made in New England by concealing art, then he would depict his sitters against a dark ground, subdue their personalities, paint shadows that were not really shadows, and establish perspective that only hinted at a sense of three dimensions.[54] Early New England paintings thus were works of fine art adapted to the expression of Puritan values, not works of folk art imbued with traditional values.

The Eighteenth Century:
The Case of Pieter Vanderlyn

Unlike the Puritans, who were carriers of a relatively art-denying culture, America's Dutch colonists had come from a society awash in art, particularly paintings. At the time of Holland's colonial expansion to North America the painted picture was a commonplace of domestic furnishing for both the middle and upper classes. Most of these pictures were done in a highly realistic style and they depicted familiar, everyday events rather than heroic or holy scenes. These pleasing, often light-hearted, genre pictures were enthusiastically received, and increasing demand assured a market for the works of hundreds of painters:

At first the demand for this popular art was larger than the supply, but as the production was so easy, overproduction soon inevitably arrived. From being cheap, the pictures soon became cheaper, and finally so cheap that all classes, except the very poor, could afford to buy them. In Holland in the middle of the seventeenth century there were oil paintings everywhere—in all the rooms of the houses of the middle classes, in the taverns, in brothels, in the back rooms of shops, and in the cottages. They were hung up everywhere.[1]

Paintings were sold in large lots at open-air markets. John Evelyn, an English traveler to the Netherlands in 1641, wrote, "'tis an ordinary thing to find, a common farmer lay out two or 3,000 pounds in his community, their houses are full of them [paintings]."[2] One reason for such large expenditures for artworks was that since there was little land to buy, people put their money into art. To maintain the value of their art some towns even passed laws to keep dealers from other towns from "dumping" pictures on their market.[3]

As unlikely as it might seem to us today, paintings were a cornerstone of Holland's domestic economy. Paintings of seventeenth-century Dutch interiors show rooms full of car-

pets, cupboards, chairs, tables, musical instruments, clocks, sets of porcelain, and pewter tankards; they also show walls covered with maps, charts, and all manner of paintings—landscapes, seascapes, historical allegories, genre scenes, and portraits.[4] One English visitor noted with envy, "Their interior decorations are far more costly than our own, not only in hangings and ornaments, but in pictures which are found even in the poorer houses. No farmer or even common laborer is found, that has not some kind of interior ornaments of all kinds, so that if it all were put together, it often would fill a booth at the fair."[5] It was homes like these America's Dutch colonists had left; it was homes like these they occasionally were able to recreate in their new land.

Many of the houses of New Amsterdam—Dutch New York—were furnished with paintings, usually in great quantities. The inventory taken in 1658 of the property of Dr. Jacob de Lange showed that he had hung fifty-four paintings in a three-room house. The "Great Chamber" alone held thirty-three pictures:

One great picture, Banquets; *one ditto; one small ditto; one Picture* Abraham and Hagar; *four small* Countreys, *two small* Countreys; *one* Flower Pot; *one smaller ditto, one* Country People Frolic; *one* Sea-Strand; *one* Portraiture; *one* Plucked Cock Torn; *two small* Countreys; *one* Flower Pot, *small without list [frame]; one "small print broken"; and "thirteen East Indic prints past[ed] upon paper."*[6]

We find in this list landscape, seascape, genre, portrait, still life, Scripture picture, and Asian import. The good surgeon's taste apparently ran to scenes of country life and, unlike the English colonists of Massachusetts, he cared little for pictures of faces. Of the five portraits he owned only two were displayed; the others (including his own likeness) were stored in the cellar.

What is most significant about de Lange's accumulation of pictures is that he was not an exception. Mrs. Margarita Van Varick owned eighteen paintings, twelve prints, and fourteen "East India Pictures" (prints produced in Asia for export). Cornelius Steenwyck had thirty-nine pictures of various sorts.[7] Additionally, ownership of paintings was not confined to city dwellers. Well up the Hudson, at the edge of the frontier, paintings were counted as valuable household possessions. At an auction of the goods of Gerrit Teunison, held in Albany in 1655, seven paintings were listed for bid.[8] Through the last years of the seventeenth century inventories of Albany resi-

dents consistently included parcels of pictures, sometimes as many as fifteen. Half a century later, Dutch settlers in Albany continued to ornament the walls of their homes in an elaborate manner. Dr. Alexander Hamilton of Maryland observed in 1744, "They affect pictures much, with which they adorn their rooms. . . . They hang earthen or delft plates and dishes, having a hole drilled through the edge of the plate or dish and a loop of ribbon put into it to hang it by."[9] Four years later Swedish naturalist Peter Kalm, while on a visit to the upper Hudson, recorded of Dutch houses, "The walls were quite covered with all sorts of drawings and pictures in small frames."[10] For over a hundred years, from one end of the Hudson to the other, Dutch settlers behaved as if they were still in Holland. They retained their language, their religion, and their appreciation for excessive pictorial decoration. Even at the edge of what they considered the civilized world, they continued to put their money into art.

The works that dominated the wall space of New Netherlands from 1650 to 1750 were not created by local artists but rather had been dragged along on the voyage to America or imported from the prolific art world of Holland. In the seventeenth century alone, Dutch artists are estimated to have painted as many as 200,000 pictures.[11] Local shops in New Amsterdam were selling popular European prints, and there were well-established trading links that connected colonists with their favorite Old World painters. The only market local artists could claim for themselves would have been for portraits, but portraits were not very popular. Professional painters in Dutch New York thus had to branch out into the decorative branches of the painter's craft in order to survive. Gerrit Duyckink (1660–1710), son of a soldier turned artist, assumed his father's glazing business and occasionally taught drawing. One of his sons, Gerardus (1695–1742), sold paint, repaired mirrors, and decorated their frames. He also advertised "all sorts of pictures made and sold."[12] Three generations of painters had not been able to find dependable, full-time patronage for their prime calling.

Through the Treaty of Westminster, negotiated in 1674, the Dutch surrendered their colony of New Netherlands to the British in exchange for the South American colony of Surinam. At that point the cultural tone of New York began to change as a new political regime came into power: in the last quarter of the seventeenth century New York City became an English city, with only a moderate Dutch accent.[13] Most critical to the local taste in art was the enforcement of the Navigation Acts, which required that all trade must be with England. This rule was to change noticeably the looks of Dutch interiors as well

as the entire profit structure of the colony. The growing popularity of British taste is indicated by a 1692 report that Lawrence Deldyke's New York print shop carried during that year thirty pictures of the English monarchs William and Mary.[14] New York was a port city with active and far-reaching international connections, and so it became increasingly cosmopolitan. Its taste in art was in step with the style of the Peter Lely-Godfrey Kneller school then in fashion in England. Local self-trained artists in New York had to fall in line with this mannerist mode of painting, give up, or look elsewhere for clients.

It is in the upper Hudson Valley that we find most of the distinctively Dutch painters, the so-called folk artists. Also known as the "patroon painters," they were most active from 1700 to 1750 in places like Schenectady, Albany, and Kingston—upriver settlements where Dutch identity was stronger. While New York City became the most culturally diverse colonial city in North America, the towns of the upper Hudson remained enclaves of a conservative, seventeenth-century culture. A visitor would have found Dutch gable-entry houses in the towns, Dutch barns and hay barracks on farms, and all manner of Dutch artifacts from wheeled plows to cabinet beds.[15] The Dutch language was still commonly spoken in Albany as late as 1750. Even into the last decade of the eighteenth century the upper Hudson retained a pronounced Dutch identity.[16]

The works of the patroon painters are better known than their names. It has, in fact, taken great diligence on the part of collectors and curators to separate eighteenth-century Dutch canvases into different styles and to attribute them to distinct hands. Since these Dutch painters used similar conventions and techniques, some attributions are not certain. These rural artists generally imitated the same mezzotints and served the same clientele, a rural gentry that was extensively intermarried and thus in constant communication. It is likely that these artists not only shared the same fund of painterly ideals but also knew of each other's work; they probably borrowed as much from one another as they did from prints imported from Europe. As a result, the crossed paths of their careers have been very difficult to untangle.

The two major types of paintings known from the upper Hudson Valley during the first half of the eighteenth century are Scripture paintings and portraits. For the first of these genres (fig. 64) over twenty artists' hands have been identified, but only one artist can be confidently named—Gerardus Duyckink of New York City. Operating out of his painting shop "under the sign of the two cupids," he was quite knowledgeable of

Fig. 64 Unknown artist, *Christ on the Road to Emmaus*, ca. 1720, oil on canvas, 25½″ × 30½″. National Gallery of Art, Washington, D.C.; Gift of Edgar William and Bernice Chrysler Garbisch.

the academic conventions of fine art. But his skill was not matched by his upriver competitors; their attempts to copy the illustrations they found in Dutch Bibles generally turned out quite awkward and naive.[17] A visitor to the Albany area in the 1760s reported of the Schuyler house that it was the "best furnished that I had ever entered. The family pictures and scripture paintings were to me particularly awful and impressive. I compared them to the model which had before existed in my imagination, and was delighted or mortified, as I found they did not resemble them."[18] Sacred images, although prohibited in Dutch churches, were nonetheless thought by some to be acceptable and useful. People tried to obtain the best ones they could find, even if that meant importing them all the way from New York City.

The patroon painters have been credited with certain sets of Scripture paintings, yet they seem mainly to have done portraits. This was the one genre in which imported pictures posed no competition. Eighteenth-century settlers of the upper Hudson particularly sought out the services of portrait makers as they tried to establish their authority in their new settle-

108

ments. Families such as the Gansevoorts, the Schuylers, the Van Cortlandts, and the Van Rensselaers were amassing great land holdings and financial fortunes, achievements they felt should be emphasized by the preservation of their personal likenesses for posterity.[19]

Three artists, each associated with a different geographical region, are generally acknowledged as the painters of these leading families. The painter known today as the de Peyster limner worked chiefly in New York City and its environs. The Van Rensselaer limner plied his trade to the south of Albany, while Albany and towns to its north were the initial territory of the Gansevoort limner.[20] We will examine the work of this last artist as a representative of Dutch colonial painting.

Mary Black has identified the Gansevoort limner as Pieter Vanderlyn. She defends her claim on two grounds, patterns of residence and the evidence of handwriting. Although the Gansevoort limner never signed his name to any known painting, he often inscribed the names of his sitters and the date of the painting (fig. 65). Pieter Vanderlyn, however, did leave his signature on a seven-stanza hymn he composed at

Fig. 65 Pieter Vanderlyn, *Adam Winne*, 1730, oil on canvas, 32″ × 26½″. Courtesy, the Henry Francis du Pont Winterthur Museum, Winterthur, Delaware.

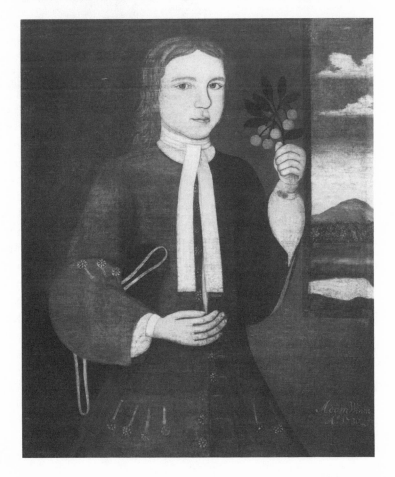

Fig. 66 John Vanderlyn II,
Helena Sleight, ca. 1856, oil
on canvas. Museum of the
City of New York.

Kingston, New York, probably in 1739. Black finds the letter-
ing of the musical manuscript convincingly similar to the
inscriptions on the Gansevoort limner's canvases.[21]

The stronger proof is found by comparing the places of
residence for the Gansevoort limner's clients with Vanderlyn's
pattern of residence. Born in Holland in 1687, Vanderlyn ar-
rived in New York by 1718 from the Dutch West Indies
colony of Curaçao. He was soon living in Kingston, where in
1722 he married his second wife. He next moved to Albany
and evidently put down firm roots, since in 1730 he was ap-
pointed fire warden of that city's second ward. But some time
during the next decade, certainly by 1738, he moved back to
Kingston, serving in the town's militia in addition to assuming
the role of church leader during the occasional absences of the
regular minister.[22] Church records show that Vanderlyn and
his wife witnessed the baptisms of their grandchildren, indicat-
ing that Vanderlyn must have lived out the rest of his life in
Kingston. His moves between Kingston and Albany coincide

110

with the sequence of paintings credited to the Gansevoort limner. Around 1730, when Vanderlyn was living in Albany, at least six portraits in the style attributed to the Gansevoort limner were painted for well-to-do residents in Albany and nearby Schenectady. Another set of similar likenesses was painted in the 1740s in Kingston County after Vanderlyn had returned to Kingston. Five other paintings in the Gansevoort style, done between 1733 and 1739, suggest that their artist was moving back and forth between Albany and Kingston. Such behavior is perfectly plausible for Vanderlyn since he had lived in both towns, was well known for his civic duties, and doubtless knew many well-placed people in both locales.[23] In the absence of any signed painting by Vanderlyn, the strong correspondence between his places of residence and those of his clients is particularly suggestive.

Equally suggestive evidence is found in the careers of Pieter's artistic descendants. His grandson John Vanderlyn (1775–1852) repainted Pieter's portrait of Domine George Wilhelmus Mancius, pastor of the Reformed Protestant Dutch Church in Kingston. Originally done around 1745, that painting was lost. John's copy, which hangs today in the church vestibule, is very much in the Gansevoort mode, although traces of his academic training are visible in his superior treatment of the minister's hands and his observance of the rules of perspective in rendering the eyes.[24] John Vanderlyn's nephew, John Vanderlyn II (1805–1876), also became a painter, and he too made copies of paintings by the Gansevoort limner—presumably because John was his descendant. In 1856 John Vanderlyn II painted a version of Pieter Vanderlyn's 1745 portrait of Helena Sleight (fig. 66). The handling of light, anatomy, and perspective in this picture is clearly an improvement over Pieter's original picture (fig. 67).[25] It is difficult to believe that trained studio artists would devote their time to copying paintings that were technically inferior to their own unless there were some deeper rationale for doing so. John Vanderlyn held a very negative opinion of paintings done in the limner style.[26] Yet he and his nephew clearly honored the work of the artist known as the Gansevoort limner. Apparently they were committed to this painter because he was their ancestor, the founder of a painting dynasty that lasted through four generations.

Nineteen known works have been attributed to Pieter Vanderlyn, all of them portraits of people who lived in the upper Hudson Valley. Thirteen are of children and young people. Among his likenesses of adults, only his painting of Leendert Gansevoort depicts a mature male. It would seem that this surviving sample represents only a fraction of his

Fig. 67 Pieter Vanderlyn, *Helena Sleight*, 1745, oil on canvas. New York State Office of Parks, Recreation, and Historic Preservation—Senate House State Historical Site, Kingston.

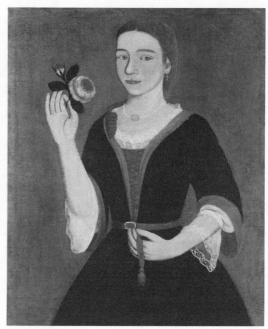

Left: **Fig. 68** Pieter Vanderlyn, *Young Lady with a Fan*, 1737, oil on canvas, 38″ × 31¾″. National Gallery of Art, Washington, D.C.; Gift of Edgar William and Bernice Chrysler Garbisch. *Right:* **Fig. 69** Pieter Vanderlyn, *Miss Van Alen*, 1735, oil on canvas, 31⅛″ × 26⅛″. National Gallery of Art, Washington, D.C.; Gift of Edgar William and Bernice Chrysler Garbisch.

total output. Vanderlyn was naive about how one might capture the illusion of three dimensions. He outlined his subjects and gave them little substance, although he did pose them against convincing backgrounds rendered with sensitive attention to atmosphere and perspective (fig. 68). Vanderlyn was aware of portrait formulas—stock poses, standard settings, conventional props. In six of his portraits of young girls, all face three-quarters to the left with the right hand raised and hold a rose, while the left arm is extended downward across the body (fig. 69). This pose may trace back to Lely's portrait of the Duchess of Portsmouth, which Vanderlyn probably saw in a 1679 mezzotint by Van Somer (fig. 70).[27] In fact, a print source can be found for either the pose or certain secondary elements of composition in each of the Gansevoort limner's paintings. For example, in the background of the portrait of Matthew Ten Eyck (fig. 71), the trees are not evidence of folk simplification, as some have suggested, but seem to have been taken directly from the cone-shaped trees found in the 1720 print of Kneller's original painting of Princess Anne.[28]

Vanderlyn might well have known of such prints because pictures of this kind commonly appeared in Dutch households as a result of the active trade in art between Europe and New York. Moreover, Vanderlyn knew more of the larger world and of the arts, both graphic and poetic, than many residents of upstate New York during the eighteenth century. He had served as a surgeon aboard ship and had visited the coast of Africa as well as the West Indies. A skilled vocalist, he became

112

Fig. 70 Van Somer after Lely, *Duchess of Portsmouth*, 1679, mezzotint. Courtesy, the Henry Francis du Pont Winterthur Museum, Winterthur, Delaware.

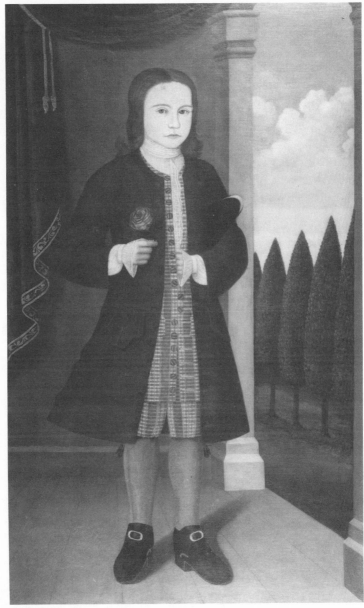

Fig. 71 Pieter Vanderlyn, *Matthew Ten Eyck*, 1733, oil on canvas. New York State Office of Parks, Recreation and Historic Preservation—Senate House State Historic Site, Kingston.

master of the choir in his Kingston church and composed hymns. Certainly he made it his business to know what sort of art was in fashion; if he did not know, his clients likely would have shown him.

It is also possible that Vanderlyn was influenced by prints indirectly. Gerardus Duyckink regularly sold mezzotints from his shop and used them as the basis for his own portraits. Duyckink's paintings of Mrs. Mose Levy or of Mrs. Joseph Hallet (fig. 72), which seem to be based on Kneller's *Countess of Ranelagh*, are also quite similar to Vanderlyn's *Caterina Gansevoort* (fig. 73).[29] How and when Vanderlyn might have

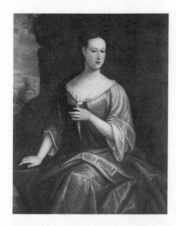

Fig. 72 Gerardus Duyckink, *Mrs. Joseph Hallet*, ca. 1728, oil on canvas, 49½″ × 40½″. Courtesy of the New-York Historical Society, New York.

seen Duyckink's paintings is not known, but a sequence moving from Kneller to Duyckink to Vanderlyn is a logical progression extending from the most elaborate image to the most plain. If Vanderlyn measured himself against another local artist instead of Kneller, the court painter, he might not have judged his flat canvases so deficient.

Vanderlyn took the composition and content of his portraits from the works of high-style masters (even if filtered through prints or other copies), but he did have admirable skill of his own. His flesh tones were handled subtly, as in his portrait of Pau de Wandelaer (fig. 74), and he rendered human anatomy accurately, keeping all the parts of the body in their correct proportions. Most impressive in his canvases is his treatment of light. His backgrounds feature a pleasing twilight glow, contrasting purposefully with the bright clarity that accents his subjects' faces. Indeed it was in the backgrounds of his paintings where Vanderlyn broke away from the conven-

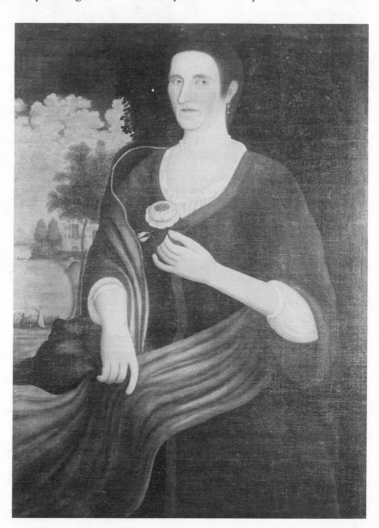

Fig. 73 Pieter Vanderlyn, *Caterina Gansevoort*, ca. 1730, oil on canvas, 47½″ × 35½″. Mr. and Mrs. Stephen C. Clark, Jr. Photo: Frick Art Reference Library.

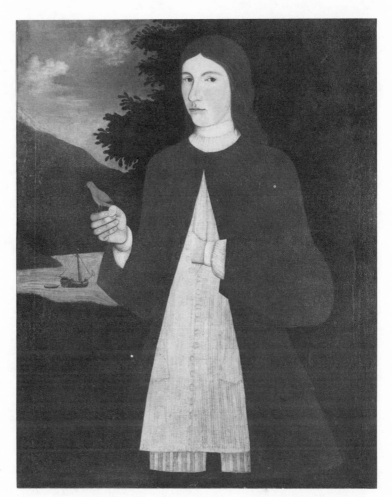

Fig. 74 Pieter Vanderlyn, *Pau De Wandelaer*, ca. 1725, oil on canvas, 48″ × 37″. Albany Institute of History and Art, New York; Gift of Mrs. Abraham Lansing.

tional burdens of fashion. The ship sailing in the background of Pau de Wandelaer came not from a print but from his observation of the Dutch schooners that sailed the waters of the upper Hudson; it is the sort of vessel on which he probably traveled many times. The castle in the background of Mrs. Gansevoort's portrait seems to derive from views of European scenery, but it also could have been inspired by Vanderlyn's visits to Dutch forts along Africa's Guinea Coast. In the background to Leendert Gansevoort's portrait (fig. 75), Vanderlyn created a visual pun on the sitter's name: what appears to be merely a pond with swans may be his version of a small flock of geese. If such is the case then the "crossing of the geese" or "geese ford" (in Dutch, *ganse voort*) is a clever rebus rather than a casual bit of fill.[30]

His experimenting at the edges of a painting does not, however, signify that Vanderlyn was a major artist. Vanderlyn's work is more derivative than innovative; one should not expect more from a self-trained, part-time artist who was also a

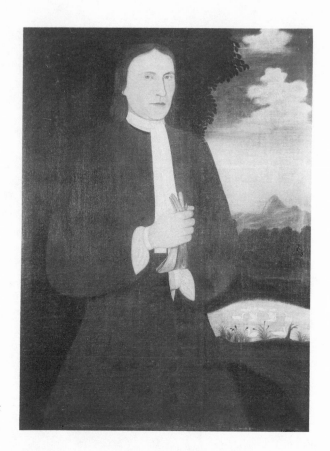

Fig. 75 Pieter Vanderlyn, *Leendert Gansevoort*, ca. 1730, oil on canvas, 47½" × 35½". Mr. and Mrs. Stephen C. Clark, Jr. Photo: Frick Art Reference Library.

composer and a land speculator. He learned from the examples around him by copying them carefully, but he apparently never learned all the tricks that most professionals knew: how to shade, how to vary colors, how to foreshorten, how to highlight. However, because his paintings lack artifice, the contrived feeling of Vanderlyn's baroque sources is replaced by what Flexner calls a "pastoral calm."[31] The figures stand out directly, forthrightly, confidently—qualities of the plain, generally unadorned style in which Vanderlyn worked. An alternative aesthetic comes through in Vanderlyn's painting, but the question remains as to whether this aesthetic was based on the tastes of his clients or on his personal notions of good art.

From 1730 to 1750, the period of Vanderlyn's painting career, Dutch society in the upper Hudson Valley was undergoing a profound transformation. The upriver Dutch began to feel the impact of British rule, which had already affected the residents of New York City. Peter Kalm found the city of Albany to be very much a Dutch enclave in 1750, but he noted that the people wore English clothes and that their children were taught both Dutch and English.[32] As early as 1718 some members of the Dutch Reformed Church had petitioned to

116

have services in English; although these requests were not accommodated until 1763, this generation often married English spouses and spoke English at home.[33] In Albany in 1748 Reverend Theodorus Freylinghuysen, observing the absence of a minister in the English church and the lack of services for English-speaking Christians, wrote, "I have undertaken by their request to preach to them in the English language, and this I have done for some time."[34] Younger Dutch people probably attended these services, interested in what they considered a progressive form of worship.

As indicative of cultural change as was the growing popularity of a new language, a perceptible shift occurred in artistic style: after the first quarter of the eighteenth century the favored Dutch mode of portraiture was abandoned. Through the 1720s several prominent people in Albany had their likenesses taken by an artist known today as the Schuyler limner. According to R. Peter Mooz, "Stylistically these pictures descended from the work of Dutch painters Maes and Netchen, whose paintings of the 1670s and 1680s grafted Flemish elegance and color derived from Van Dyck onto Rembrandt's Netherlandish realism. Their subjects were often placed against a background of a park containing architecture and sculpture in the international late Baroque vogue."[35] The Schuyler limner's style held great appeal for the conservative patriarchs of the Hudson Valley. Shown as they were, homely and brusque, his canvases provided correct if unflattering likenesses of society's leaders. But around 1730 the paintings of Vanderlyn and others took a different approach. Derived from a newer English style, they attempted to capture an ideal rather than an accurate likeness. Poses were more casual, with relaxed gestures, suggesting leisure and status. By highlighting the central figures with brighter hues and placing them against neutral shades of brown or gray, these paintings suggested a calm, peaceful environment over which their subjects had full command. Hudson Valley portraits during the second quarter of the eighteenth century were nowhere near as lavish as the mezzotints upon which they were based, but they provided their owners with a contemporary vision of themselves. It was most important to look like members of the English rather than the Dutch gentry.[36]

This change in taste is also confirmed by the architecture and furnishings associated with the Hudson Valley Dutch. The English Georgian house, noted for its symmetrical arrangement of rooms on both sides of the central passage, became widely accepted all over America during the first half of the eighteenth century. Upstate New York did not remain immune to this domineering national fashion, although the region was

117

late to adopt it. One of the earliest homes to be planned along Georgian lines was the Van Rensselaer house of Rensselaer County, built in 1742. In Albany County the Van Schaik and Gerrit Van Zandt houses, both built in 1775, also reflect Georgian influences.[37] But housing styles are quite resistant to change, especially when extant buildings (such as those the Dutch already had) are still adequate. Furnishings proved more sensitive to the whims of fashion, and it was with tables, chairs, and chests that the rising Dutch gentry most clearly showed its affection for the new. When the Queen Anne style came into vogue around 1725, wealthy Dutch merchants and farm owners were quick to purchase new chairs with fiddle-shaped splats and clubbed feet, as well as other pieces of furniture with innovative S-curved lines and delicately carved ornamentation. Paintings by Vanderlyn done in 1730 and 1745 at Schenectady and Kingston (fig. 67) include Queen Anne tea tables with tripod bases; they show how far and how soon the new style had reached into the upper Hudson Valley.

Against the background of the evolution of a new Anglicized identity, the paintings of Pieter Vanderlyn assume a significance that has not previously been recognized. He did not conserve or perpetuate a Dutch tradition; rather, he abetted the demise of the older Dutch order. His portraits fit right in with all the other changes that were occurring all around him. He had only to walk the streets of Albany or Kingston to know that his younger neighbors were behaving less like his own contemporaries: they were speaking a new tongue, dressing in English clothes, sitting in English chairs next to English tables while often looking at English portraits. Vanderlyn may not have been altogether dismayed by what was happening, since he was partly responsible for the new English look.

While Vanderlyn's paintings are not to be confused with the academic models that inspired them, neither are they to be considered merely nonacademic and therefore examples of folk art. Vanderlyn produced a derivative set of pictures that carefully followed the example of the most fashionable portraits of his day. That his efforts were not equal to Lely or Kneller does not, however, imply an execrable shortcoming. There is precision in his canvases, attention to color, adequate rendering, and occasional hints of personal experience and imagination. It would seem best to consider Vanderlyn a plain painter, an artist who stayed within his own limits and painted pictures that were modest approximations of a more elaborate and complicated idea.

Given the assemblage of pictures, plates, tiles, curtains, beds, chairs, tables, carpets, and painted chests reported for

early households in the upper Hudson Valley, one might expect the outlined image of a family member to fit right in as part of the varied flow of visual experience. Some travelers did report highly decorated rooms in Albany in the 1740s, but these must have either been exceptions or exaggerations. Probate inventories, which usually record the property of the wealthy, are surprisingly silent about paintings at this time: only four out of more than a hundred indicate ownership of pictures. Three of these lists, drawn up around 1700, show that the descendants had owned many pictures in great variety. But the 1771 inventory of Philip Verplank's estate at Fishkill reveals only five pictures—two Scripture paintings and three others, presumably portraits.[38] Admittedly the documentary evidence is quite thin, but it appears that through the first half of the eighteenth century the Dutch were clearing out their rooms, preferring empty walls with only an occasional picture to look at. The cluttered, sensory overload of their early interiors had become outdated.

Today we might find it hard to believe that sober, industrious people would rid themselves of their art, but this is exactly what happened. These people may have paid as little as six shillings for an oil painting in Holland.[39] Commonplace and inexpensive, paintings could be tossed out without regret. A Swiss artist visiting New York City in 1779 was able to buy some of these pictures. He described them as "pictures, chiefly painted in oils, on boards, in black ebony frames highly polished, of those kinds the Dutch settlers brought a great many with their furniture . . . I have picked them up in New York, in garrets where they have been confined as unfashionable when that city was modernized."[40] Thus throughout Vanderlyn's painting career the tradition of domestic galleries filled with pictures was fading. It was considered more tasteful by the middle of the eighteenth century to hang only a few paintings. Vanderlyn was painting modern images for those members of his community who wanted to break with Old World customs.

The only pictures Vanderlyn's upwardly mobile clients allowed on their bright, whitewashed walls were Scripture paintings and portraits. The former were most popular from 1720 to 1740, when Reverend Freylinghuysen was actively promoting a pietist philosophy in Albany.[41] As part of his challenge to the established orthodoxy of the Dutch Reformed Church he advocated private domestic devotion and personal reflection on doctrine. A minister from a congregation slightly upriver from Albany observed that in 1730 there were people "who have a real distaste for orthodox truth. They rejoice that they are free from the obligations of religious and public wor-

ship.'"[42] It was probably these people who created a market for Scripture paintings.

The subjects of eighteenth-century portraits generally were members of families eager to make a statement about their good fortune. Hanging one's likeness on a relatively empty wall was sure to draw attention from anyone who entered the room, and it was an effective declaration of high social status. This was certainly the case for Leendert Gansevoort, the Albany brewer whom Vanderlyn painted around 1730 (fig. 75). In the 1720s the fur traders constituted the local aristocracy, but Gansevoort had his eye on securing political authority to complement the financial success of his brewery. In 1730 the Governor of New York attempted to cut into the profits of the fur traders. This maneuver divided Albany into two factions: the established old families who controlled the fur business and social-climbing merchants hungry for greater wealth and power. Gansevoort threw in with the second group, and after they took charge he was elected alderman in 1734. Among the perquisites of the position was the option to acquire large tracts of land, and in 1736 he was granted 1,700 acres of the Cherry Valley patent. Gansevoort had, without question, become a member of the landed gentry. He commissioned his portrait when he decided to support the restructuring of Albany's political order. His likeness and that of his wife were proclamations of the future greatness of the Gansevoort line.[43]

The scriptural scenes and the portraits painted during the first half of the eighteenth century supported novelty and hastened the coming of a new era. Paintings of biblical scenes provided a material focus for a new mode of worship; the portraits announced a new social hierarchy. While folk art is not devoid of social critique, it tends to confirm the status quo and to uphold traditional values; its message is corrective rather than revolutionary. Thus in no sense can Vanderlyn be correctly labeled a folk artist. Folk artists confirm what a group of people thinks is best about themselves. That social burden, however, is not necessarily shared by plain painters. Deriving their inspiration from the academy, they are more prone to challenge conventions and ultimately, like most fine artists, to show a community what it might become.

The Nineteenth Century: Edward Hicks, Quaker Painter

Fig. 76 Thomas Hicks, *Edward Hicks*, 1838, oil on canvas, 27¼″ × 22⅛″. Abby Aldrich Rockefeller Folk Art Center, Williamsburg, Virginia.

Edward Hicks (1770–1849), who has been described as "the most appealing and distinguished of all primitive painters,"[1] provides an excellent opportunity to consider the alleged folk quality of plain paintings from the nineteenth century. Hicks (fig. 76) was a coach painter, sign painter, and Quaker minister in Bucks County, Pennsylvania, and for about thirty years he created easel paintings which he sold or gave to his neighbors and relatives. First displayed publicly in 1882 at the Bucks County Bi-Centennial Celebration, his works were among the earliest "folk" paintings to be discovered.[2] They were next seen at the Pennsylvania Academy of Fine Arts in 1926, the Newark Museum in 1930, and the Museum of Modern Art in 1932.[3] Hicks's works have been featured in twenty-four major exhibitions in the United States alone, and his paintings have been shown in European galleries as well.[4] His canvases are considered to be the masterpieces of folk art that no major collection should be without. They are at present some of the most valuable works of American art; in May 1980 a version of his often-painted *Peaceable Kingdom* brought an auction price of over a quarter of a million dollars.[5] In addition to the central role Hicks's paintings have played in the history of folk art appreciation, Hicks himself is an important subject because, unlike so many artists, a great deal of biographical material has been amassed about him, not the least of which are his 365-page memoirs.[6] Critical questions about the nature of his work can be answered for him that can barely be raised for others. In Hicks's career the notions of folk tradition and fine art are complexly intertwined. It is their relationship that we will explore here.

When Holger Cahill suggested that folk art is an expression that comes out of a craft tradition, he probably had Hicks in mind as "the rare craftsman who is an artist."[7] For Cahill, an extra measure of concern for design and decoration beyond pragmatic need pushes crafted items into the realm of

art. He recognized that the stiff, two-dimensional manner in which Hicks usually rendered his figures violated the usual academic standards of landscape painting, and thus Cahill praised Hicks for the way he ground his colors, mixed his paints, and applied them to the surface of the canvas—avoiding comment on the paintings themselves:

It is remarkable what good technicians many of these painters are, and this is especially true of the shop-trained men of the past. The works of Edward Hicks, for instance, after a lapse of a hundred years, are in a better state of preservation than the works of many other painters of far greater reputations and presumably of far greater technical knowledge. This is not surprising when one remembers that the tradition out of which the work of Edward Hicks came was in many respects not un-like that of the old masters. That is to say it was a tradition of craftsmanship which grew out of the handling of tools and materials rather than an academic tradition passed on by art schools. It was not painting by the book or by theory.[8]

In focusing on technique rather than the content and composition of Hicks's paintings, Cahill evaded the question of whether easel paintings deserve folk status. If Hicks acted in a traditional manner when he painted signs and coach dec-orations, Cahill suggested, then he was at least somewhat traditional when he painted visionary landscapes at his easel. Cahill was so committed to the importance of a craft–art con-tinuum that he interpreted a perceived similarity in style between Hicks's signs and his canvases as evidence for the tra-ditionality of the form and content of the paintings. But if the means used derive from a folk tradition, it does not follow that the forms produced must also have a folk source. In the nineteenth century (as well as now) most Americans were af-fected by the varying influences of popular and elite culture in addition to their own local folk values.[9] That Hicks's signs and easel paintings might fall into separate domains, the for-mer deriving from a craft tradition and the latter from works of fine art, is easily understood once one acknowledges that not every aspect of his life was traditional. Cahill's all-or-nothing approach, a sort of social determinism, is too simple to clarify the nature of Hicks's artistic achievements.

The flaws in Cahill's reasoning are well illustrated by the career of Thomas Hicks, Edward's cousin, who worked for several years in his uncle's sign and coach shop. Thomas learned the very same craft values as had Edward, but after some formal art education he eventually became a member of the National Academy of Design in New York and painted

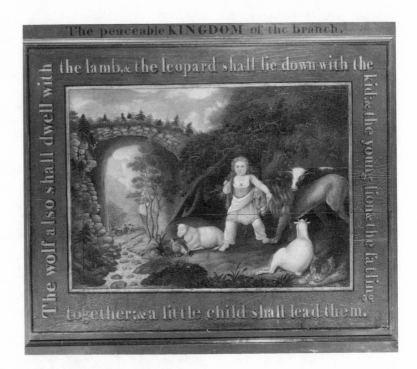

Fig. 77 Edward Hicks, *The Peaceable Kingdom of the Branch*, 1823, oil on wood, 36¼″ × 44⅞″. Yale University Art Gallery; Gift of Robert W. Carle.

Abraham Lincoln's portrait, among others.[10] Cahill would certainly not have insisted that artisan-trained Thomas Hicks was a folk artist. In using biographical details to tie Edward Hicks to folkloric traditions, then, Cahill seems to use evaluative criteria that are arbitrary, applicable in some instances and to be ignored in others.

When Cahill did turn to the content of Hicks's work he pointed out its "unexpectedness of personal style," its "freshness," its "innocence"—in short, its originality.[11] He noted that Hicks's *Peaceable Kingdom* (fig. 77) was composed quite differently from the "open window" view of the usual academic landscape. Such paintings, it appeared, were unique to Hicks; how then could they be the expression of the "common people"? Cahill could have answered this riddle by saying that Hicks was not a folk artist, that local traditions were not a prime factor in his choice of design, or that his paintings represented only his own personal point of view.

This was, in fact, the assessment of Arthur Edwin Bye, an art historian and aficionado of Hicks's paintings. As early as 1943 Bye questioned the categories Cahill had used. Folk art, said Bye, was "the product of a homogeneous group of people," and he named the Pennsylvania Germans as having a folk style. By contrast, the art of Hicks had little relationship to such art because "he stood alone and apart."[12] Nor could Hicks be thought of as primitive because that problematic term fit him in no sense; Hicks was neither the artist of an un-

123

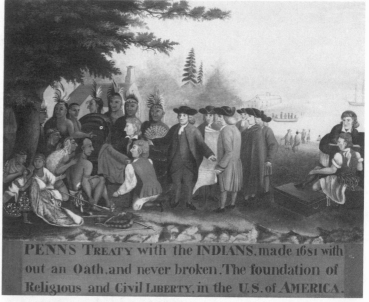

Fig. 78 Edward Hicks, *Penn's Treaty with the Indians*, ca. 1835, oil on canvas, 24¼″ × 30⅛″. National Gallery of Art, Washington, D.C.; Gift of Edgar William and Bernice Chrysler Garbisch.

PENNS TREATY with the INDIANS, made 1681 without an Oath, and never broken. The foundation of Religious and Civil LIBERTY, in the U.S. of AMERICA.

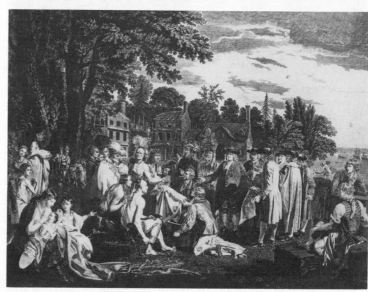

Fig. 79 Benjamin West, *Penn's Treaty with the Indians*, 1775. Engraving by John Hall. The Historical Society of Pennsylvania, Philadelphia.

cultivated people nor the first American artist. Besides, as Bye pointed out, the earliest American artists had imitated the works of European masters and thus had aligned themselves with fine rather than folk art. Bye cautioned that the term *primitive* correctly indicated only an untutored artist whose works should be admired more for their significance than their skill. The significance of Hicks's *Peaceable Kingdom* was that it expressed the artist's aesthetic sense: "*He used his subject as a pretext for indulging in fantasy*. The fact that his animals are placed in the foreground and grouped about according to his caprice, while the meaning is but subtly suggested by the little

figures of Penn and the Indians in the distance, is proof that he was interested most in his artistic creation, and only secondarily in his theme."[13] Comparing Hicks with noted genre painter Peter Brueghel, Bye found these artists equally capable of combining homely humor with seriousness. However, Bye lamented, while Brueghel was internationally acknowledged as great, Hicks was kept off the artistic honor rolls by an inappropriate folk art rhetoric.

Bye's claim of fine art status for Hicks encouraged scholars to probe more deeply into Hicks's life. It turned out that Hicks was profoundly influenced by the numerous works of art he saw in mass-produced prints and engravings. The full record of his painting activities may never be known, but an 1817 shop ledger reveals that in that year he landscaped a fireboard for the sum of forty dollars.[14] Well documented from that point onward are a variety of scenes, portraits, and landscapes that he painted, and in almost every case these involved fairly direct imitation or borrowing from other works. His *Penn's Treaty with the Indians* (fig. 78) was patterned on Benjamin West's original (fig. 79), his *The Signing of the Declaration of Independence* (fig. 80) on John Trumbull, his *Washington Crossing the Delaware* on Thomas Sully, his *Penn's Grave* on H. F. de Cort, his *Prize Bull* on Paul Potter, his *Andrew Jackson* on Ralph E. W. Earl, his *Columbus* on John G. Chapman, his *Falls of Niagara* on a map cartouche by Henry S. Tanner, a portion of his *David and Jonathan* on William Hogarth, and his *Noah's Ark* on a Currier lithograph.[15]

Fig. 80 Edward Hicks, *The Signing of the Declaration of Independence*, 1840, oil on canvas, 26¼" × 29¾". The Chrysler Museum, Norfolk, Virginia; Gift of Edgar William and Bernice Chrysler Garbisch.

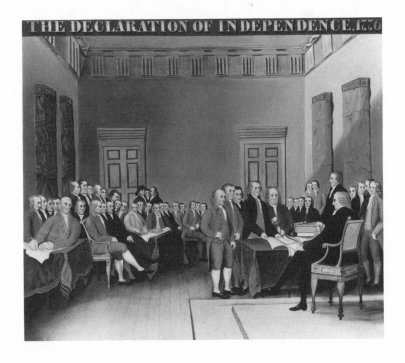

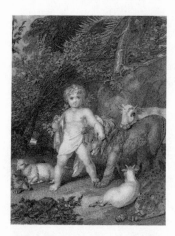

Fig. 81 Richard Westall, *The Peaceable Kingdom of the Branch*, 1815. Engraving by Chas. Heath. Rare Book Department, Free Library of Philadelphia, Pennsylvania. Photo: Joan Broderick.

Hicks painted his most famous painting, the *Peaceable Kingdom*, some sixty times between 1820 and 1849 (some estimate that he did over one hundred such scenes). The general layout of his *Kingdoms* followed the format of Asher B. Durand's *Delaware Water Gap* (1820).[16] The content of his earliest versions derived largely from Richard Westall's painting *The Peaceable Kingdom of the Branch* (fig. 81), which was widely reprinted during the nineteenth century by Bible and Book of Common Prayer publishers.[17] The Westall scene was situated to the right in Hicks's versions; the left half usually contained *Penn's Treaty with the Indians*, after West. Some time after 1827 Hicks developed a new combination with a pyramid of "Quakers with Banners" replacing the treaty scene.[18] This seemingly original element featured an image of prominent Quaker leader Elias Hicks, which Edward copied from a widely printed silhouette.[19] Recently it has been suggested that the entire pyramidal arrangement of Quakers was copied from a caricature appearing in an anonymous pamphlet entitled *The Hole in the Wall* (1828).[20] Around 1830 the *Kingdoms* changed dramatically as more animals were added (fig. 82). These new creatures seem to have been adopted from M. Anderson's *A General History of Quadrupeds* or S. G. Goodrich's *Universal Geography*.[21] New human figures also were added: a child, patterned after the Christ child that clings to Raphael's *Madonna*; another child taken from H. Rigaud's allegory of *Happiness*; and a figure derived from both *Liberty as the Goddess of Mercy* by Edward Savage and *Hebe* by William Hamilton.[22]

To speak of Hicks as an original painter is obviously erroneous. His works clearly were dependent on academic and commercial sources and, more importantly, his audience knew it. Upon receiving a painting from Hicks, S. P. Lee wrote that it was "highly creditable to your untaught pencil," and his cousin Silas Hicks noted that his gift of a *Peaceable Kingdom* was "executed in a masterly style."[23] John Comly wrote in 1817 that Hicks had a "genius and taste for imitation, which if the Divine Law had not prohibited, might have rivaled Peale or West."[24] Hicks's clients apparently were sophisticated enough to know what fine art was, and they knew that Hicks's paintings, while similar to their original sources, were not refined enough to be substituted for them.

If anything in the content of Hicks's work is traditional, it is, as Bye claimed, in the tradition of fine rather than folk art. To find distinctive characteristics in these works, suggests Julius Held, one must look to the style of the paintings: "If we are attracted by a certain 'primitive' crudeness in the execution of Hicks's pictures we should be conscious of the fact that it is

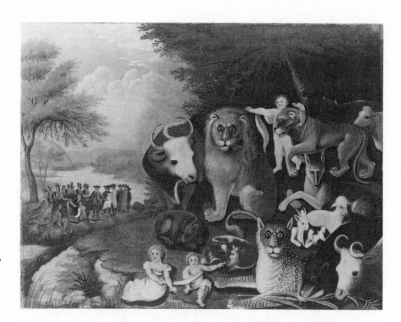

Fig. 82 Edward Hicks, *The Peaceable Kingdom*, ca. 1835, oil on canvas, 18″ × 24⅛″. The Brooklyn Museum, New York; Dick S. Ramsay Fund.

but the provincial dialect of a conventional and established language, and that the painter himself neither claimed, nor would have admitted a need for, originality of thought or syntax."[25] With this linguistic analogy Held encouraged close consideration of Hicks's works in order to discern what personal twists he had given to well-known works of fine art. Held's focus on the individualism of the artist was pursued further by other scholars, and any concern for identifying a folk tradition was buried under an avalanche of biographical details; personal psychology was treated as if it were communal philosophy.

Alice Ford compiled the most authoritative account of Hicks's life, weaving together the content of numerous records and letters, his paintings, and his own memoirs. She presented Hicks as a heroic figure who struggled with his inner fury in his search for serenity. Hicks's life was indeed marked by constant challenges, not least of which were his continual lack of money and anxiety over impending bankruptcy.[26] He also was troubled by religious matters, and after he was accepted into the Quaker ministry he felt the constant tugs and pulls of debate on moral issues, particularly temperance and the antislavery campaign.[27] Ford argued that religious angst, stemming from his Quaker conscience, carried into his paintings, specifically into the long series of *Peaceable Kingdoms*. The question arises, however, whether Hicks's representations of animals and children with Penn and the Indians in the background were solely Quaker in nature. Many Quakers cherished the scene of William Penn's treaty, but it is a depiction of an historical event that can be construed as religious

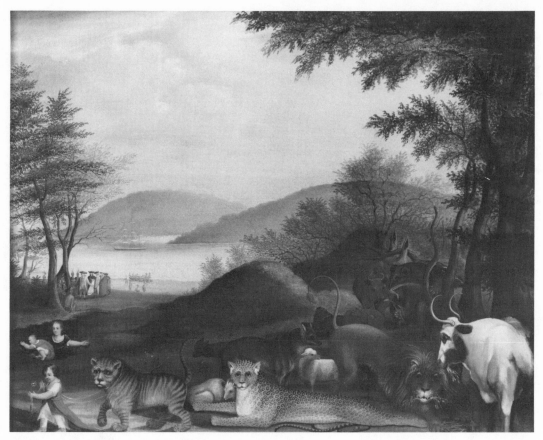

Fig. 83 Edward Hicks, *The Last Peaceable Kingdom*, 1849, oil on canvas, 24″ × 30″. Lent to the Nelson–Atkins Museum of Art, Kansas City, Missouri, by the great, great, great grandson of the artist.

principally by extension.[28] Appreciation of this picture, done by Benjamin West (a lapsed Quaker), does not make one a Quaker. The cluster of animals derives from a literal interpretation of Scripture (Isa. 11:6-9) and presents an image known to many Christians other than Quakers. Because Hicks composed sermons based on the verses of Isaiah, Ford stated that when he put Isaiah on canvas he was "teaching the Gospel with his paint brush."[29] Ford assumed that Hicks's sermons were fully internalized by his congregations, but it is unclear whether the painted figures reflected communal sentiments or only Hicks's interpretations.

The case for Hicks's traditionality was not strengthened by Ford's analysis of the paintings themselves. She set the *Peaceable Kingdoms* into three periods—early, middle, and late, roughly assigned to the years 1820–1830, 1830–1840, and 1840–1849. Significant changes occurred across these phases as Hicks refined both his intellectual perspective and his technique. Ford wrote, "doubtless he continued the first type [of painting] while developing the second, which as time proved, was to lead him into a final period of greatest brilliance in which the animals and children are integrated in a

Fig. 84 Edward Hicks, *Indians Shooting a Jaguar*, ca. 1846, oil on canvas, 17″ × 24½″. Shelburne Museum, Shelburne, Vermont.

way which approaches that of a formal painting."[30] By the end of his life Hicks was painting this same picture in what was, for him, a new style (fig. 83). He had finally learned the rules of academic painting and shunned his earlier "primitive crowding." What, then, is left of the claim for Hicks's folk traditionality? His art form and its content were clearly academic in origin, and eventually so was his style. He aspired to be not an eccentric local but an artist in full command of the internationally sanctioned standards of color, composition, and design. The fact that he learned these criteria on his own without formal instruction does not make him a folk artist, for he never intended his work to be judged according to local criteria or traditions. One need only glance at his painting *Indians Shooting a Jaguar* (1846–1847, fig. 84) to see how involved he had become in the American romantic attraction to the landscape near the end of his career.[31]

Subsequent probes into the details of Hicks's life also were directed at uncovering certifiable Quaker qualities in his paintings. George P. Winston, for example, after considering the style and content of the *Peaceable Kingdoms*, makes the following guarded claim: "Perhaps it is not going too far to suggest that at least in part the often naive drawing, the flat colors learned from his trade, are scrupulously and consciously maintained in order to keep his art clear of artifice; that the simplicity and freshness of Edward Hicks's paintings are as much a deliberate statement of Quaker beliefs as they are of his 'primitiveness.' "[32] This would be an intriguing proof of a folk aesthetic, or at least a conservative tendency, were it not for the fact that Hicks moved beyond primitive technique in his last period. Two problematic assumptions here are that Hicks was always satisfied with his paintings and that his au-

dience perceived local values in them. Quakers may have been known for their plain dress, but Quaker plainness was not why Hicks's first paintings were simplistic in execution; the early canvases represent incomplete control of medium, genre, or technique. Because Winston does not consider the full body of Hicks's works he praises his early efforts as his most accomplished. Assuming that Hicks was happy with his first canvases, Winston assigns importance to them as vehicles of Quaker values and places them in a folk tradition, although Hicks did not.

A later biography by Edna S. Pullinger alleges that the Quaker doctrine of the "Inner Light," a spiritual faculty allowing perfect vision of God's will, can be found in Hicks's *Peaceable Kingdoms*. She observes that "the figures—men in animals' clothing—are shown touched by the Light in varying degrees. Most have yielded to its governance and are therefore at peace with themselves and with one another." Dwelling specifically on the faces of the figures, she writes:

These were the faces of men who, like the lion, the leopard, and the wolf, as depicted in the Peaceable Kingdoms of the 1840s, had passed through impatience and anger, through inertia and melancholy, and at last knew the blessed fruits of inward peace. They were like some of the solemn faces of elders sitting on the facing bench in Meeting, who, themselves touched by the inward Light, were leading others in prayerful attendance upon the Spirit.[33]

Pullinger not only attempts to prove too much with too little data but also bases her argument on the faulty assumption that a Quaker painter must paint Quaker subject matter. Some of the faces in Hicks's paintings of the 1840s were indeed peaceful, but many others definitely were not. By her criteria, earlier and later versions with grouchy lions, sullen leopards, growling bears, and the like represent "disturbed kingdoms." Are these works to be interpreted as conveying Quaker belief as well? If they are not, then were Hicks's beliefs only personal opinions which he manipulated as he saw fit? Or was the doctrine of the Inner Light simply not very important for the composition of his paintings? From his memoirs it appears that Hicks was a devout Quaker. His paintings, however, reveal that Quaker doctrine did not necessarily touch his artworks, at least in terms of their iconography.

Conceding that only some of the *Kingdoms* were truly peaceful, tranquil, and serene, Pullinger argues that it was significant that these were painted in the 1840s, near the end of

Hicks's life. She explains that his canvases mapped the progress of his growing spirituality: the earlier paintings showed discord, while the last ones reflected inner peace.[34] Yet even some of his last paintings show a lion lunging forward in a threatening gesture. Pullinger's linear model of progressive evolution toward peace of mind thus is too simple to describe accurately Hicks's paintings. Either Hicks faltered along the way to his dream of peace (which is entirely possible) or his paintings were not exclusively tied to religious issues. In light of the gaps in her argument, the latter would seem to be the case.

Eleanore Price Mather has written a number of articles and pamphlets that focus on specific aspects of Hicks's iconography.[35] She observes, as have other scholars, that there were distinct phases in the *Peaceable Kingdoms* and proposes that the changes in Hicks's paintings stem from theological, not artistic, motivations. Her proof centers on the meanings of the grapevine (fig. 77) pictured in the hand of the small child who leads the lion, and on the position of the lions in later canvases. Mather asserts that the grapevine symbol, which Hicks had appropriated from Westall along with the other figures of the child and animals, was a "statement of the orthodox Christian belief in the vicarious atonement of the cross."[36] When the American Quaker community split into two factions in 1827 Edward Hicks supported the followers of his cousin Elias. One of the major beliefs of the Hicksite faction concerned the primacy of the "Christ within" over the historical Christ of the Bible. Mather suggests that Hicks's rejection of orthodox Christian symbols demonstrated his compliance with the new priorities concerning Quaker doctrine. She claims that during the 1830s Hicks deliberately dropped the grapevine emblem, said to represent Christ, and used instead an olive branch or nothing at all in the child's hand. However, the very paintings inspired by the Quaker schism—six canvases with the Quakers bearing banners—do present the grapevine in the child's hand (fig. 85).[37] The point at which the grapevine disappears corresponds instead to a period of increased artistic experimentation. In the 1830s Hicks attempted to transform his *Kingdoms* into a more literal rendition of Isaiah's verses by adding more animals and more children as mentioned in the Bible. The content of the kingdom was continuously reshuffled throughout his middle period, because space had to be found for as many as fifteen figures; earlier paintings had included only seven. It seems most likely, then, that when Hicks used the beribboned cherub taken from a painting by Rigaud as a new model for the child who leads the lion, he did so for artistic rather than theological reasons. Rigaud's original shows the child bearing an olive branch, and an olive branch also

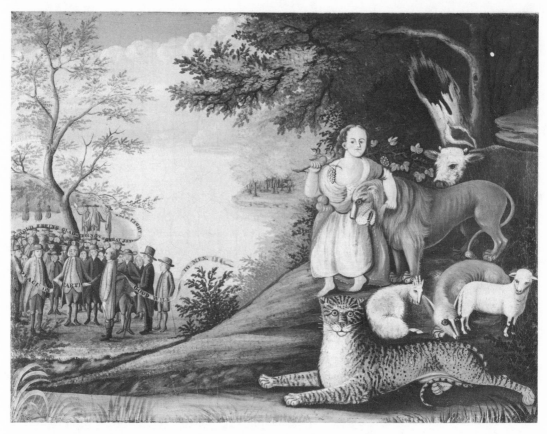

Fig. 85 Edward Hicks, *The Peaceable Kingdom with Quakers Bearing Banners*, ca. 1830, oil on canvas, 17⅝" × 23⅝". Courtesy, the Henry Francis du Pont Winterthur Museum, Winterthur, Delaware.

occurs in Hicks's first uses of that model; this borrowing underscores the importance of aesthetic rather than doctrinal influences in these paintings.

Mather is correct in asserting that the lion is more prominent in Hicks's middle (fig. 82) and late periods. Her interpretation of this shift, however, is not fully supported by the evidence. The lion is not always the central figure, even though he is often large and impressive. Sometimes he is placed at the edge of the canvas, in other instances in the lower foreground. The *Peaceable Kingdoms* of the mid-1830s present him staring menacingly back at the viewer, but in a number of versions he is shown in profile. The king of beasts in Hicks's vision does not always have a kingly presence; he is occasionally portrayed (fig. 83) according to Isaiah's dictum, "The lion shall eat straw like the ox." Mather notes, "In this configuration we see the effect of the mystical Inner Light softening the fury of the lion into the docility of the ox. The lion so far overcomes his self-will as to accept his companion's vegetarian diet."[38] But the question arises as to whether this portrayal stems from a Quaker stress on humility or Hicks's personal concern for specific biblical images. His variable treatment of the lion motif suggests that his personal view-

point overshadowed the importance of Quaker dogma. Mather herself writes of Hicks's animal imagery:

If the new iconography and composition do not represent a change in theology, they do reflect a new dimension psychologically. Tension, not serenity is their dominant mood, a tension concentrated in certain beasts: the old lion, the young lion, and leopard—all animals in which we suspect the artist saw himself. . . . It is obvious to a sensitive viewer that in these Middle Kingdoms we are dealing not with animals, but with human emotions that come straight from the stormy heart of Edward Hicks. Fear that is almost paranoid stares at us from the eyes of this lion. For in seeking a new symbol he had found a new hero, in outward form a lion, but in actuality, himself.[39]

Clearly, Hicks painted from his own vision, one which was influenced by his religious experiences. But his paintings are his art, not Quaker art. A prime clue to such an interpretation is his constant juggling of characters. There are ever more figures, new figures, new positions for them, different backgrounds and foregrounds, modifications of vegetation, changes in the quality of light—an endless program of variation. With any other artist this behavior would be called innovation or play, a key ingredient for creativity. But for the presumedly stern Quaker, the possibility that he might be playing with and therefore taking pleasure from his painting is simply dismissed. The physical evidence of the paintings suggests that this is a serious mistake. Moreover, Hicks also played with the very powerful and sacred words of Scripture: he converted the verses of Isaiah upon which his *Peaceable Kingdoms* are based into four quatrains, and with their A-A-B-B rhyme scheme they register only slightly above the quality of doggerel.[40] Hicks reacted to both words and art in the same way—he reworked them to discover and express his own vision. Uniquely individualistic expression cannot be folk art.

The current indiscriminate use of the term *folk*, according to Henry Glassie, has "confused the issue [of art classification] beyond the possibility of meaningful communication."[41] By ignoring the fact that folk art exists in communities and expresses collectively held values that may direct and focus an individual artist's creativity, many writers have celebrated Hicks for doing something he did not do. Since the 1950s Hicks's personal idiosyncrasies have been well known, yet art collectors, dealers, and museum curators continue to insist that his openly derivative, privately motivated paintings are representative of Quakers, nineteenth-century America, or the

common people. The gap between the reality of Hicks's works and their debatable attribution is aptly expressed by Mather, who terms Hicks a "supreme folk artist, but not a typical one."[42] Edward Hicks has become a folk artist, it seems, by virtue of the sheer weight of the commentary written about him. Declared a folk master at the beginning of American interest in folk art, Hicks has acquired an ever-expanding reputation from the studies discussed here, even though they show little understanding of the nature of folk tradition.

QUAKER AESTHETICS IN HICKS'S PAINTINGS

Although previous scholarship has failed to make a defensible case for the authenticity of Hicks's work as folk art, there is a way to assign his paintings a measure of folk cultural validity. Instead of conducting a content analysis of his works we should examine the painter's role in a Quaker community; it is not *what* Hicks painted that made his paintings pertinent to Quaker tradition but the way he conceived of painting. If Hicks's paintings do constitute an expression of folk art, their meaning will be found in the collectively shared opinion that forms the basis of a folk tradition.

Scholars who have extensively praised Hicks for his creative genius have been perplexed, even disappointed, to find that he held a low opinion of his art. He acknowledged ashamedly that he had "an excessive fondness for painting." He was moved to apologize for his talent because he believed that art constituted a "formidable obstacle to the attainment of that truly desirable character, a consistent and exemplary member of the Religious Society of Friends."[43] He repeatedly wrote that salvation was to be found in the "path of humble industry," stressing the contrast between practical occupations and his own frivolous pursuit of easel painting. He was never more critical of himself than when he wrote, "I am nothing but a poor, old, worthless, insignificant painter." To Hicks art was the source of many human shortcomings; he saw in easel painting a moral dilemma resonating with spiritual danger:

If the Christian world was in the real spirit of Christ, I do not believe there would be such a thing as a fine painter in Christendom. It appears clearly to me to be one of those trifling, insignificant arts, which has never been of any substantial advantage to mankind. But as the inseparable companion of voluptuousness and pride, it has presaged the downfall of empires and kingdoms; and in my view stands now enrolled

among the premonitory symptoms of the rapid decline of the American Republic.[44]

It was with marked reluctance that he continued to paint, often claiming that he did it solely for the money. In an 1838 letter he confided to a friend who was selling some of his paintings, "I don't care much about them. The object of my painting them was to try to raise money to bear out my expenses in my late journey. It is all now done and settled. Therefore they are of but little consequences." But in this same letter he also demonstrated a sense of salesmanship: "Keep them out of sight, hung up in some upper rooms till some suitable person should be at thy house that thou might think would like to have one. Thou then might show them."[45]

Hicks was troubled by his painting, but on some occasions he expressed a quite different perspective. He wrote of one of his artworks in 1844, "I send thee by my son one of the best paintings I have ever done," and to help clinch the deal he added parenthetically, "and it may be one of my last."[46] He shrewdly realized that a customer would relish something of special status and thus not quibble over the cost. Many of his *Peaceable Kingdoms* were gifts for his friends; Hicks likely enjoyed painting these pictures and probably felt little guilt in their creation. Early in his career as a painter a friend had counseled him, "Edward, thee has now the source of independence within thyself, in thy peculiar talent for painting. Keep to it."[47] This comment and other positive public responses lifted the burden of self-doubt that weighed heavily on him, so that at times he saw his painting as a worthwhile and proper occupation. The events surrounding his last canvas clearly illustrate a strong desire to leave behind a legacy in art. As his health failed and his death approached, he struggled to complete a *Peaceable Kingdom* (fig. 83) for his daughter. Sensing in July 1849 that he would not live through the summer, he worked diligently on the painting. He finished it on August 22 and died the next day.[48] Evidently his will to paint had sustained his desire to live.

How does one account for these two radically opposed viewpoints? The positive attitudes do not follow the negative ones in time; Hicks expressed both alternately throughout his career. Having declared in 1844 that he had done one of his best paintings, he wrote in his diary in 1847, "it seems a pity that my business should be of such a character as to be of no real use to anybody but myself."[49] Hicks himself said "my poor zig-zag nature predisposes me to extremes," but his radical reversals of opinion do not represent simply a personality trait of a moody individual. Richard Bauman has demon-

135

strated that spiritual quandaries quite like Hicks's "zig-zag nature" commonly were manifested in Quaker linguistic attitudes and were, by extension, an integral aspect of Quaker life. This condition stemmed from the religious requirement to suppress worldly values and self-will, which was constantly at cross-purposes with the natural human proclivity during religious meetings to express deeply felt convictions in moving, emotional, self-serving words. Bauman summarizes this crisis as follows:

The reconciliation of the human necessity of speaking with the spiritual need for silence was a problem that every member of the Society of Friends had to contend with throughout his life as a Quaker. . . . The true Quaker directed his behavior toward making his life maximally expressive of spiritual truth, with the understanding that a silence of the outward man was the best way of doing so. Although this was a goal of existence, however, it was essential that an earthly component be present in one's life, in order to maintain an element of spiritual struggle, for the doctrine of salvation through suffering was also central to Quakerism. The tension between the natural and spiritual faculties—between speaking and silence—was a necessary component of the Quaker experience.[50]

Hicks's feelings about painting thus were very similar to the tugs and pulls that most Quakers, and certainly all Quaker ministers, felt about speaking at meeting. Moral questions concerning worldly pleasures were compounded when he painted pictures—objects inherently overt, physical, and worldly. A spoken message could be construed as a direct communication from God, but there was no way one could make a painting and claim that God had applied the pigment to the canvas.

Winston credits the inhibitions in Quaker culture with informing Hicks's limited style of figural representation. This conclusion is spurious because Hicks eventually moved beyond the distortions of his early career as he mastered the techniques of illusionistic easel painting. However, Winston's formulation that the Quaker aesthetic involved a "contradiction in that it denied the aesthetic but could not escape the aesthetic impulse" is helpful in identifying an aspect of genuine Quaker world view in Hicks's works.[51] Just as the Quakers were cautioned to keep silent at meeting, so too were they warned to avoid showy displays of art in their homes. Robert Barclay, foremost among the Quaker theologians, listed in *An Apology for True Christian Divinity* (1679) a number of rules; Proposition XV, which condemned "unprofitable plays, frivo-

lous recreations, sporting and gaming," was assumed to extend to works of art.[52] Thomas Clarkson's *A Portraiture of Quakerism* noted specifically under "Peculiar Customs" that the Friends observed the prohibitions of their faith closely and shunned almost all pictures as superfluous. He wrote, "They are not brought up to admire such things, and they have therefore but little taste for the fine and masterly production of the painter's art. . . . There may be here and there an individual who has had a portrait of some of his family taken, but such instances may be considered as rare exceptions from the general rule."[53]

Quakers avoided paintings just as they avoided secular forms of verbal art such as jokes and folktales, but they could not avoid these expressions all the time. They had to employ spoken forms of communication at their meetings, and on occasion they tolerated witty statements during informal conversations.[54] Hicks surely was more affected by the Quaker teachings regarding paintings since he relied on a forbidden expression for his livelihood. Hicks's talent for drawing and painting probably caused him great anguish because it seemed to lead him away from the salvation he sought so actively.

The legitimate designation of Hicks as a folk artist is linked to this crucial inner debate, motivated by observance of communal standards. The quality about him that is traditional is his wholehearted commitment to and participation in Quakerism. His canvases themselves are derivative amateur paintings of the nineteenth century and consequently must be judged as personal statements, not as expressions of folk culture. Seen, however, in conjunction with the major themes of Quaker belief, they represent the locus of the critical decision that every folk artist must make—to obey the rules of one's society, to put social values ahead of personal desires. In Quaker society, painters could only feel guilty about exercising their talents.

Although the Quakers did not encourage the possession of pictorial images, they did not prohibit them altogether. Clarkson had found early in the nineteenth century that in addition to occasional family portraits the British Friends usually owned a print or two. The most common of these were a plan of Ackworth School, a cross-section of a slave ship, and a rendition of West's *Penn's Treaty with the Indians* (fig. 79). These pictures embodied the Friends' interest in education, abolition, and the saga of Penn's "Holy Experiment" in North America. Indeed, West's historical picture was so popular that it could be interpreted as virtually a Quaker icon.[55] But even as they found ways to enjoy works of art Quakers carefully monitored their use of pictures. Clarkson observed that prints were kept

137

in folios where they might be put away until needed as a source of inspiration or study.[56] Treated as elements of books, pictures could not be construed as having a decorative and therefore sinful function.

Quaker aesthetic prohibitions on the American side of the Atlantic, however, were not observed so diligently. Almost from the moment of their arrival in the colonies wealthy Quakers seemed determined to stray from the established doctrines regarding plain behavior. They were reproved for their fancy possessions and warned "that no superfluous furniture be in your homes, as great fringes about your valances, and double valances, and double curtains, and such like needless things."[57] To hang a painting on a wall would certainly have met with criticism. Many well-to-do Friends found ways to circumvent the dicta handed down at meeting. In 1738 John Reynell ordered some furniture to be imported from London, including "2 raised Japan'd Black Corner Cubbards, with 2 Doors each, no Red in 'em, of the best Sort but Plain."[58] He was clearly winking at the rules, staying just inside the boundaries of Quaker decorum.

Rules against pictures were often avoided by ordering silhouettes. The black or white profiles could not be termed pictures but still were evocative likenesses. The 1844 silhouette scene done by August Edouart for the Underhill family (fig. 86) includes detailed renderings of the carpet, furniture, mirror, windows, blinds, and a flower vase. Only the features of the people are left out. This picture stops just short of the usual nineteenth-century conversation piece and shows that some Quakers willingly violated their plain aesthetic with visual images.[59]

Well-off Quakers were expected to live differently than poorer Believers. During the eighteenth century Quaker merchants in Philadelphia acquired elegant furniture, silver tankards, china tea services, and dressed in velvet, seeming to be Quaker principally in name.[60] Such a group of Quakers would have treasured paintings, particularly portraits, and would have eagerly received imagery like that of Hicks. It might have been acceptable for rich Quakers to celebrate their status with fine things, but for a primitive Quaker like Hicks painting was still a burden. His rural meeting was decidedly more conservative than that in Philadelphia and consequently he could not readily allay his feelings of anguish as noted Quaker businessmen had. John Comly, one of his closest friends, worried that Hicks was going to be trapped in "the mire of paint."[61]

Tired of prohibitions placed on him by his faith, Hicks once preached a sermon on the value of art in life. His enthu-

Fig. 86 August Edouart, *The Underhill Family*, 1844, paper and ink on paper. Whereabouts unknown. Photo: Anna Cox Brinton.

siastic and forceful defense of painting so disturbed the meeting that a committee was appointed to condemn him for his testimony.[62] Thereafter he was careful to note that he was only an "insignificant painter" and that his art was of "no real use to anybody." Yet some Quakers managed to accept his painting; one of them wrote in 1841 to thank Hicks for a *Peaceable Kingdom* and noted, "Your historical paintings are useful."[63] The picture thus was accepted for its didactic potential rather than its artistic merits.

By the 1840s country Quakers were approaching the worldliness their city cousins had achieved a century earlier. Joseph Watson of Middletown Township outside of Newtown commissioned Hicks to paint a version of the *Peaceable Kingdom* in 1844. He apparently conceived of this work as the crowning touch to a room full of new furniture: along with the request for the painting he also commissioned a local cabinetmaker to provide an Empire-style pier table with a white marble top and legs in curly maple and decorated with lyre designs. The table, designed to rest flush against the wall, was placed just below the painting as embellishment to the privileged space decorated with Hicks's scene.[64] The increasing popularity of his *Peaceable Kingdoms* signaled the demise of old-style Quaker fervor, and therefore those paintings have an inverse relationship to the Quaker tradition.

The explanation of why Hicks was tolerated by the Friends of Bucks County must include more than the gradual lessening of prohibitions regarding art; the generosity of his meeting and the genuine piety of the man also were important factors. In a memorial to Hicks issued by the Makefield monthly meeting in 1851 only passing reference is made to his paintings and great stress is placed on his ability as a "forcible" preacher. The clerks of the meeting wrote in parentheses of his painting that it was "the only business he was able to

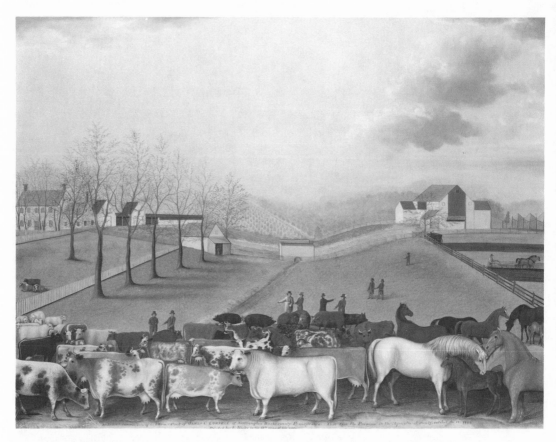

Fig. 87 Edward Hicks, *The Cornell Farm*, 1848, oil on canvas, 36¾" × 49". National Gallery of Art, Washington, D.C.; Gift of Edgar William and Bernice Chrysler Garbisch.

follow."[65] They knew of his perpetual indebtedness and his failings as a farmer; in his own words, "for notwithstanding I worked hard, I went behind daily."[66] Rather than drive Hicks into bankruptcy by imposing a strict orthodoxy, his neighbors tolerated his painting as a pragmatic, albeit problematic and offensive, solution to his financial problems. Moreover, the condition of his health dictated sympathetic treatment. The Makefield meeting's testimony noted, "For many years he was afflicted with a cough, which of latter time increasing, attended with shortness of breath, disabled him for distant journeys."[67] He therefore could not have been expected to perform the strenuous chores of cultivation and animal husbandry even if he had wanted to.

Hicks was an exception to the normal Quaker rules and was allowed to paint even though paintings were generally considered prideful extravagances. Suspension of the Quakers' behavioral code in Hicks's case may have actually reinforced group identity for a time, because the single exception to the norm reminds others all the more of what is expected of them. Given that Hicks was set in a category beyond the usual Quaker moral sanctions, his paintings cannot be construed as representing the Quaker world view. The main connection

140

between Quaker belief and Hicks's artworks was that their existence afforded the Newtown Friends an opportunity to exercise charity.[68]

The paintings that come closest to expressing the Quaker tradition are Hicks's four pictures of family farms in Bucks County done for the Cornell, Hillborn, Twining, and Leedom families. All share a similar design and depict homes, barns, outbuildings, equipment, and livestock, as well as family members and hired hands engaged in various tasks and duties. The formula employed by Hicks may derive from John A. Woodside's *County Fair* (1824) or other scenes of Pennsylvania farms.[69] Although *Cornell Farm* (fig. 87) is very close to Woodside's painting, Hicks claimed to have painted James C. Cornell's estate from sketches done on the site. Indeed, the lateral arrangement of the buildings in this farm scene and his others conforms to the linear pattern typical of a mid-Atlantic farm layout.[70] The architectural forms depicted also are faithful to the double-pile houses and bank barns representative of the region's vernacular architecture.[71] Because Hicks inventoried actual farmsteads his pictures served as records of real family achievement. In fact, the scene of the Cornell farm bears a long inscription that reads in part, "Farm & Stock of James C. Cornell of Northampton, Bucks County, Pennsylvania, That took the Premium in the Agricultural Society: October the 12, 1848." Prizewinning stock was an important family asset, and each of Hicks's farmscapes includes animals equal to Cornell's ribbon winners. These farm paintings provide an ethnographic view of the everyday experience of Hicks's rural Quaker neighbors, what might accurately be termed Quaker folklife. There is folk content here, even if it is not presented in a folk format. In depicting how particular people lived and worked, however, Hicks also idealized them. His four known farm paintings express a peaceful prosperity, the just reward for following the "path of humble industry." Hung in Quaker homes, these paintings were useful reminders that one's energies were best devoted to hard work, virtuous living, family, and community—themes repeated constantly in testimonies given at Quaker meetings.[72] Some of these sentiments might be found in the *Peaceable Kingdoms*, but finding them required much contemplation. By contrast, the promise of peace and prosperity was plainly evident in the farm scenes. It was these paintings that clearly presented a people's vision of themselves. Ironically, the reason these paintings could be publicly enjoyed at all stemmed from the changes that occurred in American Quakerism during the middle of the nineteenth century. Becoming less ascetic and more materialistic like most middle-class Americans at the onset of the

Industrial Revolution, Quakers lost some of their distinctive traits of thought and action as they gained an appreciation for paintings of pastoral landscape.

The Quakers had no pictorial art of their own, and so Hicks's works could never be embraced openly and enthusiastically. Nevertheless the plain mode of painting he developed through study of and experimentation with fine art imagery eventually did find its way into the homes of some of his neighbors. It was the kind of art they could accept as they began to question the iconoclasm of their faith. Those who dared to commission Hicks to paint a scene were groping toward an appreciation of art, just as Hicks had as much as thirty years earlier. In a modest way, then, Hicks lead the Newtown community to a new awareness, filling the role of an innovative contemporary artist rather than a traditional folk artist: the former challenges social conventions, the latter reinforces them.

CHAPTER SEVEN

The Twentieth Century: Grandma Moses, Modern "Primitive"

Fig. 88 Alex Bender, *Anna Mary Robertson Moses*, ca. 1950, photograph. The National Portrait Gallery, Smithsonian Institution, Washington, D.C.

When "folk" paintings became popular during the first few decades of this century there was a mad rush to obtain as many as possible—ideally at bargain prices. The walls and shelves of antique shops reportedly were stripped of old pictures.[1] But as venerable, old-timey paintings became more scarce a new sort of "folk" painting emerged on the art scene: the twentieth-century primitive. The art market terminology that was developed to promote these new paintings was influenced to a great extent by the career of Anna Mary Robertson Moses (1860–1961), popularly known as Grandma Moses (fig. 88). She was not the first modern primitive to be discovered, but once she achieved recognition as a folk painter all other alleged folk painters were measured against her example. So influential on the art market was Grandma Moses's reputation that one gallery owner recently declared her the "mother of 20th-century folk art."[2] How Moses arose from the obscurity of farm life in upstate New York to a position of national prominence is an intriguing story which has been well documented; her connections to a folk tradition, however, are alleged or assumed rather than substantiated. In tracing the contours of her career, this chapter will examine the legitimacy of designating Grandma Moses as a folk artist as well as general perceptions of American folk art during the twentieth century.

Born in 1860 in Greenwich, New York, Anna Robertson Moses gave most of her life to the domestic routine typical for farm women of the time. At the age of twelve she was hired out to work on a neighbor's farm where, for the next fifteen years, she cooked and kept house.[3] Yet there were a few occasions for artistic expression during her early childhood, and she took full advantage of them. Her father, Russell Robertson, frequently provided his children with large sheets of newsprint paper on which to draw and paint. During sessions of this sort of creative play Moses drew scenes of hills and

pastures, which she called her "lamb scapes." Her childhood sketches—a foretaste of her famous pastoral images—apparently were good enough to earn adult approval. In fact, a teacher once asked to keep a map she had drawn during a geography lesson because of the beautiful way in which she indicated mountains.[4] But her mother considered art frivolous and sternly advised her daughter to pay more attention to her chores: "Mother was more practical, thought I could spend my time in other ways."[5] Anna married Thomas Salmon Moses when she was twenty-seven and undertook domestic life; she kept house, helped her husband run a profitable dairying business, and gave birth to ten children, five of whom she raised to maturity. Although she was sixty-seven before she returned to making pictures, Moses was always artistically inclined; as one of her daughters recalled, she painted the walls and ceilings of her homes in a variety of contrasting colors, frequently changed wallpaper to suit her mood, and decorated her cakes and pies with fancy designs.[6]

After the death of her husband in 1927, when she was living with her children in retired status, she focused once more on easel art. About 1935 she tried painting as an alternative to embroidering scenes; afflicted with arthritis in her fingers, Moses found needlework too painful. She displayed some of these paintings at local fairs and church bazaars, but they drew little interest; her preserves and jams won ribbons while her pictures were ignored. Moses therefore painted only sporadically for her own amusement. The art career of Anna Moses was to change dramatically in 1938, when Louis J. Caldor, an engineer and art collector from New York City, chanced upon several of her paintings in the window of Thomas's Drug Store in Hoosick Falls, New York. Immediately taken with them, he inquired where he might find more and was directed to the Moses farm in Eagle Bridge. He bought all the paintings she had. In fact, because he asked for "about ten," Moses cut one large picture in half because she only had nine on hand.[7] Caldor became her "angel." He provided her with painting supplies and materials, encouraged her to continue painting, and sought out New York City galleries that would show and sell her work. Without Caldor's enthusiasm Moses probably would have remained an obscure amateur painter.

What actually prompted Caldor's devotion to Moses's work remains a mystery, but its eventual acceptance and celebration had as much to do with developments in the world of art as with the images she painted on board and canvas. As Caldor undertook promoting Moses galleries, museums, and art critics were expressing deep interest in the roots of modern

144

art. One if its acknowledged sources was the work of European amateur or Sunday painters, the most noted being Henri Rousseau of Laval, France. The avant garde of Paris had discovered him as early as 1905, and he counted among his patrons the likes of Picasso, Braque, and Brancusi.[8] In their search for inspiration the French Moderns had already considered the content of the native arts of Africa, Oceania, and the Americas; they were attracted to Rousseau's pictures because his simplified images provided a local analogy to the art of distant primitives. Modern painters found in Rousseau's amateur pictures an example of what their general rejection of the academic conventions for form, color, and design might entail. Consequently they embraced him as a colleague, a circumstance that made him something of a celebrity and made his works worth collecting. Other amateur artists also discovered in the 1920s were likewise collected and celebrated. Paintings by Louis Vivin, Camille Bambois, and Seraphine Louis were added to the school of modern primitives.[9] The paintings of this school were believed to spring from an aesthetic unfettered by studio conventions and thus were thought to parallel, if not actually inspire, the modern movement.

Interest in European primitives spread to the United States in 1910, when Rousseau's paintings were shown at Alfred Stieglitz's 291 Gallery.[10] Almost two decades later American primitives were discovered. The first was John Kane, a disabled railroad worker from Pittsburgh whose pictures were accepted by the Carnegie International exhibition in Pittsburgh in 1927.[11] Thereafter his works were annually selected for inclusion in this prestigious art competition. Holger Cahill included paintings by a twentieth-century amateur artist, Joseph Pickett of New Hope, in his exhibition of American folk art at the Museum of Modern Art in 1932.[12] After Horace Pippin's paintings were discovered in the window of a cobbler's shop he was given a one-man show at the West Chester (Pennsylvania) Community Center in 1937.[13] These widely dispersed moments of attention were condensed into a solid declaration of approval at a 1938 exhibition at the Museum of Modern Art entitled "Masters of Popular Painting." Conceived as the final component of a series of exhibitions on the nature of modern art, the show presented the works of self-taught painters as analogues to Cubist, abstract, and Surrealist canvases.[14] In addition to presenting Kane, Pickett, Pippin and others in the prestigious setting of a midtown Manhattan museum, this exhibition also paired them with the famous European primitives. Paintings by Rousseau, Vivin, Louis, and Bambois, to name only the most prominent, all were included. The clear message of this exhibition was that just as European

primitives had provided inspiration for Europe's contemporary artists, so too might America's artists find new directions in the works of American primitives. To American artists debating the question of whether there was such a thing as "American art" "Masters of Popular Painting" gave an affirmative answer. *American* art, it was suggested, required the use of local resources, and America's primitive painters were proffered as one of those crucial resources.

During the 1930s and 1940s the climate of opinion in the art world was marked by an overwhelming concern for archaic, timeless, rooted essences. There was a feeling among the intelligentsia, and to some extent among the general public as well, that the larger civilization had become sterile and meaningless because of its industrial and scientific preoccupations. The antidote for society's ills was to be found in the seemingly untainted art of self-taught amateurs, who painted, it was suggested, purely from a deep need to create art.[15] It was no surprise, then, that Sidney Janis and Otto Kallir, two prominent New York gallery directors much interested in modern primitives, were pleased with Caldor's discovery. They sensed at once that he had found that unaffected, innocent, expressive power so frequently mentioned by the members of the art crowd. They saw in the pictures of Grandma Moses the "greater reality" that Wassily Kandinsky ascribed to naive painters, the more complete vision that he said stemmed from concentration less on the details of sight and more on the emotion of the experience represented. Many years later one commentator would say that Moses painted in the "colors of the soul."[16] Such appeals to the emotions were commonly made on behalf of modern primitives.

Caldor nevertheless was rebuffed initially in his attempts to promote Moses's paintings. He searched for almost a year for a gallery that would show her works; he agonized as people laughed at her pictures. But he pressed on, writing to Moses, "[I] have not permitted myself to be discouraged by the many negative answers, excuses and 'no's' that I have been receiving."[17] Finally in October 1939 he found Janis, who agreed to include three of her paintings in a show of "Contemporary Unknown American Painters" to be held at the Museum of Modern Art. Since this exhibition was not open to the general public, the impact of this show on Moses's career was negligible.

The first real break in the resistance to Moses's art came the following year when Kallir, director of the Galerie St. Etienne, offered to give her a one-woman show. Entitled "What a Farm Wife Painted," the show attracted considerable press coverage; *Time* magazine gave it two columns. Many

people attended the three-week-long exhibition, but only three paintings were sold. This low figure did not, however, signal public indifference. The show was extended for one month at Gimbels department store in conjunction with a "Thanksgiving Festival" promotion. A great deal of advertising was directed at Moses and her paintings. A pleasant, charming image was starting to take shape around the personality of Anna Moses; in one notice she was called "the white-haired girl of the U.S.A." She would soon become everyone's ideal grandmother.

When Moses first visited New York City as an artist she was relatively unimpressed with both the city and the ceremony held in her behalf. When asked her thoughts on her new-found fame she responded, "Well, people tell me they're proud to be seen on the street with me. But I just say, 'Well, Why weren't you proud to be seen with me before?' If people want to make a fuss over me, I just let 'em, but I was the same person before as now."[18] Statements like this confounded the art establishment. In the art world, public notice is craved and cultivated; even notoriety occasionally is perceived as beneficial. But Moses appeared not to want or need any of the art world's attention. Later she would write in her autobiography, "If I didn't start painting I would have raised chickens. I could still do it now . . . I never dreamed that pictures would bring in so much, and as for the fame which came to Grandma so late, that I am too old to care for it now."[19]

Moses's independence intrigued the New York press. A free spirit in a conformist age was a great story, especially when the free spirit was a little old grandmother. At first puzzled and somewhat dismayed with all the media attention, Moses eventually came to enjoy giving interviews. She joked with interviewers and at times turned the situation around, asking them the questions herself. No matter what she did or said, it was all good copy and worth reporting.

Press attention generated not only more stories in newspapers and magazines but also more opportunities for shows. In 1941 Moses won the New York State Prize at the Syracuse Museum of Fine Arts. The next year her paintings were included in an exhibition entitled "They Taught Themselves" held at the Marie Harriman Gallery in New York. In 1944 she had two shows at the Galerie St. Etienne and in 1945 a one-woman show at Madison Square Garden. Between 1945 and 1950 paintings by Grandma Moses were included annually in the exhibitions of the Carnegie Institute in Pittsburgh.

Moses's reputation also spread by a number of other ventures. In 1946 Otto Kallir edited a book, *Grandma Moses, American Primitive*, which was in its second printing by 1947.

Also in 1946 her pictures were first reproduced on greeting cards; a series of sixteen was published by the Brundage Company, each with a print run of a million cards. The following year the Hallmark Company signed a long-term agreement with Moses to produce a line of Grandma Moses Christmas cards; it is estimated that between fifty and eighty million of these cards were printed.[20] Without a doubt, Moses had become the best-known artist in the United States. Stories about her success continued to fill the news wires, and after 1947 her birthday was annually reported as a national event.

Her fame was raised to an even higher level in 1949 when the Women's National Press Club recognized Moses for "Outstanding Achievement in Art." In a ceremony held in Washington, D.C., awards were given to a group of five distinguished women—including Eleanor Roosevelt. President Truman did the honors and afterwards he invited Moses to Blair House for a visit; hordes of reporters followed. When asked if they had talked about politics, Moses responded, "No, we talked about ploughin'" and added, "he is a country boy like my own boys."[21] Truman's rural outlook was well known, but the approving words of the "nation's Grandma" were not to be ignored. Thereafter Truman always sent Moses a card on her birthday. In fact, Presidents Eisenhower and Kennedy also found it politically expedient to send birthday greetings. Of course, the gesture was always reported in the press.

Moses continued to have high visibility throughout the 1950s. Having entered into an arrangement with the Galerie St. Etienne, she worked at a more relaxed pace. She did more versions of her favorite pictures, many of which were exhibited in Europe by the United States Information Service. In 1952 she wrote her autobiography, entitled *My Life's History*, edited by Otto Kallir. Kallir also established a corporation, Grandma Moses Properties, Inc., that issued commercial licenses for reproducing her pictures in any medium. Included among the Grandma Moses products were high-quality prints, plates, drapes, and a wall mural. The mural was a four-by-eleven-foot copy of a rural scene, designed to be applied in sections like wallpaper. *Look* magazine reported of this venture, "What for little Anna Robertson was a work of handicraft in 1867 has become a booming business in 1956. Modern factories produce her home mural . . . in brilliant oil colors on washable canvas. Pre-trimmed to size, they can be easily hung by any paste-pot amateur."[22] The textile factory of the Riverdale Drapery Company produced a million yards of drapery fabric with a Grandma Moses scene woven in horizontal bands.[23] With all of these images available, during the

1950s Americans could encounter Grandma Moses at almost every turn. So successful were her licensing operations that Moses once joked, "I got a broken neck, I got it from leaning over to sign so many checks."[24]

As Moses neared her one hundredth birthday she received increased attention, for she seemed as vigorous as a much younger person. The public marveled at her energy and wanted to know the secret of her long and active life—how much she slept, how much and what she ate, and so forth. Reporters visited her frequently to learn the answers. In 1952 her life was dramatized on television with Lillian Gish playing the role of Grandma Moses. Moses herself appeared on Edward R. Murrow's television series "See It Now" in 1955. The show proved to be so popular that it was broadcast several times.[25] Moses died on December 13, 1961, at age 101. It is estimated that she painted over 1,500 pictures. Most impressive was the fact that she was painting right up to the end of her life. Never convinced that she was as special as so many had claimed, she worked unceasingly at her painting, seeking a perfection of her technique.

The large body of work Moses produced, although much admired by the general public, was quite problematic to art critics. Indeed her great popularity, in addition to clear signs of amateur status, made it all the more difficult for them to accept her art as important. Emily Genauer, for example, at first was intrigued with Moses's work, but in 1946 she recanted her earlier praises: "if you ask me whether this is important as art—which it certainly ought to be to merit such to-do—my answer must be an unequivocal no."[26] Moses's paintings, according to S. J. Wolf, suffered from a "feebleness in her drawing" even though her pictures were "sincere."[27] James Thrall Soby similarly observed in the *Saturday Review* that Moses's paintings had both positive and negative qualities; he said her art was "pleasant but extremely mild." As he pondered the Grandma Moses phenomenon he hit upon a formula to explain why her success was all out of proportion to her art: although she was a mediocre artist, she was a wonderful woman—"brave, vigorous, forthright, unspoiled . . . of great age and remarkable beauty."[28] Harold C. Schonberg later agreed, noting that Moses was "incredibly frail, incredibly old, incredibly indomitable, sound of sight and digestion."[29] To avoid the bad news that America's favorite painter was not really a great artist, commentators chose instead to praise Moses for her personal virtues. Only John Canaday dared to say what many felt about her pictures. In the lead sentence to her obituary in the *New York Times* he wrote that she "was not a very good artist by the standards

149

that prevail today, or for that matter, by the standards that have always prevailed in art of much consequence." However, he blunted the harsh edge of his criticism with kind words about her as a person. Canaday credited her with knowing "how magical it is to be alive" and concluded, "In a time when painters are befuddled both by life and by theories of life and art, Grandma Moses cannot be emulated. She can only be envied."[30] Ultimately, in the critics' view Moses mattered more as a person than as an artist.

That Moses was so routinely praised despite shortcomings in her artwork indicates the great success of the publicity campaign waged on her behalf. Each effort had a multiplier effect: exhibitions led to additional exhibitions, awards and prizes led to still higher honors, newspaper stories led to magazine articles, radio interviews led eventually to television specials. By the last decade of her life she had become a figure of national stature. In 1956 Vice-President Richard M. Nixon proclaimed her an "amazing woman of our time" and presented President Eisenhower one of her paintings as a gift from his Cabinet.[31] Another of her paintings, *July Fourth*, was already hanging in the White House, having been accepted by President Truman. It has recently been suggested that Moses's enduring appeal derives mainly from the qualities of her art, but it seems that her art was incidental to most of her followers. After she was declared a star, media commentary tended to focus mainly on her personal attributes—her beauty, vitality, charm, and the like. As Katherine Kuh explained in 1960, "Without her heart-warming story and equally heart-warming spirit, [she] could hardly have become America's favorite painter."[32] Even the staunchest defenders of conventional artistic criteria had to soften their criticisms; to offer hard words about Grandma Moses would have been bad form.

The perceived need to say only nice things about Moses's paintings often led to extremely syrupy pronouncements. Louis Bromfield, for example, wrote that her pictures "give one a sense of the profound and fundamental goodness of small things."[33] Alternatively, grandiose claims were made: "By believing in her paintings," wrote Soby, "we are able to believe that the past has never stopped."[34] Remarking generally on twentieth-century American primitive painters and on Moses in particular, Sidney Janis suggested that such artists "unwittingly arrive" at their final results, and that their works are characterized by a "pleasing awkwardness."[35] One does not normally consider paintings executed in a rather accidental and clumsy manner as having much merit, but in the case of primitive paintings features usually considered as mistakes are counted as positive attributes. Evaluations of primitive paint-

150

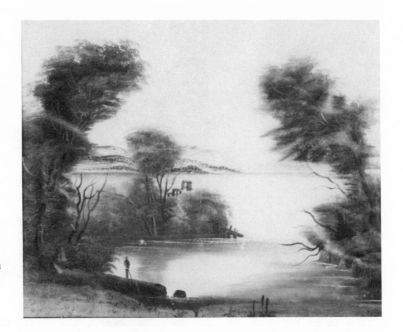

ings thus are often unclear and conjectural because the common meanings of critical terms have been twisted or inverted. For Moses the dilemma was resolved by either concentrating on her personality or describing in simple terms the style or content of her pictures. Commentary of this sort only proclaims "here she is" or "here it is"; neither strategy facilitates a deep exploration of the origins, growth, and impact of her art.

Comments about Moses's paintings also remain simplistic because of the expectations held for so-called primitives. Time is believed to pass them by as they create in blissful ignorance or innocence of the world around them.[36] It is considered pointless to search for traditional precedents, communal ideals, or customary formulas because these artists are seen as free of connections to historical context. Thus if a primitive is also referred to as a folk artist, as Moses frequently is, the term implies only that the artist is not a fine artist—conveying nothing beyond what is already evident. Given the longstanding adoration of Moses as a charming person or a quaint primitive, it has taken more than forty years for basic questions to be raised and investigated regarding her connections to a folk tradition.

In a recent detailed study Jane Kallir has set forth the developmental sequence of Moses's art, making it abundantly clear that her conception of painting, her selection of subject matter, and a good deal of her compositional strategy derived from the popular and commercial art of the nineteenth and twentieth centuries.[37] She painted the world of her own

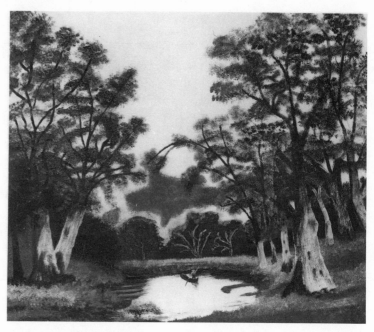

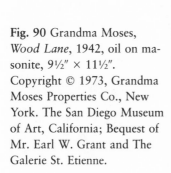

Fig. 90 Grandma Moses, *Wood Lane*, 1942, oil on masonite, 9½″ × 11½″. Copyright © 1973, Grandma Moses Properties Co., New York. The San Diego Museum of Art, California; Bequest of Mr. Earl W. Grant and The Galerie St. Etienne.

experience, but she filtered that vision through some of the conventional formulas of studio art.

Moses's earliest surviving painting, done in 1918, was a landscape fireboard on which she depicted a lake framed by stands of trees.[38] It is a scene very similar to a painting done by her father sometime before 1900. His painting (fig. 89) has a lake with large trees to each side but it also shows a spit of land extending into the water and includes buildings and a human figure. Little is known of Russell Robertson's artistic career; all that survives is this one landscape, apparently of the sort commonly suggested in nineteenth-century art instruction manuals. Its finished quality suggests that he was quite serious about his painting, a commitment he affirmed by encouraging his children to draw and paint. From the skimpy evidence that survives it appears that Grandma Moses was positively affected by her father's example, perhaps copying his pictures and certainly carrying on his interest in art. Schonberg reported upon visiting Moses when she was ninety-nine that a painting by her father hung on the wall of her painting room.[39] Its presence suggests that Robertson's work provided a continuous source of inspiration for his daughter throughout her painting career. Indeed, a landscape Moses painted in 1942 entitled *Wood Lane* (fig. 90) strongly echoes her father's work, as do other views of scenery painted up through the mid-1950s.[40] From his example Moses became familiar with academic conventions for subject matter, composition, and perhaps color as well. She understood very well the use of the diagonal element to enhance the illusion of depth (fig. 91); al-

152

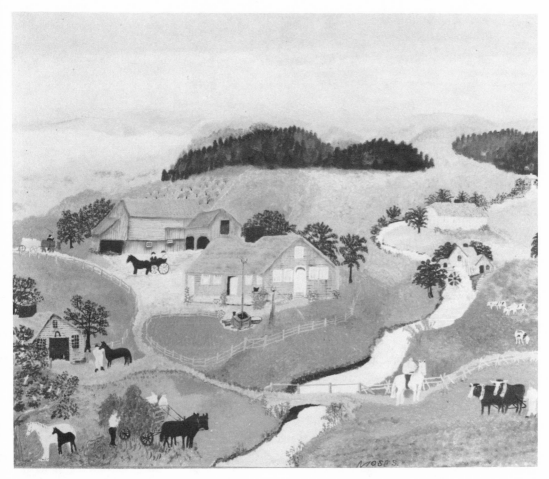

Fig. 91 Grandma Moses, *The Home of Hezekiah King, 1776*, 1943, casein on masonite, 19″ × 23½″. Copyright © 1973, Grandma Moses Properties Co., New York. The Phoenix Art Museum, Phoenix, Arizona; Gift of Mrs. N. A. Bogdan, New York, in Memory of Mr. Louis Cates.

most all of her landscapes have a pronounced diagonal feature in them. When asked how she designed a painting she responded that she always balanced her pictures: "a house would be placed on the right to harmonize with a tree on the left."[41] She clearly understood the need for deliberate composition; her paintings were not merely the results of spontaneous urges. Even though she never had an art lesson, she had internalized the academic approach to painting very early in her career.

Other important influences on Moses's paintings were the chromolithographs published by the Currier and Ives Company. She at first copied them stroke for stroke; her *Home in Winter* (1938) differs only slightly from its model *Winter Morning—Feeding the Chickens*, published first in 1863.[42] Moses's colors are different but the content and composition of the two pictures are identical. Although commercial prints are considered a popular medium, their content unquestionably derived from the studio tradition. Thus they provided Moses with another point of access to the academic art world

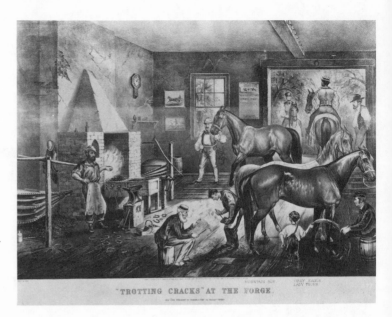

"TROTTING CRACKS" AT THE FORGE.

Fig. 92 Currier and Ives, *Trotting Cracks at the Forge*, 1869, lithograph. Courtesy of the Library of Congress, Washington, D.C.

and reinforced the example she had received from her father's paintings.

Moses began painting pictures based on her own compositions in the early 1940s and continued to do so throughout her career. As she acquired more experience with painting Moses depended less heavily on Currier and Ives sources, but she continued to use them for general inspiration and as models for particular details. In her painting *The First Skating* (1945), for example, she appears to have consulted Currier and Ives's *Central Park, Winter—The Skating Pond* (1862).[43] Moses located the pond in the rural countryside and scaled down the urban crowd to a more reasonable (and more manageable) two dozen figures. In the process of making the scene her own, however, she still lifted most of her skaters from the print. Six years later she showed more confidence in her own compositional abilities when painting *The Blacksmith Shop* (1951). In this picture she divided the board in half with a tall tree. To the right of this tree she reproduced figural elements from an 1869 Currier and Ives print, *Trotting Cracks at the Forge* (fig. 92), but to the left she created a farmscape of her own design. Segments of popular prints continued to appear in her paintings as late as 1960 (*The Wagon Repair Shop*, fig. 93).

Moses also was attracted to the scenery printed on Christmas cards as well as to rural images published in newspapers and magazines. She carefully clipped and saved these pictures and used them as models for components of her landscapes. Moses would rummage through her file of pictures until she found the house, horse, or buggy that she needed.

154

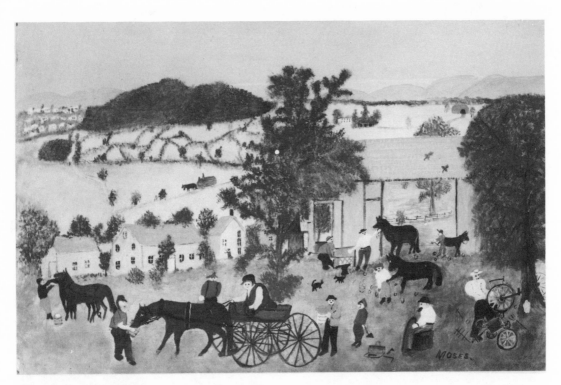

Fig. 93 Grandma Moses, *The Wagon Repair Shop*, 1960, oil on masonite, 16″ × 24″. Copyright © 1973, Grandma Moses Properties Co., New York. The Bennington Museum, Bennington, Vermont.

Placing them on her painting board where they best suited her composition—smaller elements to the top or background, larger ones to the bottom or foreground—she would trace around them with a pencil.[44] This stenciling technique helped her produce reasonably correct renderings of buildings, people, and animals.

It should be readily apparent that Moses's accuracy owed to the originals from which she made her copies. She had to copy from the works of others because she lacked the skill to render subjects freehandedly. Her own touch consisted mainly in arranging the different visual components into a harmonious order and selecting their color and degree of finish—features that are not unimportant, but clearly matters of style rather than content. Moses's pictures extensively derived from commercial images that matched her rural experience, and so it is an exaggeration to claim, as many have, that her work was wholly self-generated. Whatever ideals she had about painting were manifested chiefly in aspects other than content and composition. Far from being an aroused primitive, Moses worked in a careful manner, observing her own ad hoc rules of perspective and paying strict attention to the lines of her popular models.

Just as she gradually shed her dependence on commercial sources, Moses eventually established her own style of rendering. At first when she copied a picture she took pains to be

155

Fig. 94 Grandma Moses, *The Old Ox Cart*, 1948, oil on masonite, 6″ × 7½″. Copyright © 1973, Grandma Moses Properties Co., New York. The Bennington Museum, Bennington, Vermont.

Fig. 95 Grandma Moses, *Soft Green*, 1961, oil on masonite, 16″ × 24″. Copyright © 1973, Grandma Moses Properties Co., New York. The Bennington Museum, Bennington, Vermont.

exact; if there were a certain number of spokes in a wheel or clapboards on a house she would try to delineate each one. In her last paintings she abandoned this concern for detail, preferring a more impressionistic approach. This change can be seen by comparing *The Old Ox Cart* (fig. 94), painted in 1948, with *Soft Green* (fig. 95), painted in 1961. In the later painting her fluid brushwork produces an atmospheric quality in which foliage overtakes the buildings. One senses color before one recognizes form. This effect might be dismissed as resulting from a progressive unsteadiness caused by advanced age, but she herself declared as early as 1956, "I'm changing my style, getting modern in my old age, with a head full of ideas."[45] By 1956 Moses had been painting seriously for

Fig. 96 Grandma Moses, *The Shepherd Comes Home*, ca. 1935, embroidery thread on cloth, 14″ × 24″. Copyright © 1973, Grandma Moses Properties Co., New York. The Bennington Museum, Bennington, Vermont.

twenty years, a period during which she had had ample time and motive to reflect upon the way in which she worked and to analyze what she wanted to do. The experience of working constantly with pigment and brush, painting more than a thousand pictures, likely provided her with ideas about technique. After two decades of experimentation and growing confidence Moses realized that the mood she wanted to convey could best be captured with an impressionist rather than a realist technique. She had never been very accurate with minute details; further, no matter how hard she tried, she had tended toward impressionism all along. Consequently, after a long series of cautious steps Moses opted for a style that suited her intentions. This sort of progress again sets her apart from most of the naive and primitive artists with whom she is usually grouped. A deliberate change in her approach to painting indicates a level of consciousness that primitives by definition are not supposed to have. Hailed as an instinctive artist by such luminaries as Archibald MacLeish, Moses actually arrived at her technique through diligence and hard work.[46]

Jane Kallir has suggested that the roots for Moses's impressionist technique are to be found in her embroidered pictures (fig. 96). Kallir writes, "she was inclined to apply pigment the same way she applied yarn: in broad, smooth swaths, or short stitchlike daubs. Experience with embroidery taught her to isolate blocks of color to break forms into their component hues."[47] The transition from a craft format to a painterly mode might be interpreted as ample rationale to identify Moses's easel pictures as inspired by folk custom and practice. However, it is significant that her most impressionistic style emerged at the end of her career. The timing indicates that even if Moses's stitchery contributed to her painting style, other factors also had their impact. After she switched from

157

needlework to painting she learned how pigments produce their effect. For example, she recognized that particular tonalities are created by mixing colors in specific ways, and that a light ground would give a bright, almost radiant luster to her pictures. Painting is a different craft with different requirements that depends on the optical effect of layers of pigment, not on filling space with color. Moses seems to have realized that stitchery effects would not help her meet Caldor's requests to paint "more and clearer details."[48]

If there is a valid folkloric dimension to Moses's paintings it is to be found in their aesthetic underpinnings rather than in technique. Moses was first and last a homemaker. More than half a century of domestic tasks had shown her the value of order and cleanliness. When she turned to painting in the last years of her life she applied a domestic aesthetic sensibility. At the age of fourteen she had written in an essay on home life, "Then let man be happy in adorning his home, in making his home the dwelling of happiness and comfort. . . . Let industry and taste make home the abode of neatness and order, a place which brings satisfaction to every inmate and which on absence draws back the heart by the fond memories of comfort and content." She concluded that parents should provide their children with a "pleasant, a cheerful, a happy home."[49] Eighty-two years later she would express the same purposes for her paintings: "I paint to be pleasing, cheerful—enticing in color or scenery."[50] In her landscapes her roads are always in good repair, the walls are never broken, the houses are freshly painted, the air is clear, and the light is bright. Nothing is ever out of place, messy, or unkempt. Some have credited these qualities to her meticulous rendering of detail, but Dorothy Seckler was perhaps closer to the truth when she observed that Moses had applied "good housekeeping to painting."[51] Indeed, she painted her pictures from the top down so that by the time she reached the bottom of her board she was done. She might have swept or mopped a floor the same way, continuously from one end to the other. When she composed her landscapes, balancing one element against another and filling in the open gaps with elements of the proper size, it was like tidying up the living room in anticipation of visitors. John Canaday wrote that Moses presented her audiences with ordinary aspects of everyday life, yet she did not show the everyday world as it normally was—she dressed it up, as any diligent mother might, in its Sunday best. Her paintings convey, then, not the "everlasting morning of life" but an ideal of what the world should look like after all the chores are done.[52]

To draw a connection between art and housework is not to belittle Moses's paintings but to ennoble them and the cre-

ative vision that produced them. Moses's years of domestic work were not a time when her aesthetic gifts faded from lack of use. In fact, they were sharpened by a constant regimen of tasks intended to keep her household not only functioning but pleasant. The ideal orderliness of her house was later transferred onto board and canvas, where it became the ideal orderliness of her art. Millions of people instantly recognized it as attractive and reassuring.

Unlike the work of many primitive painters whose art spoke of estrangement, Moses's pictures encouraged reflection on the normative, the ordinary, the commonplace. Her artworks focused on the concerns and values out of which folk traditions arise and are perpetuated.

Moses depicted in an idealized manner the content of regional life in upstate New York, using a format derived ultimately from the realm of studio art. Although her paintings are generally about folklife—seasonal festivals, rites of passage, traditional games and occupations, and customary domestic routines—they are not themselves works of folk art. They did not result from any customary practice shared by the other people of her Hoosick Valley community, for her neighbors did not normally paint pictures. Moses worked in privacy producing pictures that no local person cared to buy; it was outsiders who made Moses important, initially for reasons unrelated to her abilities. In fact, when she was first hailed as a primitive artist her family took offense at the term, and Moses herself reported with some irritation that neighbors had called her up to find out if it was true that she could not read or write.[53] To her family and friends, Anna Moses was merely a nice grandmother who made excellent jam and occasionally painted copies of old lithographs.

The public relations efforts of the New York art world created the folk art label for Moses and made it stick. Fortunately for her promoters, Moses's discovery coincided with an attack by America's big-name artists on the established conventions of studio art.[54] Moses's pleasant scenes contrasted sharply with Abstract Expressionism, Surrealism, and action painting. It turned out that the general public yearned most for pictures like Moses's that were nonthreatening and easy to interpret. Modernist paintings, according to one art reporter, presented visual puzzles so difficult that viewers were hard pressed to know if they were looking at "a fricassee of a sick oyster or maybe an abscessed bicuspid or just a plain hole in the ground."[55] Grandma Moses's pictures presented no such problems. The millions of images of her paintings distributed throughout the country during the 1940s and 1950s sent a clear message to the art establishment, and it retaliated in

159

1950 by rejecting Moses's paintings from an exhibition held at the Metropolitan Museum in New York.[56] But this gesture of defiance mattered very little. Moses became a noted art celebrity and the best known painter in America. She became so famous that a category for her art was no longer needed; more than a folk, naive, primitive, amateur, or self-taught artist, she was simply Grandma Moses, the nation's grandma.

It is important that Moses no longer be thought of as a folk artist. That designation only prevents the accurate assessment of what she accomplished and how she did it. Starting from the example of the amateur paintings of her father and the popular prints of Currier and Ives, Moses began to paint copies of pictures for her own amusement. Once her art was promoted in galleries she assumed a professional demeanor and concentrated seriously on the content, composition, and technique of her artwork. Over the years she became a better painter, although never a great one. Nevertheless, she achieved a fame usually reserved for people of great talent. That she continued to work diligently after she had become quite famous says much about her commitment to art and her professionalism as an artist. She legitimately could be considered a fine artist (certainly for the last phase of her career), but given her lack of connection to the dominant studio idioms of the twentieth century such a label is unlikely. Referring to Moses as a plain painter may be the best alternative. The term accurately identifies the level of competence Moses was able to reach. Her paintings were generally plain versions of illusionistic easel art. While not without appeal, they were never as outstanding as her public notices would suggest.

Contemporary Plain Painting:
New Forms, New Criteria

Twentieth-century plain or "folk" painters are so strongly linked with the past that plain paintings and antiques often are considered to be the same thing. There is ample evidence of this point of view. The 1924 Whitney Studio Club exhibition that first highlighted plain painting for the New York art world, for example, was entitled "Early American Art." The next major folk art exhibition—"American Primitives," held at the Newark Museum—made it clear that a primitive was a nineteenth-century painter.[1] With the publication of *Some American Primitives* by Clara Endicott Sears in 1941 and Jean Lipman's *American Primitive Painting* in 1942 the image of plain painters as folk artists from an earlier time was firmly established. Lipman argued then that primitive painters had flourished only up to the middle of the nineteenth century, and she has persisted in this view. Only recently has she admitted that "there have been some, but not many, genuinely creative folk artists since the end of the nineteenth century."[2] With this grudging recognition of contemporary "folk" painters Lipman makes clear her view of the appropriate priorities of connoisseurs and collectors. In a retrospective account of her career as a dealer in American folk art from the 1930s to the present, gallery owner Adele Earnest acknowledged that Lipman's book was "our bible."[3] The book served as a basic reference work from the 1940s through the 1960s, outlining the evaluative criteria for judging paintings. While Lipman pointed to certain formal traits as positive features that might be understood as the seeds of modern art, the strongest message to readers was that the older folk paintings were the better. As recently as 1961, when a new museum devoted exclusively to American folk art opened in New York City, it was named the Museum of Early American Folk Art.[4] The adjective *early* in the title indicated that the antiquarian interests which had sparked the first exhibitions of plain painting were just as strong almost forty years later.

There was a natural fusion of collector interests in plain paintings and antiques. To be antiques objects need only to be old, and since the first plain paintings to be collected were works from the distant past they necessarily were of sufficient age to be regarded as antiques. Plain paintings were extremely important for antiquers chiefly interested in Americana because these works were alleged to stem from the deepest roots of the American experience. Moreover, those whose taste in collectibles favored the rustic rather than the refined also found plain paintings attractive since they often had rural origins or depicted rural persons or scenes. Dealers in antiques and Americana quite easily became dealers in folk art; they simply added a new category to their advertisements. Magazines for collectors of antiques became the major forums for opinions about folk art. For example, the famous 1950 symposium that attempted to define folk art was conducted in the pages of *Antiques* rather than in an academic publication such as the *Journal of American Folklore* or the *Art Quarterly.*[5] Such a crucial and scholarly exchange appeared in a commercial magazine mainly because folk art was widely understood as a portion of the antiques field; plain paintings were considered a subset of old country furnishings produced by semiprofessional artisans. Dealers and collectors might have debated whether the pictures were simply crude or done deliberately in an unconventional style, but they did not argue the fact that old paintings had monetary value as antiques. If they had marks of wear, a patina of use, the look of age, they were worth having—regardless of the skill of the artist.[6]

The early discoverers of folk artists chose to see plain paintings and various reputed folk objects as the antecedents for modern American art, a claim which was seconded by many folk art dealers and their clients.[7] Those who held a modernist view of folk art called painters primitives, a label intended to compare plain painters from New England with the creators of the tribal arts of Africa and Oceania. Tribal carvings and rural American portraits were worlds apart culturally as well as geographically, yet a deep psychological unity was suggested: tribal folk and country folk were alleged to possess the same innocence or naivete, which in turn gave them a primeval view of reality free from the contamination of modern civilization.[8] Despite the positive intentions of labeling folk artists as primitives, the term carried clear associations with exotic savages and uncivilized peasants—people who needed or deserved conquest and correction.

The vogue for primitivism is traceable to the actions of such celebrity artists as Picasso and Brancusi, who by 1905 had befriended the French amateur painter Henri Rousseau

162

and hailed his canvases as the manifestation of a natural and untainted primitive genius. Yet when Rousseau's paintings were displayed at the Museum of Modern Art in 1938, art historian Robert Goldwater warned that Rousseau was not the primitive folk artist his collectors had claimed: "true folk art is . . . always part of, understood by, and reabsorbed into the environment that has produced it. With Rousseau this is eminently not the case." He observed further that Rousseau had been motivated by fine art ideals and that his paintings were "but a stopping place along the road which he would have traveled if he could."[9] Goldwater asserted that Rousseau's art resulted from arrested development, a consequence of both his own modest level of talent and encouragement from supporters *not* to improve. Art created under such conditions normally does not merit high praise, but in the highly charged arena of aesthetic gamesmanship common sense is often suspended.

In the United States plain paintings by so-called American primitives were celebrated as the equal of works by the greatest academic painters. The rational voice of critics such as Goldwater had little impact. It was believed that American primitives would vitalize the American art scene, just as Rousseau and his fellow amateurs allegedly had done in France.[10] Cahill framed the case for them most succinctly in remarks that accompanied the 1938 exhibition "Masters of Popular Painting," held at the Museum of Modern Art: "During the past few years . . . the idea of art of the people has stirred large groups of American artists to enthusiasm. This enthusiasm has been nourished by the discovery that our country has always had an art of the people, a popular and folk interest in painting and sculpture, which has found spontaneous expression in the work of artisan, craftsman, and amateur."[11]

If the discovery of folk or popular expression gave rise to a new enthusiasm, one thing was reassuringly familiar about those artists: with few exceptions they were older men. Of the thirteen artists Cahill presented as masters of popular painting in North America, nine were over fifty years of age. Two of them were unquestionably old-timers: Edward Hicks, nineteenth-century Quaker painter, and Joseph Pickett, who was born in 1846. The tendency thus was to find primitives among the ranks of artists who could also be seen as antiquated. When Sidney Janis staged his exhibition "Contemporary Unknown American Artists" at the Museum of Modern Art in 1939, he selected artists such as Grandma Moses (born in 1861) and Morris Hirshfield (1872–1946, fig. 97). Janis's book *They Taught Themselves: American Primitive Painters of the Twentieth Century* (1942) featured thirty artists

Fig. 97 Morris Hirshfield, *Tiger*, 1940, oil on canvas, 28″ × 39⅞″. Collection, the Museum of Modern Art, New York; Abby Aldrich Rockefeller Fund.

of whom nine were deceased and thirteen were more than fifty years old. Folk painting was still so firmly controlled by an antiquarian mentality that contemporary folk art was generally thought to be paintings done by old-timers. Viewed as the art of another time or by artists oriented primarily to the past, these works became less a source of inspiration for modern art than a record of the also-rans found along the course of fine art.

Identifying folk artists as primitives prepared the way for a new attitude regarding the collection of American folk art. According to art historian Luigi Salerno, "each [primitive] painting is self-sufficient, each one captivates with its gripping reality."[12] Sociologist Howard Becker has said of the art of modern primitives, "Their works just are and can be described only by enumerating their features. Once described, they cannot be assigned to a class; each is its own class, because it was made without reference to anything else, and nothing else has been made with reference to it."[13] Understanding works of this sort thus requires only studying the individual artist; it is pointless to attempt to trace relationships to prevailing art styles. If such rootless paintings were acceptable as folk art, as museum exhibitions and oversized books repeatedly suggested during the 1930s and 1940s, then folk artists could be identified simply by finding artists whose work followed no conventional rules—painters, for example, whose pictures looked strange. Such painters were everywhere. New York City collector Sidney Janis only had to visit the exhibitions of amateur artists held at the Washington Square Outdoor Art Mart in Greenwich Village to find an artist like William Doriani, or make a short trip up to Manchester, Vermont, to attend the fairs staged by the Southern Vermont Artist's Asso-

164

ciation to discover the pictures of William S. Mulholland. To qualify as folk artists they only had to be alive and unmindful of studio conventions for pictorial illusionism; that is, their paintings had to manifest the simplified, two-dimensional look of the plain style. Since there was no counter opinion this art gradually came to be called twentieth-century American folk art. According to art historian Daniel Robbins, "Folk art had triumphed. It was collected; it had a market; it even provided a tradition for contending traditions; it was a source for whatever wanted proof in the contemporary scene."[14]

One important signal that a new view of American folk art was emerging was a change in the name of the Museum of Early American Folk Art. In 1966 the word *early* was dropped, allowing the museum to acquire works by so-called contemporary folk artists.[15] By 1978 the museum's permanent collection included forty-four paintings, sixteen of which were done in the twentieth century. In fact, eleven of these works were painted after 1970.[16] During the late 1960s folk painting was divided into two classes, antiques (pictures painted mainly by self-trained professionals before the twentieth century) and modern works (paintings done after 1900 by hobbyists and amateurs). The legitimation of this second category grew out of new fascination with artistic free spirits, people whose paintings compare closely with the works of Rousseau or the so-called Sacred Heart Group.[17]

The trend for collecting contemporary works of folk art is generally credited to Herbert Waide Hemphill, Jr.[18] In 1974, Hemphill and Julia Weissman published *Twentieth-Century Folk Art and Artists*, a book regarded today as the key reference work for collectors of modern folk art. Hemphill and Weissman ratified an expanded definition of folk art that includes recently created works. The lineup of new folk art features examples by almost 150 artists, more than half of whom are painters. Hemphill argues that their work is folk art because it is created by "everyday people out of ordinary life" who are "unaffected by the mainstream of professional art."[19] While this is true for some of these examples, such as the Mexican-American *santos* makers of Cordova, New Mexico, almost all of the painters knew something about the conventional requirements of an easel painting. Grandma Moses, John Kane (fig. 98), and Horace Pippin, to name but a few, had their paintings displayed in museums and galleries and were certainly aware of the activities and practices of the art world. Indeed in the late twentieth century it is hard not to know at least something about academic art. As Becker notes, "Any well-socialized member of a Western society know[s] what paintings look like and how they are done. The materials

Fig. 98 John Kane, *Self-Portrait*, 1929, oil on canvas over composition board, 36⅛″ × 27⅛″. Collection, the Museum of Modern Art, New York; Abby Aldrich Rockefeller Fund.

are widely available. Anyone with minimal drawing skills can easily begin painting, drawing images from conventional stereotypes, traditional subjects, or private obsessions."[20]

Hemphill essentially frees the definition of folk art from any social or cultural connection, claiming that "the vision of the folk artist is a private one, a personal universe, a world of his or her own making."[21] Even though Hemphill asserts that "the products of the folk art world are truly the art of the people, by the people, and for the people," his view of folk art reasonably can be summarized as art made by people of modest means who do as they please.

Hemphill urges appreciation of offbeat, eccentric, and whimsical works of art. In them, he suggests, one encounters a special vision that resides in the unconscious mind of the folk artist, a vision which he or she may not understand but which is important nonetheless. This is essentially the same defense of primitives that Kandinsky, Klee, and others made during

166

the first years of the twentieth century, repeated periodically by those critics and curators who wish to connect folk art to the modernist movement. What is new in Hemphill's statement on primitivism is that he applies his aesthetic evaluations to works created after 1950; in so doing he pushes the realm of folk art collectibles well ahead of the current dividing line between the antique and the modern. In Hemphill's view almost any object is worth having, although his personal preference is for "off-beat things made of found materials."[22] Such a perspective, once published, stimulated extensive collecting of paintings by artists regarded as outsiders and isolates. Previously collectors had considered such works disturbing and without aesthetic basis; however, in Hemphill's approach anyone could be a folk artist, no matter how cranky or crazy he or she might be.

Outsider art, which Hemphill attempts to legitimize, has been collected and studied in Europe since the first decade of the twentieth century. In 1922 Dr. Hans Prinzhorn published a lengthy monograph that presented psychological diagnoses based on the art produced by patients afflicted with schizophrenia and other forms of dementia.[23] This and other books generated a small following for this sort of art, an interest that expanded significantly after World War II. In 1945 artist Jean Dubuffet initiated curatorial concern for art he considered "beyond culture," what he called *art brut* or "raw art": the art of mental patients, children, and reclusive amateurs. Dubuffet's campaign eventually matured into the *Collection de l'Art Brut*, put on permanent display in Lausanne, Switzerland, in 1976.[24]

A similar concern for American artists at the margins of society was first demonstrated in 1968 by artist Greg Blasdel. In searching for what he called "grass roots artists" he turned up numerous visionary environments, examples of roadside decoration, and yard art that seemed to have few conventional precedents.[25] These "found artworks" accorded well with the sorts of objects Hemphill was amassing. In a conversation with Michael D. Hall Hemphill recalled of one of his forays: "I once found a pair of dolls made out of ceramic insulators. They were thrown on the floor of a Texas junk shop in the midst of a lot of detritus. I saw them as something special— something that is beyond tacky."[26]

When Hemphill displayed his collection at the Museum of American Folk Art in 1970 and then published much of it in his 1974 book, he succeeded in stretching the accepted boundaries of folk art. What had previously been considered bizarre and outré was now in-bounds. In 1981 Michael and Julie Hall staged an exhibition at the Philadelphia College of Art entitled

Fig. 99 Martin Ramirez, *Untitled*, no date, pencil, ink and crayon on paper, 31″ × 17½″. Collection of Herbert W. Hemphill, Jr. Photo: Jay Johnson.

"Transmitters: The Isolate Artist in America," and in 1986 the Museum of American Folk Art opened "Muffled Voices: Folk Artists in Contemporary America." The contents of these exhibitions suggest that American folk art collectors have forged a strong link with the *art brut* movement, but these collectors seem to have lost sight of the fact that such art frequently is the result of mental pathologies. Germaine Greer has warned of this sort of art, "it is certainly disturbing, especially when the work of any one such artist is seen in quantity and the relentlessness of the obsessions is communicated to an appalled viewer."[27] What is most reprehensible about this development is the distorted image it foists onto traditional cultures. If folk art is the art of the insane, then what is the worth of folk society and its members? Praising patients from hospitals for the mentally disturbed as great folk artists mocks real folk artists, who demonstrate their eminent sanity as they perpetuate traditions handed down through family lineages for generations.

From the moment of their discovery contemporary folk paintings have posed tough questions for anyone who might

attempt to interpret them. One would have to determine in them the boundary between art and craft, the varying influences of popular and traditional culture, and the relationship between personal aesthetic preferences and social restraints. But twentieth-century folk paintings resist interpretation. Created without any social connections and in a manner that often manifests little skill, they frequently are unique, one-of-a-kind pictures. Works like the drawings of Martin Ramirez (fig. 99) or the paintings of Morris Hirshfield make American folk painting exceedingly difficult to define with any precision; there is little fit between them and the sorts of paintings initially heralded as representative works of folk art. As a result modern folk painting is frequently defined in the negative—as those paintings that are not fine art, or as works of nonacademic art. It would be best to abandon reference to folk culture completely and simply refer to these contemporary, nonacademic pictures as modern plain paintings. It is, after all, their strong sense of outline and bright, unshaded colors—the attributes of plain painting—that attract and sustain collectors' attention.

Several varieties of contemporary folk painting compete for the collector's wall space. Robert Bishop has named a few of them: memory paintings, obsessive paintings, and neonaive paintings.[28] The memory painters are usually the easiest to identify: they are artists who concentrate on scenes of domestic life from yesteryear. They offer a chronicle of personal events and places, a local history composed of daily chores, seasonal changes, annual festivals, holidays, and a variety of pleasant memorable occurrences. The rural scenes painted by Grandma Moses, Mattie Lou O'Kelly, Fannie Lou Spelce, Clara Williamson, Minnie Rinehart, and Queena Stovall all fit comfortably within the category of memory paintings in terms of the content of their works.[29] In style, however, some of these artists are impressionistic, others are precisionist, and still others are given to abstraction. Personal historical content alone does not qualify a body of work as memory painting. When Ralph Fasanella visually recounts his tenement upbringing, he might appear to be a memory painter.[30] His paintings, loaded as they are with interminable detail, intrigue and delight the viewer (fig. 100). But just as often his pictures present surreal images and the rage of political protest, quite different from the typical memory picture scenes of domestic or small-town bliss. Fasanella is so driven, even compulsive at times, that he may fit better in the category of so-called obsessives.

Under the label *obsessive* are pictures by patients in mental institutions, social misfits, and visionaries motivated by personal fantasy or religious mission. Representative painters

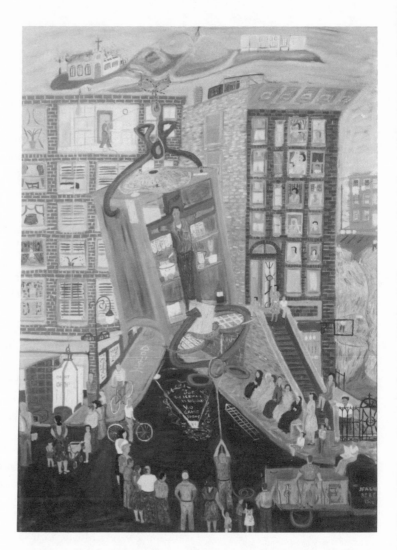

Fig. 100 Ralph Fasanella, *Joe the Iceman*, 1956, oil on canvas, 30″ × 40″. Collection of Mr. and Mrs. Maurice C. Thompson, Jr. Photo: Jay Johnson.

in this category include: Eddie Arning, Martin Ramirez, Bill Traylor, Reverend Howard Finster, Sister Gertrude Morgan, and Mose Tolliver.[31] Sometimes referred to as outsiders, eccentrics, or isolates, these artists have little connection with each other. Obsessive painting is really a catchall phrase for works that don't fit elsewhere, but as a group they do seem to be statements of the present; in this way they contrast sharply with memory paintings, which evoke a reverence for the past.

Contemporary studio-trained artists have been quite supportive of obsessive art. According to art historian Jonathan Fineberg, highly regarded conceptual and performance artists in New York consider the insane, the handicapped, and the very young to be very close to the origins of human creativity.[32] Since World War II a group known as the Chicago Imagists has valued alternative sources of inspiration. Some of these artists, such as James Nutt, Karl Wirsum, and Ray

170

Fig. 101 Lee Godie, *Portrait of a Woman,* no date, tempera paint on paper. Photo courtesy of Michael Bonesteel.

Yoshida, have regularly sought out paintings by outsider artists and self-trained naives. Bag ladies, recluses, and other creators of so-called "trash treasures" have become important local celebrities in the Imagists' circle.[33] Approval by teachers and students at the Art Institute of Chicago has conferred significant creditability on outsider paintings, but the personalities of these outsiders have as much appeal as their paintings. Portraits by bag lady Lee Godie (fig. 101), for example, are simplistic, but it is difficult to forget a person who dashes off in the middle of a conversation saying, "I've got to go, my hair's on fire."[34] The interest of contemporary fine artists in obsessive painters thus may indicate not the excellence of these works but rather the surprises to be found at the margins of society—the places most attractive to fine artists imbued with romantic and bohemian spirit.

Neonaive painters, the third of Bishop's categories for

Fig. 102 Barbara Moment, *Two Sheep*, 1983, oil on canvas, 20″ × 24″. Collection of Dr. and Mrs. David Bronstein. Photo: Jay Johnson.

modern folk artists, also might be called pseudonaives. These are trained artists who capitalize on the popularity of untrained artists by aping their simplified manner of rendering or by adopting their pastoral or imaginary subject matter. Their paintings are basically opportunistic ventures. Even so eclectic a connoisseur of contemporary folk art as Hemphill draws the line at such pictures: "The abundance of 'faux naives' or conscious naives . . . is muddying the water. Inspiration is one thing—exploitation is another."[35] Barbara Moment, for example, who retails her work through department stores such as Bloomingdale's and Marshall Fields, certainly is mindful of what appeals to the general public. Her pictures reproduce scenes from old lithographs and almanacs in a style associated with plain painting and are calculated to appeal to the current fad for nostalgic images of Americana (fig. 102). Moment and artists such as Susan Slyman, Susan Powers, Kathy Jakobsen, and Janet Munro might alternatively be called folk stylists, because their paintings have at least the look of memory paintings or naive landscapes and still-lifes.[36] However, since this visual effect is consciously contrived it cannot be granted the same significance as the work of genuine amateurs. Amateur painters, one presumes, do the best they can; neonaives paint less well than they might otherwise. Such works should not be confused with folk art, old or new.

Since any sort of picture now is a potential candidate for inclusion in the domain of folk painting, the definition of folk

art has become what Howard Rose has termed "an art-historical nightmare."[37] Yet one theme emerges in all of the defenses offered for the hodgepodge of works now counted as contemporary folk art: all of this work is described as equivalent to fine art. One of the most forthright claims was published in Alice Winchester's 1963 article entitled "Antiques for the Avant-Garde," which demonstrated how folk art might stand in for modern art. For example, if one didn't have a Modigliani to grace the living room, a New Mexican *santo* could be substituted.[38] Jean Lipman expanded on suggestions of this sort in her book *Provocative Parallels*. In this volume she established visual linkages between art she labeled naive and works considered to be masterpieces of the contemporary international idiom. Noting that her proposed relationships were only casual and based on serendipitous resemblance, she nevertheless reported that modern artists had long found value in the works of primitives, naives, and folk artists.[39] Lipman stated that folk and modern art are only parallel forms, but she strongly implied that they are equal, interchangeable expressions. This is indeed how collectors Rort and Betty Marcus view the matter. Ms. Marcus recently recalled the moment when she and her husband discovered folk art: "There was right away a love match between our love for modern art and folk art; the folk art seemed to us very modern in its pure, raw, expressive power."[40] Clearly, the Marcuses and many others collect folk art not because they value and appreciate its connections to folk societies but because it provides a point of access into the realm of modern fine art.

When critics, collectors, and curators make folk art the equivalent of modern art, they dismiss the actual conditions of its creation. According to Robbins, the effect of such treatment is to deny folk artists their "fundamental link with society's continually evolving ideal of art." He adds further, "Like a serf to his land, the folk artist remains chained to the organic nature of things—as if there were an organic nature of things."[41] Contemporary plain painters are basically denied the ability to produce art because their alleged unconsciousness places them in the category of the childlike or the inept. Collectors then obtain the power of creation by assuming that pictures have little inherent worth until they find them and connect them to their own modern aesthetic code. Such acts of arrogance reveal a significant aspect of the "organic nature of things" during our time: the financially better off have dominion over the worse off. In a society like ours, in which collectors exercise power over artists of all stripes, plain painters cannot be exempt from social control.

James Clifford has noted that the modernist movement in

fine art reveals disquieting aspects of Western society, particularly its "taste for appropriating or redeeming otherness, for constituting the non-Western in its own image."[42] Although Clifford's remarks refer to contemporary concern for the art of tribal peoples, they also apply to that local American "tribe" known as the common people. Many collectors pursue contemporary American folk art not because of their love of art but because of the "restless desire and power of the modern West to collect the world."[43] Anthropologist Nelson H. H. Graburn offers some insights into why this has happened: "*all* people (even the 'primitives') tend to want to make the unfamiliar less frightening and more 'understandable' by bending it to their own preconceptions." However reassuring such a tactic might be, Graburn warns, "The danger is that what often results is not the world as we know it, but the world as we would have it."[44] In other words, when a body of art is in hand the world, or least some part of it, appears to be under control.

At stake in the 1960s when collectors, dealers, and curators expanded the definition of American folk painting to include contemporary works was the matter of social power, the sense of superiority that accrues to the owner of property—especially prestigious property such as works of art. As long as folk paintings were restricted to canvases painted in the nineteenth century and earlier there was a limit on the number of discoverable pictures, and consequently only a limited opportunity to obtain the social power that accompanies their collection. But if folk painting could be defined as constantly evolving, as open-ended, the options for entry into this realm of social power would expand. If there is new folk art to collect, there also can be new collectors.

It is exceedingly ironic that spurious fine art criteria were used to expand the boundaries of folk painting. Traditional folk art of the sort usually consigned to preindustrial times is just as vital now as in the past. Collectors could have satisfied their need to acquire folk art with the authentic product: thousands of quilters, potters, carvers, basketmakers, weavers, blacksmiths, and other artisans are still at work perpetuating received traditions and modifying them with their own personal contributions.[45] For over twenty years the Smithsonian Institution has annually staged the Festival of American Folklife on the Mall in Washington, D.C. Every summer since 1966 this open-air exhibition has presented thousands of excellent folk artists to a visiting public which by now must number in the millions. These artists demonstrate how vital traditional art forms remain in communities throughout the country. Yet these artists' work has been consciously over-

looked, dismissed as mere craft, because greater prestige has always been associated with "purer," nonutilitarian art forms like painting and sculpture. Regardless of all the manifestos uttered by collectors in support of folk art, the bottom line in the art world is that the greatest status belongs to the owners of fine art. If one cannot enter that marketplace, a version of folk art that closely resembles modern abstract art serves almost as well. Given the terms with which it is usually described, twentieth-century folk art is really modern art created by artists who happen to lack a studio pedigree and who have no connection to folk culture, and it is consumed by collectors more interested in the art of the contemporary scene than in the art of traditional societies.

Conclusion

The capsule biographies presented in chapters 4 through 7 reveal not only the ways in which reputed folk artists worked but also the motives that actually shaped their aesthetic choices. In each case an alleged folk painter was either competent in or mindful of an academic idiom. The Freake limner opted for mannerism, as did Vanderlyn. Hicks paid close attention to landscapes, history paintings, and allegories as he fashioned a romantic vision consistent with the dominant sentiments of mid-nineteenth-century American painting. Moses offered Victorian sentimentalism as an option to the shock of modernism before she evolved her impressionistic mode of painting.

Traditional ideas and values were, however, part of the cultural systems that shaped how these artists and their clients perceived the world. The Puritans of New England set for themselves the regimen of a strict moral order that esteemed church and family over the individual. Celebration of personal achievement was tempered by a large dose of restraint; portraits, for example, had to look austere and provided only the mere outline of the person. A system of folk or communal values—a folk aesthetic—thus impinged directly on how the Freake limner set about his business even as he moved toward an artistic formula calculated to make the individual more important than any communal institution. Vanderlyn's Hollanders also had their local aesthetic codes, in their case replacing Dutch ostentation with English asceticism. In developing this new local taste they deemed Vanderlyn's mannerist images to be suitable signs of arrival in the social order. Although newly evolved, the mid-eighteenth-century tastes of the New York Dutch constituted a code of preference as pervasive as the modes of ethnic identity that had preceded them. Hicks seems to have demonstrated his Quaker beliefs in a negative way: he painted when he shouldn't have and worried constantly about what he had done. He was pardoned for his too worldly paintings, but his art only reminded the other Quak-

ers in Newtown that painting was not really allowed. Moses brought to her art the experience of six decades of domestic and maternal concerns. Although she diligently worked at mastering the painter's craft, those experiences and concerns were never far from her thoughts; in fact, they were so deeply embedded in her perceptions that they shaped both the content and the style of her painting.

Importantly, to discover a folk cultural connection in the lives of painters does not guarantee that their works are folk art. Rather, they are works of fine art affected to some degree by folk values. If they had really wanted to produce folk art these artists would have chosen other formats and other media: the Freake limner might have designed the heading for a funerary broadside, Vanderlyn might have stenciled decorations on case furniture, Hicks would have limited himself to verbal artistry, and Moses might have pieced a quilt. These are expressions with clear traditional precedents and the support of longstanding custom in their various communities. Instead, these artists chose the illusionistic easel painting, the most specialized and sophisticated genre of the studio tradition. Just as a novel written in dialect instead of standard English is no less a novel, so too an easel painting is not transformed into another kind of expression because of its content. If content were as important as form, then any genre painting would be folk art. Yet no one would ever declare William Sidney Mount a folk artist even though he painted folk subjects, nor Thomas Hart Benton because he did a series of paintings based on traditional ballads and folk songs.

Comparisons of the early careers of selected master artists and selected "folk" painters show that both groups acquired their painterly competence in the same way as they encountered the same kinds of technical problems and attempted to find similar solutions. The key difference between them was that the "folk" artists either had a longer period during which they continued to commit apprentice-level errors or never improved beyond amateur status. The people who purchased these paintings did so because of their resemblance, however slight, to academic portraiture and landscape. So strong was their desire to own painted pictures that they willingly lowered their usual evaluative criteria. Current collectors of these paintings behave in much the same way: they consider amateur works from both the past and the present as parallels or equivalents of modern fine art and buy them more for this questionable association than for their intrinsic quality. Like their nineteenth-century forebears, modern collectors are very concerned with the status that accompanies the ownership of paintings.

The artists presented in chapters 4 through 7 were participants in the academic tradition of fine art, but they were positioned closer to its periphery than to its core. The Freake limner and Vanderlyn were both late to catch on to dominant fashions. Hicks and Moses learned about fine art as it trickled down to them via popular prints and other commercial media. They all were followers of movements begun in faraway places by people they didn't know. If the fine art tradition were to be conceptualized as a pyramid, these four artists would be nearer to its base than its apex. Given their low position, it is highly unlikely that they will ever be recognized as the studio-based artists they were. Since their connections to folk culture were largely incidental to their art, an alternative designation is needed to replace the folk category to which they are usually assigned. The term *plain painter*, as suggested here, serves an important terminological need. It succinctly identifies artists who occupy the middle ground between fine and folk art, artists moving toward a fine art ideal but still connected to local traditions they may have to abandon.

Plain paintings are works of art that follow most of the conventions of illusionistic easel painting. What makes them different is that the illusion of three dimensions in these pictures is unconvincing if not nonexistent. One could say that these canvases are still rough, lacking the polished touch that comes only from superior talent or patient practice. Illusionistic easel painting is a demanding and difficult genre. The pictures discussed in this book are simpler, plainer versions of a complex format. Instead of seeing them as inept, it would be more productive to recognize that these paintings stand somewhere along an artist's developmental path to professional studio performance. Artists who paint in a plain style move along that path in a direction and at a rate dictated by their own abilities and the reactions of their teachers and clients. The decisions they make in the process constitute the bases for a meaningful history of plain painting, a story that is lost when these artists are erroneously explained away as the bearers of folk traditions.

It is often implied that during the early years of our nation's history amateur painters satisfied the public's longing for pictures with awkward but sincere attempts at likeness and landscape. That awkward but sincere paintings are still being produced by amateur dabblers is generally taken as a sign that the folk tradition is still very much alive. What is particularly wrong with this point of view is that these paintings, both the new and the old, represent not folk but popular culture. Because these paintings bespeak novelty or the need for modish imagery, they are best understood not in terms of the history

of folk traditions—which at bottom consist of conservative motives aimed at the preservation of social norms—but in terms of the history of fashion, the enthusiasm for new styles of art, dress, and decoration. The history of popular painting is very interesting and awaits further scrutiny, but it is a story that will never be told so long as the aficionados of "folk" art prefer to tell their version of the tale, in which common people just naturally create art that is unique, bold, and direct.

Such an entity as folk painting does exist—the *fraktur* calligraphy of the Pennsylvania Germans, the rosemaling of Norwegian-Americans in the Midwest, and certain street murals by Mexican-Americans in the Southwest are valid examples. However, such works are a minor aspect of American folk art, which consists mostly of crafted objects finished and decorated beyond necessity. Once we recognize that "folk" painting is actually plain painting and thus an expression of popular rather than folk art, we are better prepared to sort out the histories of both idioms and to assign them their rightful places in the scheme of American art. Removing easel paintings from the folk realm not only corrects the general perception of folk art but opens up an intriguing aspect of American art history for more productive investigation.

The lives of America's plain painters recount an attempt to conquer the challenges of art in a complex Western mode. The old myths casting them as valiant heroes who gave visual form to the American spirit will no doubt die hard, but it is time to recognize what they really did, how, and why. Heroes or not, plain painters provide access to crucial episodes in America's social history; their works tell us much about who we were and who we have become.

Notes

NOTES TO THE INTRODUCTION

1. These opinions can be found throughout "What is American Folk Art?—A Symposium," *Antiques* 52 (May 1950): 355–62.

2. Alice Ford, *Pictorial Folk Art, New England to California* (New York: Studio Publications, 1949), p. 7.

3. H.W. Janson, *History of Art* (Englewood Cliffs, N.J.: Prentice-Hall, 1962), p. 285.

4. For a representative contemporary comment *see* Jean Lipman and Alice Winchester, *The Flowering of American Folk Art 1776–1876* (New York: Viking Press, 1974), p. 8.

5. Jean Lipman, *American Primitive Painting* (New York: Oxford University Press, 1942), pp. 5–18.

6. James Thomas Flexner, "New Bottles for Old Old Wine: American Artisan, Amateur, and Folk Paintings," *Antiques* 41 (April 1942): 246–49.

7. James Thomas Flexner, "What is American Folk Art?," p. 355.

8. Holger Cahill, "Artisan and Amateur in American Folk Art," *Antiques* 59 (March 1951): 210.

9. *See* John Michael Vlach, "'Properly Speaking': The Need for Plain Talk About Folk Art," in *Folk Art and Art Worlds*, ed. John Michael Vlach and Simon J. Bronner (Ann Arbor: UMI Research Press, 1986), pp. 13–26, especially pp. 14–15.

10. The term *plain painting* was inspired to some extent by the musical term *plainsong*. This type of song is basically a chant with a restricted, minimal melody; songs with elaborate and complex tunes might be called *art songs*. These classifications do not mark one type as superior to the other. Rather, fundamental qualities are highlighted, allowing one to point directly to differences. That the term *plain painting* may already be on the horizon of scholarly use is suggested by Charles Bergengren's essay "'Finished to the Utmost Nicety': Plain Portraits in America, 1760–1860," in Vlach and Bronner, *Folk Art and Art Worlds*, pp. 85–120.

11. Jane Kallir, *The Folk Art Tradition: Naive Painting in Europe and the United States* (New York: Viking Press, 1981), p. 8.

1. John and Katherine Ebert, *American Folk Painters* (New York: Charles Scribners Sons, 1975), p. 4.

2. Jules David Prown, "Style as Evidence," *Winterthur Portfolio* 15 (1980): 208.

3. Holger Cahill, "Folk Art: Its Place in the American Tradition," *Parnassus* 4, no. 3 (1932): 4.

4. Joshua Taylor, *The Fine Arts in America* (Chicago: University of Chicago Press, 1979), p. 21.

5. For West's career *see* John Galt, *The Life, Studies and Works of Benjamin West Esq. President of the Royal Academy of London, Composed from Materials by Himself* (London: T. Cadell & W. Davies, 1820); and William Sawitzky, "The American Works of Benjamin West," *Pennsylvania Magazine of History and Biography* 62 (1938): 433–62. Especially helpful is James Thomas Flexner, *America's Old Masters*, rev. ed. (New York: McGraw-Hill, 1982), pp. 19–97.

6. Flexner, *America's Old Masters*, p. 33.

7. Ann Uhry Abrams, "A New Light on Benjamin West's Pennsylvania Instruction," *Winterthur Portfolio* 17 (1982): 243–44.

8. Flexner, *America's Old Masters*, pp. 101–67, provides an able summary of Copley's career. Jules David Prown, *John Singleton Copley* (Cambridge, Mass.: Harvard University Press, 1966), provides a complete summary of Copley's American and British work.

9. Alfred Frankenstein, *The World of Copley, 1738–1815* (New York: Time-Life, 1970), p. 23.

10. Flexner, *America's Old Masters*, p. 118.

11. James Thomas Flexner, *History of American Painting, Vol. I: First Flowers of Our Wilderness* (1947; reprint ed., New York: Dover, 1969), p. 228.

12. Ibid., p. 234.

13. Flexner, *America's Old Masters*, p. 123.

14. Frankenstein, *The World of Copley*, p. 9.

15. On Peale's life *see* Charles Coleman Sellars, *The Artist of the Revolution, the Early Life of Charles Willson Peale* (Hebron, Conn.: Feather and Good, 1939); and Flexner, *America's Old Masters*, pp. 171–244.

16. Flexner, *America's Old Masters*, p. 183.

17. Ibid., pp. 187–88.

18. Dorinda Evans, *Benjamin West and His American Students* (Washington: National Portrait Gallery, 1980), p. 40.

19. Ibid., p. 42.

20. Flexner, *America's Old Masters*, p. 190.

21. E. P. Richardson, *Painting in America: The Story of 450 Years* (New York: Thomas Y. Crowell, 1956), p. 100.

22. For the career of Morse *see* Samuel Prime, *Life of Samuel F. B. Morse* (New York: D. Appleton, 1875); Carleton Mabee, *The American Leonardo: A Life of Samuel F. B. Morse* (New York: Knopf, 1943); and Oliver W. Larkin, *Samuel F. B. Morse and American Democratic Art* (Boston: Little, Brown, 1954).

23. James Thomas Flexner, *History of American Painting, Vol. II: The Light of Distant Skies* (1954; reprint ed., New York: Dover, 1969), p. 108.

24. Paul J. Stati, "Samuel F. B. Morse's Search for a Personal Style: The Anxiety of Influence." *Winterthur Portfolio* 16 (1981): 258.

25. Larkin, *Samuel F. B. Morse*, p. 17.

26. Stati, "Morse's Search for a Personal Style," pp. 260–67.

27. Flexner, *Light of Distant Skies*, p. 236.

28. The most comprehensive treatment of Field is found in Mary Black, *Erastus Salisbury Field, 1805–1900* (Springfield, Mass.: Museum of Fine Art, 1984). *See also* Agnes M. Dods, "A Checklist of Portraits and Paintings by Erastus Salisbury Field," *Art in America* 32, no. 1 (1949): 32–40.

29. Black, *Field*, p. 11.

30. Ibid., pp. 9-10.

31. Ibid., p. 15.

32. David Jaffee, " 'One of the Primitive Sort': The Portrait Makers of the Rural North, 1760–1860," in *Rural America, 1780–1900: Essays in Social History*, ed. Jonathan Prude and Stephen Hahn (Chapel Hill: University of North Carolina Press, 1985), pp. 103–38.

33. Neil Harris, *The Artist in American Society: The Formative Years, 1790–1860* (Chicago: University of Chicago Press, 1966), pp. 247–48.

34. Black, *Field*, fig. 22 on p. 24 and fig. 39 on p. 37.

35. Abraham A. Davidson, *The Eccentrics and Other American Visionary Painters* (New York: E. P. Dutton, 1978), pp. 69–70.

36. Frankenstein, *The World of Copley*, p. 95.

37. For Prior *see* Grace Adams Lyman, "William M. Prior: The 'Painting Garret' Artist," *Antiques* 26 (November 1934): 180; Clara Endicott Sears, *Some American Primitives: A Study of New England Faces and Folk Portraits* (Boston: Houghton, Mifflin, 1941), pp. 31–50; and Nina Fletcher Little, "William M. Prior, Traveling Artist and His In-Laws the Painting Hamblens," *Antiques* 53 (January 1948): 44–48.

38. Little, "William M. Prior," p. 48.

39. Virgil Barker, *American Painting: History and Interpretation* (New York: Macmillan, 1950), p. 533.

40. On Blunt *see* Robert Bishop, "John S. Blunt," *Antiques* 112 (November 1977): 964–71; idem, "John S. Blunt: The Man, the Artist and His Times," *Clarion* (Spring 1980): 20–39.

41. John Wilmerding, *A History of American Marine Painting* (Boston: Little, Brown, 1968), pp. 144, 149–50.

42. Barker, *American Painting*, p. 418.

43. Bishop, "Blunt: The Man," p. 26.

44. Ibid., p. 21.

45. Flexner, *First Flowers of Our Wilderness*, pp. 30–31.

1. Wayne Craven, *Colonial American Portraiture: The Economic, Religious, Social, Cultural, Philosophical, Scientific, and Aesthetic Foundations* (New York: Cambridge University Press, 1986), pp. 78–85.

2. Janice G. Schimmelman, "Books on Drawing and Painting Techniques Available in Eighteenth-Century American Libraries and Bookstores," *Winterthur Portfolio* 19 (1984): 193–208.

3. Foster Wygant, *Art in American Schools in the Nineteenth Century* (Cincinnati: Interwood Press, 1983), p. 9.

4. Neil Harris, *The Artist in American Society: The Formative Years, 1790–1860* (Chicago: University of Chicago Press, 1966), p. 36.

5. Ibid., p. 52.

6. Wygant, *Art in American Schools*, p. 8.

7. Peter Marzio, *The Art Crusade: An Analysis of American Drawing Manuals, 1820–1860* (Washington: Smithsonian Institution Press, 1976), p. 22.

8. James Thomas Flexner, *History of American Painting, Vol. II: The Light of Distant Skies* (1954; reprint ed., New York: Dover, 1969), pp. 157–58.

9. Harris, *The Artist in American Society*, p. 44.

10. Marzio, *The Art Crusade*, p. 1.

11. Carl W. Drepperd, *American Pioneer Arts and Artists* (Springfield, Mass.: Pond-Ekberg, 1942), chapter 2.

12. Carl W. Drepperd, " 'Drawing Cards': . . . The Sunday Game That Gave Us So Much Amateur Art," *American Collector* (November 1944): 6–7; *see also* Diane Korzenik, *Drawn to Art: A Nineteenth-Century American Dream* (Hanover, N.H.: University of New England Press, 1985), p. 48.

13. Marzio, *The Art Crusade*, p. 9.

14. Ibid., p. 14.

15. Ibid., p. 13.

16. Ibid.

17. Ibid., p. 21.

18. Ibid., p. 38.

19. Ibid., p. 50.

20. John Lee Clarke, Jr., "Joseph Whiting Stock," in *Primitive Painters in America*, ed. Jean Lipman and Alice Winchester (New York: Dodd, Mead and Co., 1950), pp. 113–20.

21. Holger Cahill, *American Folk Art: The Art of the Common Man in America, 1750–1900* (New York: Museum of Modern Art, 1932), pp. 14, 29–30.

22. Donald R. Walters and Carolyn J. Weekly, *American Folk Portraits: Paintings and Drawings from the Abby Aldrich Rockefeller Folk Art Center* (Boston: New York Graphic Society, 1981), p. 186.

23. Leah Lipton, *"A Truthful Likeness": Chester Harding and His Portraits* (Washington: Smithsonian Institution Press, 1985), p. 20.

24. Frances Trollope, *Domestic Manners of the Americans* (1833; reprint ed., Barre, Mass.: Imprint Society, 1969), p. 316.

25. Lipton, *"A Truthful Likeness,"* pp. 25–26.

26. Juliette Tomlinson, ed., *The Paintings and the Journal of Joseph Whiting Stock* (Middletown, Conn.: Wesleyan University Press, 1976), p. 6. Franklin White appears in the *Springfield and Chicopee Almanac, Directory and Business Advertiser* of 1849, p. 95, where he is listed as a daguerian with a shop on Fountain Row.

27. For a publishing history of the works issued by Currier and Ives *see Currier & Ives: A Catalogue Raisonne*, 2 vols. (Detroit: Gale Research Co., 1984).

28. Tomlinson, *Journal of Joseph Whiting Stock*, p. 6.

29. Lipton, *"A Truthful Likeness,"* p. 27.

30. Tomlinson, *Journal of Joseph Whiting Stock*, pp. xii, 51.

31. Ibid., p. 50.

32. James Thomas Flexner, *That Wilder Image: The Painting of America's Native School from Thomas Cole to Winslow Homer* (Boston: Little, Brown, 1962), p. 112.

33. Mary Bartlett Cowdrey, ed., *American Academy of Fine Arts and American Art-Union: Introduction, 1816–1852* (New York: New York Historical Society, 1953), p. 285. For subsequent references to Art-Union activities *see* the second volume of this work, *Exhibition Record*, esp. pp. 11, 125–26, 264.

34. Charles Davies, *A Treatise on Shades and Shadows and Linear Perspective* (New York: J & J Harper, 1832), p. iv.

35. Ibid., pp. 138–48.

36. John Gadsby Chapman, *The American Drawing-Book: Manual for the Amateur and Basis of Study for the Professional Artist especially adapted to the Use of Public and Private School, as well as home instruction* (New York: J. J. Redfield, 1847), p. 9.

37. Rufus Porter, *Scientific American* 1, no. 13 (1845): n.p.

38. Henry T. Tuckerman, *American Artist-Life, or, Sketches of American Painting* (New York: D. Appleton & Co., 1847), p. 153.

39. Ibid., p. 188.

40. Mary Black, "Phrenological Associations: Footnotes to the Biographies of Two Folk Artists," *The Clarion* (Fall 1984): 46.

41. Lipton, *"A Truthful Likeness,"* p. 121.

42. Tomlinson, *The Journal of Joseph Whiting Stock*, p. 58.

43. Lipton, *"A Truthful Likeness,"* p. 15.

44. Lipman and Winchester, *Primitive Painters in America*, pp. 169–82, identify locations for 497 American "primitive painters." Of this total 426 were working in New York and New England. On the matter of literacy *see* Kenneth A. Lockridge, *Literacy in Colonial New England: An Inquiry into the Social Context of Literacy in the Early Modern West* (New York: W. W. Norton, 1974), p. 78; he presents evidence that by 1790 male literacy in New England was above 90%, while in Virginia only 50% were literate. Although literacy rates in the South improved considerably during the nineteenth century, the gap between the two regions remained considerable.

1. Russell Lynes, *The Tastemakers: The Shaping of American Popular Taste* (New York: Dover, 1949), p. 343.

2. Abbott Lowell Cummings, "Inside the Massachusetts House," in *Common Places: Readings in American Vernacular Architecture*, ed. Dell Upton and John Michael Vlach (Athens: University of Georgia Press, 1986), p. 232.

3. Virgil Barker, *American Painting: History and Interpretation* (New York: Macmillan, 1950), p. 242; *see also* Thomas D. Cowan, "Philip Freneau: The Artist in the Early Republic," *New Jersey History* 92 (1974): 225–39.

4. James Thomas Flexner, *History of American Painting, Vol. II: The Light of Distant Skies* (1954; reprint ed., New York: Dover, 1969), p. 200.

5. Avrahm Yarmolinsky, *Picturesque United States, 1811, 1812, 1813, Being a Memoir on Paul Svinin* (New York: William Edwin Rudge, 1930), p. 33.

6. Flexner, *Light of Distant Skies*, p. 209.

7. John W. McCoubrey, ed., *American Art, 1700–1960: Sources and Documents* (Englewood Cliffs, N.J.: Prentice-Hall, 1965), p. 125. (Emphasis in the original.)

8. Harold Edward Dickson, ed., *Observations on American Art: Selections from the Writings of John Neal (1793–1876)*, The Pennsylvania State College Series No. 12 (State College: The Pennsylvania State College, 1943), p. 51.

9. Wilbur D. Peat, *Pioneer Painters of Indiana* (Indianapolis: Art Association, 1954), p. 21.

10. Ibid., p. 88.

11. Henry T. Tuckerman, *American Artist-Life* (New York: G. P. Putnam, 1867), p. 23.

12. Jean Lipman and Alice Winchester, *The Flowering of American Folk Art 1776–1876* (New York: Viking Press, 1974), p. 21. *The Maine Antique Digest* 14, no. 3 (1986) reported on an auction at Sotheby's under the headline "Folk Art Strong." Plain paintings sold there for between $6,600 and $126,500.

13. Lipman and Winchester, *The Flowering of American Folk Art*, p. 7.

14. Mark Twain, *Life on the Mississippi* (1883; reprint ed., New York: Penguin, 1984), pp. 276–77.

15. Mark Twain, *The Adventures of Huckleberry Finn* (1884; reprint ed., San Francisco: Chandler Publishing Co., 1962), pp. 137–38.

16. Ibid., p. 139.

17. Edgar M. Branch, ed., *Clemens of the "Call": Mark Twain in San Francisco* (Berkeley: University of California Press, 1969), pp. 61–62.

18. William Dunlap, *Diary of William Dunlap* (New York: Benjamin Blom, 1930), p. 468.

19. Yarmolinsky, *Picturesque United States*, pp. 35, 37.

20. Frances Trollope, *Domestic Manners of the Americans* (1833; reprint ed., Barre, Mass.: Imprint Society, 1969), p. 211.

21. Robert Bishop, *Folk Painters of America* (New York: Greenwich House, 1979), p. 189.

22. Oliver Wendell Holmes, "Sun-Painting and Sun-Sculpture," *Atlantic Monthly* 8 (July 1861): 14.

23. Tuckerman, *American Artist-Life*, p. 34.

24. Neil Harris, *The Artist in American Society: The Formative Years, 1790–1860* (Chicago: University of Chicago Press, 1966), p. 72.

25. Oliver W. Larkin, *Samuel F. B. Morse and American Democratic Art* (Boston: Little, Brown, 1954), p. 42.

26. Harold Spencer, ed., *American Art: Readings from the Colonial Era to the Present* (New York: Charles Scribner's Sons, 1980), p. 22.

27. Chester Harding, *My Egotistigraphy* (Cambridge, Mass.: John Wilson and Son, 1866), p. 37.

28. Ibid., p. 43.

29. Ibid., p. 45.

30. William B. O'Neal, *Primitive into Painter: Life and Letters of John Toole* (Charlottesville: University Press of Virginia, 1960), p. 12.

31. Oliver W. Larkin, *Art and Life in America* (New York: Rinehart and Co., 1949), p. 224.

32. James Guild, "From Tunbridge, Vermont to London, England—The Journal of James Guild, Peddler, Tinker, School Master, Portrait Painter, from 1818 to 1824," *Proceedings of the Vermont Historical Society* 5 (1937): 235.

33. Ibid., p. 265.

34. Ibid., pp. 268–69.

35. Ibid., p. 268.

36. Ibid., p. 295.

37. Ibid., p. 301.

38. For examples *see*, in *Godey's Lady's Magazine*, "The Veiled Picture: A Tale of the Fine Arts" in 7 (January 1833): 43–47; "The Happy Expression" in 38 (February 1849): 102–3; and "Two Portraits" in 41 (July 1850): 40–43.

39. Louisa H. Sheridan, "My Portrait," *Godey's Lady's Magazine* 4 (May 1832): 231.

40. Cimabue Briggs, "Pictorial Passages from the Life of Theophilus Smudge," *Godey's Lady's Magazine* 24 (February 1847): 100.

41. Ibid., p. 102.

42. *Godey's Lady's Magazine* 20 (January 1840): 19–24.

43. Ibid., p. 23.

44. Joseph J. Ellis, *After the Revolution: Profiles in Early American Culture* (New York: W. W. Norton, 1970), p. 219.

45. Glyndon G. Van Deusen, *The Jacksonian Era: 1828–1848* (New York: Harper & Row, 1959), pp. 2–3.

46. Edward Pessen, *Jacksonian America: Society, Personality, and Politics* (Homewood, Ill.: The Dorsey Press, 1969), p. 29.

47. Letter of John Vanderlyn to John Vanderlyn, Jr., September 9, 1825. Collection of the Senate House, Kingston, New York.

48. Information on the Thompson family is from Neil G. Larson, "The Politics of Style: Rural Portraiture in the Hudson Valley: 1825–1850" (M.A. thesis, University of Delaware, 1980), pp. 40–41.

49. Pessen, *Jacksonian America*, pp. 31–32.

50. Harding, *My Egotistigraphy*, pp. 43–44.

51. Peat, *Pioneer Painters of Indiana*, pp. 88–89.

52. Alan Gowans, "The Mansions of Alloways Creek," in Upton and Vlach, *Common Places*, p. 382.

53. Ibid., p. 382.

54. Ibid., p. 385.

55. Anita Schorsch, *Mourning Becomes America: Mourning Art in the New Nation* (Clinton, N.J.: Main Street Press, 1976).

56. Phoebe Lloyd, "Death and American Painting: Charles Willson Peale to Albert Pinkham Ryder" (Ph.D. diss., City University of New York, 1980), p. 141.

57. Ibid., pp. 93–98.

58. Phoebe Lloyd, "A Young Boy in his First and Last Suit," *Minneapolis Institute of Arts Bulletin* 44 (1978–80): 111, note 18.

59. Ibid., note 6.

60. Clara Endicott Sears, *Some American Primitives: A Study of New England Faces and Folk Portraits* (Boston: Houghton, Mifflin, 1941), p. 39.

61. James Thomas Flexner, *That Wilder Image: The Painting of America's Native School from Thomas Cole to Winslow Homer* (Boston: Little, Brown, 1962), pp. 113–14.

62. Ibid., p. 113.

63. Lynes, *The Tastemakers*, pp. 47–48.

64. William Lamson Williams, "Ammi Phillips: A Critique," *Connecticut Historical Society Bulletin* 31, No. 1 (1966): 5.

65. Clive Bush, *The Dream of Reason: American Consciousness and Cultural Achievement from Independence to the Civil War* (London: Edward Arnold, 1977), p. 108; *see also* Carl W. Drepperd, *Early American Prints* (New York: The Century Co., 1930), pp. 126–34.

66. Jean Lipman, *Rufus Porter Rediscovered: Artist, Inventor, Journalist, 1792–1884* (New York: Clarkson N. Potter, 1980), pp. 69–70.

67. Yarmolinsky, *Picturesque America*, p. 38.

68. Samuel W. Price, *Old Masters of the Bluegrass* (Louisville: John P. Morton Co., 1902), p. 89.

69. Louisa May Alcott, *Little Women or Meg, Jo, Beth, and Amy* (1868; reprint ed., Boston: Little, Brown, 1968), pp. 231–32.

70. Frances Byerly Parke, *Domestic Duties or Instructions to Young Married Ladies on the Management of their Households* (New York: J. & J. Harper, 1829), p. 319.

71. Bishop, *Folk Painters*, p. 40; Peat, *Pioneer Painters of Indiana*, p. 111; and Theodore Bolton and Irwin F. Cortelyou, *Ezra Ames of Albany: Portrait Painter, Craftsman, Royal Arch Mason, Banker, 1768–1836* (New York: New York Historical Society, 1955), p. 21.

72. Pessen, *Jacksonian America*, p. 32.

73. Edward Pessen, *Riches, Class, and Power Before the Civil War* (Lexington, Mass.: D. C. Heath, 1973), p. 383.

74. Lee Soltow, *Men and Wealth in the United States, 1850–1870* (New Haven: Yale University Press, 1975), p. 178.

75. Ibid., p. 60.

76. Pessen, *Jacksonian America*, p. 57.

77. For further discussion *see* David Jaffee, " 'One of the Primitive Sort': The Portrait Makers of the Rural North, 1760–1860," in *Rural America, 1780–1900: Essays in Social History*, ed. Jonathan Prude and Stephen Hahn (Chapel Hill: University of North Carolina Press, 1985), pp. 103-38.

78. *See* Barbara C. and Lawrence B. Holdridge, *Ammi Phillips: Portrait Painter 1788–1865* (New York: Clarkson N. Potter, 1968), pp. 12–14; Donald R. Walters and Carolyn J. Weekly, *American Folk Portraits: Paintings and Drawings from the Abby Aldrich Rockefeller Folk Art Center* (Boston: New York Graphic Society, 1981), p. 69; and Bolton and Cortelyou, *Ezra Ames*, pp. 15-16.

79. Bolton and Cortelyou, *Ezra Ames*, p. 56.

80. *Gilbert Stuart: Portraitist of the Young Republic, 1755–1828* (Washington, D.C.: National Gallery of Art, 1967), p. 9; *see also* John Morgan Hill, *Gilbert Stuart and His Pupils* (New York: New York Historical Society, 1939).

81. Hill, *Gilbert Stuart*, p. 92.

82. Barker, *American Painting*, p. 250.

83. Kenneth L. Ames, *Beyond Necessity: Art in the Folk Tradition* (New York: W. W. Norton, 1977), p. 21.

NOTES TO CHAPTER FOUR

1. Louisa Dresser, *Seventeenth-Century Painting in New England* (Worcester, Mass.: Worcester Art Museum, 1935).

2. "Letter from Holger Cahill to Edgar P. Richardson on Federal Patronage of the Arts," *Archives of American Art Journal* 24, no. 3 (1985): 22.

3. John Michael Vlach, "Holger Cahill as Folklorist," *Journal of American Folklore* 98 (1985): 150–51.

4. Dresser, *Seventeenth-Century Painting*, p. 28.

5. For examples *see* Mary Black and Jean Lipman, *American Folk Painting* (New York: Clarkson Potter, 1966), p. 2; and Robert Bishop, *Folk Painters of America* (New York: Greenwich House, 1979), pp. 16-19.

6. Oskar Hagen, *The Birth of the American Tradition in Art* (New York: Charles Scribners Sons, 1948), p. 15; R. Peter Mooz,

"Colonial Art," in *The Genius of American Art*, ed. John Wilmerding (New York: William Morrow, 1973), p. 30; Dresser, *Seventeenth-Century Painting*, pp. 20-21; Jonathan L. Fairbanks, "Portrait Painting in Seventeenth-Century Boston: Its History, Methods, and Materials," in *New England Begins: The Seventeenth Century*, ed. Jonathan L. Fairbanks and Robert F. Trent (Boston: Museum of Fine Arts, 1982), pp. 463-64.

7. Dresser, *Seventeenth-Century Painting*, p. 23.

8. Alexander Eliot, *Three Hundred Years of American Painting* (New York: Time, Inc., 1957), p. 5.

9. Oliver W. Larkin, *Art and Life in America* (New York: Rinehart and Co., 1949), p. 20.

10. Dresser, *Seventeenth-Century Painting*, p. 126.

11. Fairbanks, "Portrait Painting," p. 462.

12. Perry Miller, *The New England Mind: The Seventeenth Century* (Cambridge: Harvard University Press, 1954), p. 476.

13. Robert F. Trent, "New England Joinery and Turning before 1700," in Fairbanks and Trent, *New England Begins*, pp. 532-33.

14. Larkin, *Art and Life in America*, p. 20.

15. Abraham A. Davidson, *The Story of American Painting* (New York: Harry N. Abrams, 1974), p. 8.

16. Matthew Baigell, *A History of American Painting* (New York: Praeger, 1971), p. 16.

17. Hagen, *Birth of the American Tradition*, p. 14.

18. Alan Burroughs, "A Report on the X-Ray Examination of Seventeenth-Century American Paintings Exhibited at the Worcester Art Museum," in Dresser, *Seventeenth-Century Paintings*, pp. 166-67.

19. Roy Strong, *The English Icon: Elizabethan and Jacobean Portraiture* (New York: Pantheon, 1969).

20. Lucy Baldwin Smith, " 'Christ, What a Fright': The Tudor Portrait as Icon," *Journal of Interdisciplinary History* 4 (1973): 125, 127.

21. Strong, *The English Icon*, p. 11.

22. Samuel M. Green, "The English Origins of Seventeenth-Century Painting in New England," in *American Painting Before 1776: A Reappraisal*, ed. Ian M. G. Quimby (Charlottesville: University Press of Virginia, 1971), p. 51.

23. Lillian B. Miller, "The Puritan Portrait: Its Function in Old and New England," in *Seventeenth-Century New England*, ed. David D. Hall and David Grayson Allen (Boston: The Colonial Society of Massachusetts, 1984), p. 158.

24. Strong, *The English Icon*, p. 15.

25. Eliot, *Three Hundred Years of American Painting*, p. 5.

26. Hagen, *Birth of the American Tradition*, p. 17.

27. Strong, *The English Icon*, p. 13.

28. Hagen, *Birth of the American Tradition*, p. 15.

29. John Ebert and Catherine Ebert, *American Folk Painters* (New York: Charles Scribner's Sons, 1975), p. 21.

30. E.P. Richardson, *Painting in America: The Story of 450 Years* (New York: Thomas Y. Crowell, 1956), p. 28.

31. John McCoubrey, *American Tradition in Painting* (New York: George Braziller, 1963), p. 14.

32. Barbara Novak, *American Painting in the Nineteenth Century: Realism, Idealism, and the American Experience* (New York: Praeger, 1976), p. 15.

33. Wayne Craven, *Colonial American Portraiture: The Economic, Religious, Social, Cultural, Philosophical, Scientific, and Aesthetic Foundations* (New York: Cambridge University Press, 1986), pp. 101-11.

34. Miller, "The Puritan Portrait," pp. 178-79.

35. Davidson, *Story of American Painting*, p. 8.

36. Fairbanks, "Portrait Painting." Plate 28, p. 439.

37. Hagen, *Birth of the American Tradition*, pp. 16-17.

38. The discussion of the repainting of the Freake portraits is based largely on Susan E. Strickler, "Recent Findings on the Freake Portraits," *Journal of the Worcester Art Museum* 5 (1981): 49-55. Also useful are Fairbanks, "Portrait Painting," pp. 460-61; and Burroughs, "X-Ray Examination," pp. 165-77.

39. Fairbanks, "Portrait Painting," p. 460.

40. Dresser, *Seventeenth-Century Painting*, p. 23.

41. Fairbanks, "Portrait Painting," p. 422.

42. Ibid., pp. 421-22.

43. Ibid., p. 425.

44. Remy G. Saisselin, *Style, Truth, and the Portrait* (Cleveland: Cleveland Museum of Art, 1963), p. 3.

45. Eliot, *Three Hundred Years of American Painting*, p. 15.

46. Fairbanks, "Portrait Painting," p. 447.

47. Ibid., p. 453.

48. Holger Cahill, *American Primitives: An Exhibit of the Paintings of Nineteenth-Century Folk Artists* (Newark, N.J.: Newark Museum, 1931), p. 7.

49. Craven, *Colonial American Portraiture*, p. 82.

50. Abbott Lowell Cummings, "Decorative Painting in Seventeenth-Century New England," in Quimby, *American Painting Before 1776*, pp. 71-125; idem, *The Framed Houses of Massachusetts Bay, 1625-1725* (Cambridge, Mass.: Belknap Press, 1979), pp. 192-201.

51. John Demos, *The Little Commonwealth: Family Life in Plymouth Colony* (New York: Oxford University Press, 1970), pp. 183-88.

52. David Hall, "Literacy, Religion, and the Plain Style," in Fairbanks and Trent, *New England Begins*, p. 110.

53. Ibid., p. 111.

54. Miller, *The New England Mind*, pp. 173-74.

NOTES TO CHAPTER FIVE

1. R. H. Wilenski, *An Introduction to Dutch Art* (London: Faber, 1929), p. 185.

2. Ruth Piwonka and Roderic H. Blackburn, *A Remnant in the Wilderness: New York Dutch Scripture History Paintings of the Early Eighteenth Century* (Albany: Albany Institute of History and Art, 1980), p. 4.

3. Wilenski, *Introduction to Dutch Art*, p. 185.

4. *Paintings of 17th Century Dutch Interiors* (Kansas City: Nelson Gallery of Art, 1967), especially p. 27.

5. Esther Singleton, *Dutch New York* (New York: Benjamin Blom, 1968), p. 104.

6. Ibid., pp. 105-6.

7. Ibid., p. 106.

8. Piwonka and Blackburn, *Remnant in the Wilderness*, p. 16.

9. Alice P. Kenney, *Stubborn for Liberty: The Dutch in New York* (Syracuse: Syracuse University Press, 1975), p. 81.

10. Jessie J. Poesch, "Dutch Taste in Colonial America," *Proceedings of the New Jersey Historical Society* 76 (1958): 9.

11. Piwonka and Blackburn, *Remnant in the Wilderness*, p. 12.

12. James Thomas Flexner, *History of American Painting, Vol I: First Flowers of Our Wilderness* (1947; reprint ed., New York: Dover, 1969), p. 60.

13. Kenney, *Stubborn for Liberty*, pp. 56-59.

14. Singleton, *Dutch New York*, p. 107.

15. On Dutch material culture *see* Maud Esther Dilliard, *An Album of New Netherland* (New York: Twayne Publishers, 1963), pp. 71-122; Helen W. Reynolds, *Dutch Houses in the Hudson Valley Before 1776* (1929; reprint ed., New York: Dover, 1965); and John Fitchen, *The New World Dutch Barn* (Syracuse: Syracuse University Press, 1968).

16. Timothy Dwight, *Travels in New England and New York* (1823; reprint ed., Cambridge, Mass.: The Belknap Press, 1969), p. 340.

17. Piwonka and Blackburn, *Remnant in the Wilderness*, p. 22.

18. Anne McVicar Grant, *Memoirs of an American Lady* (1808; reprint ed., New York: Dodd, Mead and Co., 1909), p. 85.

19. Alice P. Kenney, *The Gansevoorts of Albany: Dutch Patricians in the Upper Hudson Valley* (Syracuse: Syracuse University Press, 1969), p. 20.

20. Mary Black, "Pieter Vanderlyn and Other Limners of the Upper Hudson," in *American Painting Before 1776: A Reappraisal*, ed. Ian M. G. Quimby (Charlottesville: University Press of Virginia, 1971), p. 217.

21. Mary Black, "Pieter Vanderlyn," in *American Folk Painters of Three Centuries*, ed. Jean Lipman and Tom Armstrong (New York: Hudson Hills Press, 1980), p. 43.

22. Charles X. Harris, "Pieter Vanderlyn," *New York Historical Society Quarterly Bulletin* 5 (1921): 66.

23. Mary Black, "The Gansevoort Limner," *Antiques* 96 (1969): 741.

24. S. Lane Faison, Jr., and Sally Mills, *Hudson Valley People: Albany to Yonkers, 1700-1900* (Poughkeepsie, N.Y.: Vassar College Art Gallery, 1982), p. 29; Black, "Pieter Vanderlyn," p. 45.

25. Dilliard, *Album of New Netherland*, plate 37.

26. Letter of John Vanderlyn to his nephew John Vanderlyn II, March 1825. Collection of the Senate House, Kingston, New York.

27. Waldron Phoenix Belknap, Jr., *American Colonial Painting: Materials for a History* (Cambridge, Mass.: The Belknap Press, 1959), plate 35.

28. Ibid., plate 31.

29. Ibid., plate 25.

30. Kenney, *Stubborn for Liberty*, p. 83.

31. Flexner, *First Flowers of Our Wilderness*, p. 80.

32. Roland Van Zandt, *Chronicles of the Hudson: Three Centuries of Travelers' Accounts* (New Brunswick, N.J.: Rutgers University Press, 1971), p. 55.

33. Kenney, *Stubborn for Liberty*, p. 125.

34. Robert G. Wheeler, "The Albany of Magdelena Down," *Winterthur Portfolio* 4 (1968): 72.

35. Peter Mooz, "Colonial Art," in *The Genius of American Art*, ed. John Wilmerding (New York: William Morrow, 1973), p. 41.

36. G. C. Groce, Jr., "New York Painting Before 1800," *New York History* 19 (1938): 48.

37. Reynolds, *Dutch Houses*, p. 118; Allison P. Bennett, *The People's Choice: A History of Albany County in Art and Architecture* (Albany: Albany County Historical Association, 1980), pp. 20, 24.

38. Piwonka and Blackburn, *Remnant in the Wilderness*, p. 16.

39. Wilenski, *Introduction to Dutch Art*, p. 186.

40. Flexner, *First Flowers of Our Wilderness*, p. 66.

41. Kenney, *Stubborn for Liberty*, p. 129.

42. Piwonka and Blackburn, *Remnant in the Wilderness*, p. 14.

43. *See* Kenney, *The Gansevoorts of Albany*, pp. 29-37.

NOTES TO CHAPTER SIX

1. Alice Ford, *Pictorial Folk Art, New England to California* (New York: Studio Publications, 1949), p. 21.

2. Alice Ford, *Edward Hicks, Painter of the Peaceable Kingdom* (Philadelphia: University of Pennsylvania Press, 1952), p. 125.

3. *See A Gallery of National Portraiture and Historic Scenes* (Philadelphia: Pennsylvania Academy of Fine Arts, 1926), p. 9; Holger Cahill, *American Primitives: An Exhibit of the Paintings of Nineteenth-Century Folk Artists* (Newark, N.J.: Newark Museum, 1931), p. 66; idem, *American Folk Art: The Art of the Common Man in America, 1750-1900* (New York: Museum of Modern Art, 1932), nos. 21-22.

4. A list of exhibitions is provided by Eleanore Price Mather and Dorothy Canning Miller, *Edward Hicks: His Peaceable Kingdoms and Other Paintings* (Newark: University of Delaware Press, 1983), pp. 218-19.

5. "American Art: The New Star," *International Art Market* 20, no. 5 (1980): 1.

6. Edward Hicks, *Memoirs of the Life and Religious Labors of Edward Hicks Late of Newtown, Bucks County, Pennsylvania Written by Himself* (Philadelphia: Merrihew and Thompson, 1851).

7. Cahill, *American Folk Art*, p. 6.

8. Holger Cahill, "Artists of the People," in *Masters of Popular Painting: Modern Primitives of Europe and America*, ed. Holger Cahill et al. (1938; reprint ed., New York: Arno Press, 1966), p. 98.

9. Henry Glassie, "Artifacts: Folk, Popular, Imaginary," in *Icons of Popular Culture*, ed. Marshall Fishwick and Ray B. Brown (Bowling Green: Bowling Green University Press, 1970), pp. 103-22.

10. Ford, *Edward Hicks*, p. 82.

11. Cahill, "Artists of the People," p. 100.

12. Arthur Edwin Bye, "Edward Hicks, 1780-1849," *Bulletin of the Friends Historical Association* 22, no. 2 (1943): 59.

13. Ibid., p. 6 (emphasis in the original).

14. Ford, *Edward Hicks*, p. 30.

15. Julius S. Held, "Edward Hicks and the Tradition," *Art Quarterly* 14 (1951): 122; Ford, *Edward Hicks*, pp. 143, 145, facing 54; Mather and Miller, *Edward Hicks*, pp. 165, 197, 207.

16. Mather and Miller, *Edward Hicks*, p. 69.

17. Ford, *Edward Hicks*, p. 42.

18. Eleanore Price Mather, "A Quaker Icon: The Inner Kingdom of Edward Hicks," *Art Quarterly* 36 (1973): 68.

19. Frederick B. Tolles, "The Primitive Painter as Poet (With an Attempted Solution of an Iconographical Puzzle in Certain of Edward Hicks's *Peaceable Kingdoms*)," *Bulletin of the Friends Historical Association* 50, no. 1 (1961): 12-30. For an example of this silhouette *see* Bliss Forbusch, *Elias Hicks: Quaker Liberal* (New York: Columbia University Press, 1956), p. 218.

20. Mather and Miller, *Edward Hicks*, p. 32.

21. Held, "Edward Hicks," p. 127.

22. Ford, *Edward Hicks*, pp. 154, 149, 160; Mary Black and Jean Lipman, *American Folk Painting* (New York: Clarkson Potter, 1966), p. 175; Mather and Miller, *Edward Hicks*, p. 65.

23. Ford, *Edward Hicks*, pp. 99, 41.

24. Mather and Miller, *Edward Hicks*, p. 15.

25. Held, "Edward Hicks," p. 132.

26. Hicks, *Memoirs*, p. 71.

27. Ford, *Edward Hicks*, p. 30.

28. Frederick J. Nicholson, *Quakers and the Arts: A Survey of British Friends to the Creative Arts* (London: Friends Home Service Committee, 1968), p. 31.

29. Ford, *Edward Hicks*, p. 41. Recently Ford has considerably revised her earlier views, giving more emphasis to Hicks's artistic motives; *see* her *Edward Hicks: His Life and Art* (New York: Abbeville Press, 1985), p. 104.

30. Ibid., p. 42.

31. Barbara Novak, *Nature and Culture: American Landscape Painting, 1825-1875* (New York: Oxford University Press, 1980), pp. 34-44.

32. George P. Winston, " 'The Wolf Did with the Lambkin Dwell,' " *Pennsylvania History* 33 (1966): 264.

33. Edna S. Pullinger, *A Dream of Peace: Edward Hicks of Newtown* (Philadelphia: Dorrance and Co., 1973), pp. 55, 77.

34. Ibid., p. 83; *see also* Mather and Miller, *Edward Hicks*, p. 133.

35. Eleanor Price Mather, *Edward Hicks, Primitive Quaker: His Religion in Relation to His Art*, Pendle Hill Pamphlet 170 (Wallingford, Pa.: Pendle Hill, 1970); idem, "The Inward Kingdom of Edward Hicks: A Study in Quaker Iconography," *Quaker History* 62 (1973): 3-13; and idem with Miller, *Edward Hicks*.

36. Mather, "A Quaker Icon," p. 86.

37. For examples *see* Ford, *Edward Hicks*, p. 139; Pullinger, *Dream of Peace*, p. 58; and John Ebert and Catherine Ebert, *American Folk Painters* (New York: Charles Scribners' Sons, 1975), p. 135.

38. Mather, "A Study in Quaker Iconography," p. 11.

39. Mather, "A Quaker Icon," pp. 92, 97.

40. Ford, *Edward Hicks*, p. 41, includes the text of this poem.

41. Henry Glassie, "Folk Art," in *Folklore and Folklife: An Introduction*, ed. Richard M. Dorson (Chicago: University of Chicago Press, 1973), p. 262, note 16.

42. Eleanore Price Mather, "Edward Hicks," in *American Folk Painters of Three Centuries*, ed. Jean Lipman and Tom Armstrong (New York: Hudson Hills Press, 1980), p. 95.

43. Hicks, *Memoirs*, p. 12.

44. Ibid., pp. 28, 149, 48.

45. Ford, *Edward Hicks*, p. 88.

46. Ibid., p. 93.

47. Hicks, *Memoirs*, p. 71.

48. Ibid., p. 258; Ford, *Edward Hicks*, p. 114.

49. Hicks, *Memoirs*, p. 232.

50. Richard Bauman, "Speaking in the Light: The Role of the Quaker," in *Explorations in the Ethnography of Speaking*, ed. Richard Bauman and Joel Sherzer (London: Cambridge University Press, 1974), p. 159.

51. Winston, " 'The Wolf Did With the Lambkin Dwell,' " p. 273.

52. Nicholson, *Quakers and the Arts*, p. 32.

53. Thomas Clarkson, *A Portraiture of Quakerism* (New York: Samuel Stansbury, 1806), pp. 273-74.

54. Richard Bauman, "Quaker Folk Linguistics and Folklore," in *Folklore: Performance and Communication*, ed. Dan Ben-Amos and Kenneth S. Goldstein (The Hague: Mouton, 1975), p. 259.

55. Ellwood Parry, "Edward Hicks and a Quaker Iconography," *Arts Magazine* 44, no. 10 (1975): 93; Ellen Starr Brinton, "Benjamin West's Printing of *Penn's Treaty With the Indians*," *Bulletin of the Friends Historical Association* 30, no. 2 (1941): 99-189.

56. Clarkson, *A Portraiture of Quakerism*, p. 273.

57. "Letter of the 1698 Yearly Meeting of Women Friends," quoted in Frederick B. Tolles, " 'Of the Best Sort But Plain': The Quaker Esthetic," *American Quarterly* 11 (1959): 495.

58. Ibid., p. 499.

59. Anna Cox Brinton, *Quaker Profiles: Pictorial and Biographical, 1750-1850* (Wallingford, Pa.: Pendle Hill Publications, 1964), frontispiece.

60. For examples of fancy furniture made by Quakers, *see* Elizabeth Bidwell Bates and Jonathan L. Fairbanks, *American Furniture, 1620 to the Present* (New York: Richard Marck, 1981), pp. 78, 144, 171.

61. Ford, *Edward Hicks*, p. 34.

62. Arthur Edwin Bye, "Edward Hicks," *Art in America* 39, no. 1 (1951): 31.

63. Ford, *Edward Hicks*, p. 91.

64. Jane W. T. Brey, *A Quaker Saga* (Philadelphia: Dorrance and Co., 1967), p. 479.

65. The Makefield meeting testimony is included in Hicks, *Memoirs*, pp. 5-10; for the comment on Hicks's painting *see* p. 8.

66. Ibid., p. 71.

67. Ibid., p. 8.

68. *See* Simon J. Bronner, "Investigating Identity and Expression in Folk Art," *Winterthur Portfolio* 16 (1981): 65-83, for a parallel instance of art being allowed in an art-denying community—in this case, Old Order Mennonites.

69. Virgil Barker, *American Painting: History and Interpretation* (New York: Macmillan, 1950), p. 530; James Ayres, "Edward Hicks and His Sources," *Antiques* 109 (1976): 368.

70. *See* Henry Glassie, "Eighteenth-Century Cultural Process in Delaware Valley Folk Building," *Winterthur Portfolio* 7 (1977): 51-54.

71. *See* Charles H. Dornbusch and John K. Heyl, *Pennsylvania German Barns* (Allentown: Pennsylvania German Folklore Society, 1958); and Amos Long, Jr., *The Pennsylvania German Family Farm* (Breinigsville, Pa.: Pennsylvania German Society, 1972).

72. Howard Brinton, *Friends for 300 Years* (New York: Harper and Bros., 1952), chapter 7.

NOTES TO CHAPTER SEVEN

1. "Early American Art," *New York Herald*, February 17, 1925.

2. Jay Johnson and William C. Ketchum, Jr., *American Folk Art of the Twentieth Century* (New York: Rizzoli, 1983), p. 206.

3. Grandma Moses, *My Life's History*, ed. Otto Kallir (New York: Harper & Bros., 1952), pp. 35-38.

4. Jane Kallir, *Grandma Moses: The Artist Behind the Myth* (New York: Clarkson N. Potter, 1982), pp. 11, 13.

5. Moses, *My Life's History*, p. 27.

6. Fifty-two-minute tape-recorded interview, "Grandma Moses at Ninety-Six," Center for Cassette Studies (1975), cassette no. 456.

7. Otto Kallir, *Grandma Moses* (New York: Harry N. Abrams, 1973), pp. 30-34; Moses, *My Life's History*, pp. 129-30; and "Grandma Moses at Ninety-Six."

8. Jane Kallir, *The Folk Art Tradition: Naive Painting in Europe and the United States* (New York: Viking Press, 1981), p. 38.

9. Ibid., pp. 42-46; Oto Bihalji-Merin, *Modern Primitives: Naive Painting, Seventeenth Century Until the Present Day* (London: Thames and Hudson, 1971), pp. 71-89.

10. Barbara Rose, *American Art Since 1900: A Critical History* (New York: Praeger, 1967), p. 35.

11. Leon Anthony Arkus, ed., *John Kane, Painter* (Pittsburgh: University of Pittsburgh Press, 1971), p. 85.

12. Holger Cahill, *American Folk Art: The Art of the Common Man in America, 1750-1900* (New York: Museum of Modern Art, 1932), pp. 33-34.

13. Selden Rodman, *Artists in Touch with Their World: Masters of Popular Art in the Americas and Their Relation to the Folk Tradition* (New York: Simon & Schuster, 1982), pp. 72-77.

14. Alfred H. Barr, Jr., "Introduction," in *Masters of Popular Painting: Modern Primitives of Europe and America*, ed. Holger Cahill et al. (New York: Arno Press, 1966), pp. 9-10.

15. For the intellectual predispositions of the New York intelligentsia during the first half of the twentieth century *see* William E. Leuchtenburg, *The Perils of Prosperity, 1914-1932* (Chicago: University of Chicago Press, 1958), pp. 225-26.

16. Bihalji-Merin, *Modern Primitives*, pp. 20, 107.

17. Kallir, *Artist Behind the Myth*, p. 13.

18. Ibid., p. 15.

19. Ibid., p. 17.

20. "Little Old Lady of Eagle Bridge, New York," *Newsweek* 56 (September 5, 1960): 70.

21. Kallir, *Artist Behind the Myth*, p. 19.

22. "Grandma Moses by the Yard," *Look* 20 (November 13, 1956): 124.

23. "Little Old Lady," p. 70.

24. William H. Armstrong, *Barefoot in the Grass: The Story of Grandma Moses* (New York: Doubleday, 1970), p. 87.

25. Kallir, *Artist Behind the Myth*, p. 20.

26. Ibid., p. 28.

27. S. J. Wolf, "Grandma Moses Who Began to Paint at 78," *New York Times Magazine* (December 2, 1945): 16.

28. James Thrall Soby, "A Bucolic Past and a Giddy Jungle," *Saturday Review* 33 (November 4, 1950): 40.

29. Harold C. Schonberg, "Grandma Moses: Portrait of the Artist at Ninety-Nine," *New York Times Magazine* (September 6, 1959): 12.

30. John Canaday, *Culture Gulch: Notes on Art and Its Public in the 1960s* (New York: Farrar, Straus, & Giroux, 1969), p. 32. Canaday later modified this opinion, illustrating the difficulty of staking claim to firm positions in the art world.

31. "Grandma Moses at Ninety-Six."

32. Katherine Kuh, "Grandma Moses: Portrait of an Artist as a Centenarian," *Saturday Review* 43 (September 10, 1960): 45.

33. Armstrong, *Barefoot in the Grass*, p. 90.

34. Soby, "A Bucolic Past," p. 41.

35. Sidney Janis, "Twentieth-Century Primitives," in *Primitive Painters in America*, ed. Jean Lipman and Alice Winchester (New York: Dodd, Mead and Co., 1950), p. 167.

36. Sidney Janis, *They Taught Themselves: American Primitive Painters of the 20th Century* (Port Washington, N.Y.: Kennikat Press, Inc., 1942), p. 7.

37. Kallir, *Artist Behind the Myth*, pp. 47-57.

38. *See* Kallir, *Grandma Moses*, p. 28, for a color reproduction of this work.

39. Schonberg, "Portrait of an Artist," p. 38.

40. *See* Kallir, *Grandma Moses*, catalogue entries 647 (p. 300), 928 (p. 308), and 1116 (p. 313), painted in 1946, 1950, and 1954, respectively.

41. "Grandma Moses at Ninety-Six."

42. Kallir, *Artist Behind the Myth*, pp. 50-51.

43. Ibid., p. 71.

44. Ibid., pp. 86-87.

45. Sally MacDougall, "Grandma Moses Finally Views December TV Appearance," *New York World-Telegram and the Sun* (May 1, 1956).

46. *Grandma Moses: Anna Mary Robertson Moses (1860-1961)* (Washington, D.C.: National Gallery of Art, 1979), p. 9.

47. Kallir, *Artist Behind the Myth*, p. 57.

48. Ibid., p. 63.

49. Kallir, *Grandma Moses*, p. 123.

50. "Grandma Moses at Ninety-Six."

51. Dorothy Seckler, "The Success of Mrs. Moses," *Art News* 50 (May 1951): 65.

52. Armstrong, *Barefoot in the Grass*, p. 90.

53. Kallir, *Artist Behind the Myth*, p. 16.

54. Irving Sandler, *The Triumph of American Painting: A History of Abstract Expressionism* (New York: Praeger, 1970), chapter 2, especially pp. 30-33.

55. "The Low Down," *Oakland Neighborhood Journal* (November 23, 1949), cited in Kallir, *Artist Behind the Myth*, p. 21.

56. Ibid., p. 24.

NOTES TO CHAPTER EIGHT

1. Beatrix T. Rumford, "Uncommon Art of the Common People: A Review of Trends in the Collecting and Exhibiting of American Folk Art," in *Perspectives on American Folk Art*, ed. Ian M. G. Quimby and Scott T. Swank (New York: W. W. Norton, 1980), pp. 16, 36-37.

2. Jean Lipman and Tom Armstrong, eds., *American Folk Painters of Three Centuries* (New York: Hudson Hills Press, 1980), p. 222.

3. Adele Earnest, *Folk Art in America: A Personal View* (Exton, Pa.: Schiffer Publishing Co., 1984), p. 59.

4. Ibid., p. 146.

5. "What Is American Folk Art? A Symposium," *Antiques* 52, no. 5 (1950): 355-62.

6. Nina Fletcher Little, *Little by Little: Six Decades of Collecting American Decorative Arts* (New York: E.P. Dutton, 1984), pp. 117-18.

7. Jean Lipman, "American Primitive Portraiture—A Revaluation," *Antiques* 40 (September 1941): 142-44.

8. Daniel Robbins, "Folk Art Without Folk," in *Folk Sculpture U.S.A.*, ed. Herbert W. Hemphill, Jr. (New York: Brooklyn Museum, 1976), p. 12.

9. Robert Goldwater, *Primitivism in Modern Painting* (New York: Harper & Bros., 1938), p. 148.

10. *See* the tenth anniversary exhibition staged by the Museum of Modern Art, *Art in Our Time* (New York: Museum of Modern Art, 1939), especially pp. 16-28.

11. Holger Cahill, "Artists of the People," in *Masters of Popular Painting: Modern Primitives of Europe and America*, ed. Holger Cahill et al. (1938; reprint ed., New York: Arno Press), p. 104.

12. Luigi Salerno, "Primitivism," in *Encyclopedia of World Art*, vol. 9 (New York: McGraw-Hill, 1961), p. 712.

13. Howard Becker, *Art Worlds* (Berkeley: University of California Press, 1982), p. 260.

14. Robbins, "Folk Art Without Folk," p. 20.

15. Earnest, *Folk Art in America*, p. 172.

16. Museum of American Folk Art, "A Guide to the Permanent Collection," *The Clarion* (Winter 1978): 32-59.

17. Jane Kallir, *The Folk Art Tradition: Naive Paintings in Europe and the United States* (New York: Viking Press, 1981), p. 42.

18. Michael D. Hall, "The Hemphill Perspective—A View from a Bridge," in *American Folk Art: The Herbert Waide Hemphill Jr. Collection* (Milwaukee: Milwaukee Art Museum, 1981), p. 7.

19. Herbert W. Hemphill, Jr., and Julia Weissman, *Twentieth-Century American Folk Art and Artists* (New York: E.P. Dutton, 1974), p. 9.

20. Becker, *Art Worlds*, p. 259.

21. Hemphill and Weissman, *Twentieth-Century American Folk Art*, pp. 9-10.

22. Hall, "The Hemphill Perspective," p. 15.

23. Roger Cardinal, *Outsider Art* (New York: Praeger, 1972), pp. 16-17.

24. Michel Thevoz, *Art Brut* (New York: Rizzoli, 1976), p. 44.

25. Greg Blasdel, "The Grass Roots Artist," *Art in America* (September 1968): 24-41. *See also Naives and Visionaries* (New York: E.P. Dutton, 1974).

26. Hall, "The Hemphill Perspective," p. 15.

27. Germaine Greer, *The Obstacle Course: The Fortunes of Women Painters and Their Work* (New York: Farrar, Straus, & Giroux, 1979), p. 116. For an example of how cavalier folk art dealers are about insulting the authentic bearers of tradition, *see* James Auer, "His Primitives Grow Older, and This Dealer is Worried," *Milwaukee Journal* (February 17, 1985): entertainment section, p. 10, which discusses the attitudes of the Ricco-Johnson Gallery in New York. I would like to thank Robert Teske of the John Michael Kohler Arts Center in Sheboygan, Wisconsin, for this reference.

28. Robert Bishop, *Folk Art: Painting, Sculpture and Country Objects* (New York: Alfred A. Knopf, 1983).

29. For examples of memory paintings *see* Otto Kallir, *Grandma Moses* (New York: Harry N. Abrams, 1973); Mattie Lou O'Kelly, *From the Hills of Georgia: An Autobiography in Paintings* (Boston: Little, Brown, 1983); Jay Johnson and William C. Ketchum, Jr., eds., *American Folk Art of the Twentieth Century* (New York: Rizzoli, 1983), pp. 303-5; Donald and Margaret Vogel, *Aunt Clara: The Paintings of Clara McDonald Williamson* (Austin: University of Texas Press, 1966); Charles G. Zugg, III, " 'Mine's My Style': Memory Paintings of Minnie Smith Reinhart," in *Five North Carolina Folk Artists* (Chapel Hill: Ackland Art Museum, 1986), pp. 49-59; and Claudine Weatherford, *The Art of Queena Stovall: Images of Country Life* (Ann Arbor: UMI Research Press, 1986).

30. *See* Patrick Watson, *Fasanella's City* (New York: Ballantine, 1973).

31. For examples of obsessive paintings *see*: Alexander Sackton, "Eddie Arning: Texas Folk Artist," in *Folk Art in Texas*, ed. Francis Edward Abernathy (Dallas: Southern Methodist University Press, 1985), pp. 189-95; Johnson and Ketchum, *American Folk Art*, pp. 259-61; Jane Livingston and John Beardsly, *Black Folk Art in America, 1930-1980* (Oxford: University of Mississippi Press, 198), pp. 97-104, 133-45; and John F. Turner and Judith Dunham, "Howard Finster: Man of Visions," *Folklife Annual* I (1985): 158-73.

32. Jonathan Fineberg, "On Art and Insanity: The Case of Adolf Wolfli," *Art in America* 67, no. 1 (1979): 12.

33. Michael Bonesteel, "Chicago Originals," *Art in America* 73, no. 2 (1985): 130; Whitney Halstead, "Made in Chicago," in *Made in Chicago* (Washington: Smithsonian Institution, 1974), p. 14.

34. Bonesteel, "Chicago Originals," p. 131.

35. Hall, "The Hemphill Perspective," p. 16.

36. *See* Johnson and Ketchum, *American Folk Art*, pp. 122-26, 200-13, 244-47, and 296-99.

37. Howard Rose, "My American Folk Art," *Art in America* 70, no. 1 (1982): 127.

38. Alice Winchester, *Art in America* 51, no. 4 (1963): 53-59.

39. Jean Lipman, *Provocative Parallels* (New York: E.P. Dutton, 1975), p. 9.

40. David W. Courtney, "Acquiring Masterworks: The Rort and Betty Marcus Collection," *The Clarion* (Summer 1984): 56-57.

41. Robbins, "Folk Art Without Folk," p. 20. *See also* Eugene W. Metcalf, "Black Art, Folk Art, and Social Control," *Winterthur Portfolio* 18 (1983), especially p. 271, for a comment on what happens when social elites determine the definition of folk art.

42. James Clifford, "Histories of the Tribal and the Modern," *Art in America* 73, no. 4 (1985): 166.

43. Ibid., p. 167.

44. Nelson H. H. Graburn, *Ethnic and Tourist Arts: Cultural Expressions from the Fourth World* (Berkeley: University of California Press, 1976), p. 5.

45. There is much scholarship that analyzes these ongoing traditions. For examples *see*: Charles Briggs, *The Wood Carvers of Cordova, New Mexico: Social Dimensions of an Artistic "Revival"* (Knoxville: University of Tennessee Press, 1980); John Michael Vlach, *Charleston Blacksmith: The Work of Philip Simmons* (Athens: University of Georgia Press, 1981); John A. Burrison, *Brothers in Clay: The Story of Georgia Folk Pottery* (Athens: University of Georgia Press, 1983); Geraldine N. Johnson, *Weaving Rag Rugs: A Women's Craft in Western Maryland* (Knoxville: University of Tennessee Press, 1985); and Simon J. Bronner, *Chain Carvers: Old Men Crafting Meaning* (Lexington: University Press of Kentucky, 1985).

Index